Food Styling & Photography

FOR DUMMIES®

D0943431

Food Styling & Photography FOR DUMMIES®

by Alison Parks-Whitfield

WILEY

John Wiley & Sons, Inc.

YUMA COUNTY
LIBRARY DISTRICT
2951 S. 21st Dr. Yuma, AZ 85364
(928) 782-1871
www.yumalibrary.org

Food Styling & Photography For Dummies®

Published by
John Wiley & Sons, Inc.
111 River St.
Hoboken, NJ 07030-5774
www.wiley.com

Copyright © 2012 by John Wiley & Sons, Inc., Hoboken, New Jersey

Published by John Wiley & Sons, Inc., Hoboken, New Jersey

Published simultaneously in Canada

No part of this publication may be reproduced, stored in a retrieval system or transmitted in any form or by any means, electronic, mechanical, photocopying, recording, scanning or otherwise, except as permitted under Sections 107 or 108 of the 1976 United States Copyright Act, without the prior written permission of the Publisher. Requests to the Publisher for permission should be addressed to the Permissions Department, John Wiley & Sons, Inc., 111 River Street, Hoboken, NJ 07030, (201) 748-6011, fax (201) 748-6008, or online at http://www.wiley.com/go/permissions.

Trademarks: Wiley, the Wiley logo, For Dummies, the Dummies Man logo, A Reference for the Rest of Us!, The Dummies Way, Dummies Daily, The Fun and Easy Way, Dummies.com, Making Everything Easier, and related trade dress are trademarks or registered trademarks of John Wiley & Sons, Inc., and/or its affiliates in the United States and other countries, and may not be used without written permission. All other trademarks are the property of their respective owners. John Wiley & Sons, Inc., is not associated with any product or vendor mentioned in this book.

LIMIT OF LIABILITY/DISCLAIMER OF WARRANTY: THE PUBLISHER AND THE AUTHOR MAKE NO REPRESENTATIONS OR WARRANTIES WITH RESPECT TO THE ACCURACY OR COMPLETENESS OF THE CONTENTS OF THIS WORK AND SPECIFICALLY DISCLAIM ALL WARRANTIES, INCLUDING WITHOUT LIMITATION WARRANTIES OF FITNESS FOR A PARTICULAR PURPOSE. NO WARRANTY MAY BE CREATED OR EXTENDED BY SALES OR PROMOTIONAL MATERIALS. THE ADVICE AND STRATEGIES CONTAINED HEREIN MAY NOT BE SUITABLE FOR EVERY SITUATION. THIS WORK IS SOLD WITH THE UNDERSTANDING THAT THE PUBLISHER IS NOT ENGAGED IN RENDERING LEGAL, ACCOUNTING, OR OTHER PROFESSIONAL SERVICES. IF PROFESSIONAL ASSISTANCE IS REQUIRED, THE SERVICES OF A COMPETENT PROFESSIONAL PERSON SHOULD BE SOUGHT. NEITHER THE PUBLISHER NOR THE AUTHOR SHALL BE LIABLE FOR DAMAGES ARISING HEREFROM. THE FACT THAT AN ORGANIZATION OR WEBSITE IS REFERRED TO IN THIS WORK AS A CITATION AND/OR A POTENTIAL SOURCE OF FURTHER INFORMATION DOES NOT MEAN THAT THE AUTHOR OR THE PUBLISHER ENDORSES THE INFORMATION THE ORGANIZATION OR WEBSITE MAY PROVIDE OR RECOMMENDATIONS IT MAY MAKE. FURTHER, READERS SHOULD BE AWARE THAT INTERNET WEBSITES LISTED IN THIS WORK MAY HAVE CHANGED OR DISAPPEARED BETWEEN WHEN THIS WORK WAS WRITTEN AND WHEN IT IS READ.

For general information on our other products and services, please contact our Customer Care Department within the U.S. at 877-762-2974, outside the U.S. at 317-572-3993, or fax 317-572-4002.

For technical support, please visit www.wiley.com/techsupport.

Wiley publishes in a variety of print and electronic formats and by print-on-demand. Some material included with standard print versions of this book may not be included in e-books or in print-on-demand. If this book refers to media such as a CD or DVD that is not included in the version you purchased, you may download this material at http://booksupport.wiley.com. For more information about Wiley products, visit us at www.wiley.com.

Library of Congress Control Number: 2012931724

ISBN 978-1-118-09719-9 (pbk); ISBN 978-1-118-22368-0 (ebk); ISBN 978-1-118-22646-9 (ebk); ISBN 978-1-118-23015-2 (ebk)

Manufactured in the United States of America

10 9 8 7 6 5 4 3 2 1

WILEY

About the Author

Alison Parks-Whitfield is a successful technical writer and food photographer located in the San Francisco Bay area. After studying photography in college, Alison worked as a photographer in several different capacities, eventually finding her true bliss in food and vineyard photography. Her tasty images have been published in books, magazines, newspapers, on packaging, as well as in many online venues. To see some of her work, check out her website: www.alisonparkswhitfield.com.

Dedication

To my amazingly awesome children, Gary and Chloe.

Author's Acknowledgments

A huge thank you to Erin Calligan Mooney who first approached me about doing this book. And special thanks to Tim Gallan and Jennette ElNaggar for your mad editing skills! I am so grateful to you and the entire team at Wiley.

I want to also give a big thank you to Janet, Adam, and all the chefs at Ladies who Lunch Catering in San Francisco, California. The chefs provided many of the beautiful (and delicious!) dishes in this book.

Thanks to Kingdom Cake in San Francisco, California, for kindly preparing some of the yummy cupcakes for this book, and to 3 Bee Baking for making such darned tasty organic baked goods.

And a big shout out goes to Keeble & Shuchat Photography in Palo Alto, California, for helping me with all things photographic.

And finally, I want to say thank you so much to all my family and friends for their encouragement, love, support, and patience over this last year.

Publisher's Acknowledgments

We're proud of this book; please send us your comments at http://dummies.custhelp.com. For other comments, please contact our Customer Care Department within the U.S. at 877-762-2974, outside the U.S. at 317-572-3993, or fax 317-572-4002.

Some of the people who helped bring this book to market include the following:

Acquisitions, Editorial, and Vertical Websites

Senior Project Editor: Tim Gallan

Acquisitions Editor: Erin Calligan Mooney

Copy Editor: Jennette ElNaggar

Technical Reviewer: Lisa Bishop

Assistant Editor: David Lutton

Editorial Program Coordinator: Joe Niesen

Editorial Manager: Michelle Hacker

Editorial Assistants: Rachelle S. Amick, Alexa Koschier

Cartoons: Rich Tennant
(www.the5thwave.com)

Project Coordinator: Sheree Montgomery

Layout and Graphics: Claudia Bell, Joyce Haughey, Lavonne Roberts, Brent Savage

Proofreaders: Lindsay Amones, Melissa D. Buddendeck

Indexer: Estalita Slivoskey

Publishing and Editorial for Consumer Dummies

Kathleen Nebenhaus, Vice President and Executive Publisher

Kristin Ferguson-Wagstaffe, Product Development Director

Ensley Eikenburg, Associate Publisher, Travel

Kelly Regan, Editorial Director, Travel

Publishing for Technology Dummies

Andy Cummings, Vice President and Publisher

Composition Services

Debbie Stailey, Director of Composition Services

Contents at a Glance

Table of Contents

Introduction

*W*elcome to the amazing world of food photography! And it *is* amazing to create delicious images that can quite literally make your audience drool. Understanding what makes a food photo appear super appetizing is what this book is all about. In this book, I discuss the creative and technical aspects of food photography to help you discover how to best capture the essence of a food subject, using styling, focus, lighting, angle, and more.

My love of food photography started early on. I noticed that when traveling, instead of taking photos of monuments and notable sites, I'd take pictures of the local cheeses, pastries, and other delicacies. That's when I realized I had found my passion.

I wrote *Food Styling & Photography For Dummies* to share my love of food photography with you. I hope the tools, techniques, and tips you find in this book can help you on your way to creating some incredibly delicious photos!

About This Book

Food styling and photography are in keen focus these days, with popular food blogs and food-related websites cropping up all over the Internet. But there's a perception that good food photography is difficult and way more complicated than ordinary photography. Well, in this book, I strive to shatter that illusion.

Food Styling & Photography For Dummies uncovers the tools and tricks you need to style and create delicious food photos. And to do just that, you need an understanding of both the creative and the technical aspects of dealing with food as the subject and having all the equipment, props, backgrounds, and settings in place to capture the moment (because sometimes, you really have only a moment to get the perfect shot). The key is to take that moment and shine, whether you do so by simply keeping your yummy photos organized in your own archives or by sharing with friends, family, blog or website followers, clients, or agencies. I provide the info you need to do all the above.

In this book, I share the ins and outs of food styling and photography in a simple and friendly way to help demystify the subject. So whether you're interested in food photography as a business or for your personal blog or website, this book provides easy-to-understand, well-organized, and useful information designed to get you started on your path.

Conventions Used in This Book

In this book, I use the following conventions to make sure the text is consistent and easy to understand:

- For each pertinent photo example, I include the focal length of the lens, shutter speed, aperture (f-stop), and ISO value. For example, under each photo in this book, you'll see something like this:

 85mm, 1/40 sec., f/3.2, 200

- Words in *italics* are new terms, followed closely by a definition.
- Website URLs always appear in `monofont`.

What You're Not to Read

While reading this book, if you happen across a Technical Stuff icon along the way, you may or may not be interested in that technical information. Read it only if you need it!

Any sidebars (text in gray boxes) found within this book are also *asides* and aren't vital to the content of the book itself.

Foolish Assumptions

Before I could write this book, I had to make some assumptions about you, the reader:

- You want to figure out how to photograph food to make it appear delicious and appealing.
- You're fairly well versed in the basics of using a digital single lens reflex (SLR) camera.
- You're somewhat familiar with using Photoshop for post-processing your images.

How This Book Is Organized

To help you easily find what you want to know about food styling and photography as you need it, I've divided the chapters in this book into the following five parts. Each part takes on both technical and creative aspects of food photography.

Part I: Introducing Food Styling and Photography

In Part 1, I provide an introduction to the tools and techniques of food photography. Chapter 1 sets the stage for the rest of the book with a broad overview of the material covered within these pages. In Chapter 2, I explore the type of photo equipment you need for food photography, which includes cameras, lenses with various focal lengths, tripods, and other photographic tools.

I discuss the fun world of plates, linens, and other treasures in Chapter 3. I also cover types of backgrounds used in food photography and some nifty places to find great ingredients for your photos. Chapter 4 is all about teamwork and developing relationships with the folks you may work with on a shoot.

Part II: It's All in the Presentation (Styling)

In this part, you discover a little more of the creative side of food photography. Here, I discuss how to present a food in its very best light for the camera. In Chapter 5, I talk about the importance of preparing before a shoot and what that entails. Chapter 6 has some fun information covering creative ideas for super-yummy images. And Chapter 7 explores some cool ways to overcome those messy food problems, including tricky foods like ice cream and whipped cream.

Part III: Shooting the Food: Techniques with the Camera

Part III may seem more technical because it's all about shooting and lighting techniques for food photography, but you can still have fun with these tools. In this part, I explore image composition and camera angles to use when shooting a food subject; I also talk about lighting and focus, both critically important in a food shoot.

Part IV: And for Dessert: Managing Your Photos and More

After you've shot your beautiful images, what happens next? You find out in this part. The chapters in this part center in on what occurs after you set the camera down, including saving, backing up, and editing your photos, discovering tricks with postproduction tools, creating a portfolio (in print and/or online), and advertising your business.

Part V: Part of Tens

The Part of Tens is the well-known part found at the back of all *For Dummies* books. In this part, you can find brief and helpful info on the business of food photography, figure out how to accent your food with creative toppings, and check out important basics needed for a food shoot.

Icons Used in This Book

Icons call attention to some important tidbits of information that can help you on the road to successful food photography. In this book, I use the following icons.

I use a Tip icon whenever I have a helpful piece of information to share with you about food, styling, photography equipment or settings, or a combination of these.

The Remember icon acts as a visual nudge to remind you of certain practices or concepts.

The Warning icon warns you about problems that can trip you up on the road to creating delicious images.

I use the Technical Stuff icon to let you know when I delve in to greater detail on a particular subject. This info is purely optional, meaning it's not essential to a basic understanding of the topic, so feel free to skip it if it doesn't interest you.

Where to Go from Here

Food Styling & Photography For Dummies is the type of book that doesn't need to be read from beginning to end — of course, you can read it straight through if you want! — but know that I organized this book so you can start just about anywhere to pick up useful info as you need it.

With that said, I recommend that you do a quick read of Chapter 1, which is an overview of all the material in the book. That chapter provides a bird's-eye view of the information held within the following pages. I also suggest a read through of Chapter 3 for an introduction to the unique props and ingredients typically used in food photography.

Part I

Introducing Food Styling and Photography

The 5th Wave By Rich Tennant

"Quick—get into position! I want to capture this light."

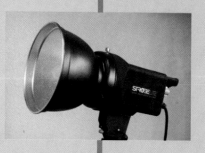

In this part . . .

1 f you want to discover how to shoot delicious food images, you've come to the right place! In this first part of the book, I introduce the craft of food photography: the hardware, the styling, and the working relationships you'll deal with on the job.

Food photography, like any photography, requires some basic tools to get started. These tools include your camera and lenses (of course), a few lights to make your food look yummy, and some supporting props and backgrounds to complement the food's best traits.

Also in this part, I provide info about working with chefs and other crew members on a shoot. So what are you waiting for? Dig in!

1

Exploring Food Photography

Maybe you picked up this book because you've started a food blog and are interested in creating more interesting photos, or perhaps you're looking to grow your budding food photography business. Or could it be that you want to create a pictorial cookbook to showcase your delicious recipes? Or maybe it's close to lunchtime and you're getting a little hungry!

Whatever the reason, welcome to the wonderful world of food styling and photography! Like most types of photography, food photography is a complementary blend of the artistic and technical, with a pinch of extra styling to make the food images look scrumptious.

In this book, I provide a robust look at food styling and photography to help you capture the deliciousness of your food subjects. I include helpful information on equipment and settings, composition and focus, managing your images, and growing your business, among other subjects.

Some folks insist that food photography is far more difficult than other types of photography, but with a little know-how under your belt, I think you'll find it's a piece of cake!

Styling Food for Delicious Photos

Food styling is all about making foods look appetizing and interesting for the camera. At its core, styling involves choosing backgrounds and settings for a shoot. That is, you pick (and place) the dishes, linens, unique surfaces, and utensils. Check out everything that's involved in Figure 1-1.

For this photo, I placed the cupcakes on a green milk glass cake plate, with a wrinkled white fabric set behind the food. The arrangement of the cupcakes may look natural and effortless, but it took a lot of experimenting to get just the right look for the shot.

You may notice a small riser hidden under the center cupcake to lift it up from the bunch. I also put one tiny plastic block under one side of the green-frosted cupcake at the back to make that cupcake lean slightly off-kilter.

85mm, 1/40 sec., f/3.2, 200

Figure 1-1: These cupcakes are carefully arranged on a green cake plate.

Getting into a little more detail, you also have the garnishes and accents, or the little something extras, that increase interest and deliciousness in a photo. You can add so many different types of accents to a food dish, such as the large sprig of dill and the cream-colored sauce in Figure 1-2. Creativity reigns with accents, so don't limit yourself to that conventional piece of parsley!

Pull it all together by placing these elements, which I discuss further in the following sections, in a pleasing composition, and shoot *a lot* of images!

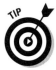

The food you're photographing may look good for only a short period of time, so use the time wisely and approach your subject from various tilts, angles, and distances (see Chapter 10 for details). If you have time, try some different backgrounds and settings as well. You can also change up the garnishes for a slightly different look. The more images and options you have to choose from, the better.

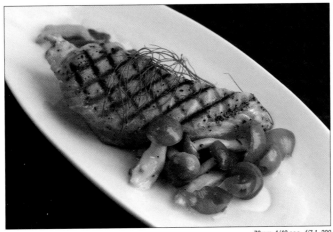

70mm, 1/40 sec., f/7.1, 200

Figure 1-2: A couple of well-placed accents can enhance any dish.

In Figure 1-2, my chef provided the lovely grilled salmon and vegetables dish on a clean white plate. For this part of the shoot, I decided to use a dark background to really make the colors of the dish stand out. I steamed away the wrinkles of a dark brown cloth napkin and then placed it under the plate to use as a background. I tweaked the vegetables slightly to make the arrangement look a little more natural. I also wanted to make sure the veggies picked up the highlights from the lights.

Speaking of lights, for the image in Figure 1-2, I had three lights going on at the shoot: a *key light,* or main light; a *fill light* (a weaker light source) to help shape the light and shadows; and a small light shooting across the back of the scene as a background light. (See the later section "Looking at lighting" and Chapter 9 for details on lighting your food subjects.)

Starting with backgrounds

Backgrounds are an integral part of a food image's overall look, even if you don't actually see more than a hint of them. Backgrounds often set the mood for the image and either blend in or contrast with the food subject. Whatever look you go for, the idea is to really make the food the star of the show. A

clean, beautifully lit white background, as shown in Figure 1-3, creates a light, whitewashed setting that can be a lovely and appetizing look for a food shot.

85mm, 1/50 sec., f/3.5, 400

Figure 1-3: An all-white background lets the food shine.

And on the other extreme, a rustic, southwestern type of background can provide a bold and colorful counterpoint to the food subject, as the rusty, well-worn painted metal chair does in Figure 1-4.

32mm, 1/125 sec., f/5.0, 400

Figure 1-4: The background in this shot complements the rustic look of the tomatillos.

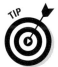

Did you notice how each of the tomatillos in Figure 1-4 points in a different direction? The variety of angles in the placement of foods against a background can also increase interest in a food photo. I go into detail about how to place and arrange your food subjects in Chapter 8.

The possibilities are endless for what you can use as a background to add texture to and increase interest in your food shots (just check out Figure 1-5). You can use metals, woods, plastics, papers, and fabrics, as well as cool organic materials, such as leaves or coffee beans. (See Chapters 3 and 4, where I talk about various styles and looks for backgrounds and settings, for more ideas.) When it comes to backgrounds, let your creativity go wild!

55mm, 1/30 sec., f/7.1, 400

Figure 1-5: Seed pods create a unique background.

Foraging for props

Part of the fun of food styling and photography is finding the cool dishes, silverware, trays, and other props to make your food images look their best. I love rummaging through a good antique store, thrift store, or flea market to find those unique items that enhance the artistic appeal of an image. And discount stores are an awesome option for finding everyday wares for your housewares library. Figure 1-6 is a shot of one of my antique store finds: a couple of 1950s' era ramekins.

How did the image come together? Well, to start, I found the pale blue rame- kins stacked in the back of a crowded antique store and immediately fell in love with the distinct shape of the cups, not to mention the color is pretty darn beautiful as well.

When baking the soufflés in the ramekins for this shot, I received a nice surprise: A unique black crackle appeared in the glaze of the ramekins as they heated. Bonus! I think the crackle makes the ramekins a little more interesting within the image.

When planning for this shot, I decided I wanted one other pastel color to round out the color palette of the image, so I added the soft yellow plate (also found at an antique store) under the ramekins. The spoon to the left came from a local thrift store. And finally, a white cake plate, which I purchased at one of my favorite discount stores, placed under the whole shebang finishes the look.

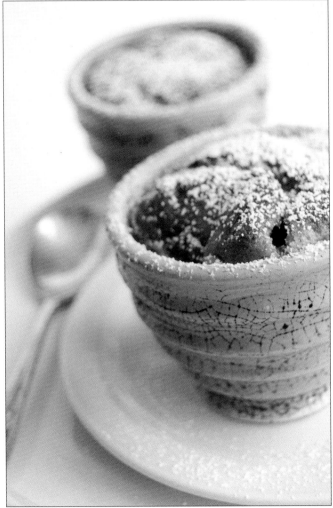

45mm, 1/20 sec., f/5.3, 640

Figure 1-6: Antique blue ramekins frame these soufflés beautifully.

After all the elements were in place, I shot as quickly as possible because the little soufflés were quickly deflating.

Another great way to add character to a photo is to add small, inexpensive, everyday items. Careful scouring at a neighborhood garage sale yielded the retro red melon baller in Figure 1-7.

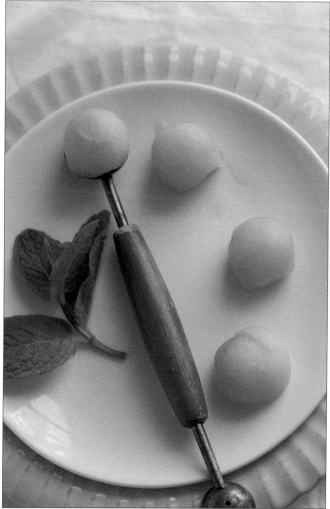

85mm, 1/80 sec., f/4.5, 400

Figure 1-7: A bit of added character takes shape in the form of an antique melon baller.

Placing the food and accents

Yes, what you've heard is true: Arranging a food subject's composition to make it look natural and effortless for the camera can actually take quite a bit of time and effort.

When composing a food shot, I like to place the majority of the subject within a circular area in or near the middle of the frame. Of course, special cases may occur, such as when shooting for packaging or editorial use where the subject needs to be placed to one side or in a corner.

To make a food subject such as vegetables, for example, appear natural, you need to mix things up a bit. Foods look more realistic when placed at seemingly random angles within a shot (see Chapter 8 for details). These angles convey a more effortless and realistic look for a composition. Figure 1-8 is a good example.

42mm, 1/40 sec., f/8, 250

Figure 1-8: Vary the angles of the food subject for a more realistic look.

And that thought carries over to food accents and garnishes, too. Change up those angles on your accents so the composition looks natural. (I talk more about placing accents in your food subjects in Chapter 6.)

Following Your Focus

Focus is a key element of food photography. With that said, focus trends in the industry sway to and fro, changing with the times.

Twenty-five years ago, food photography images were almost always in complete focus. Currently, one of the more popular styles of focus is *selective focus,* which focuses in on only one appetizing area of an image.

Depending on the subject, you may decide that focusing solely on the front or midsection of the food looks best. Or you can keep most of the food in focus and blow out the background. In other situations, you may decide to have the entire food subject and setting in focus. And, yes, sometimes you may need to have the entire food subject a bit *soft,* or out of focus. In Chapter 11, I present the details of the various focus considerations when shooting foods.

Honing in on that gorgeous little shiny highlight is what the focus is all about sometimes. In Chapter 6, I talk about ways to enhance and capture that shine in an interesting way, which helps it translate to a delicious-looking photo.

Speaking of shiny highlights, Figure 1-9 displays a beautiful one in a brownie's caramel topping. This particular photo was shot by using a super-simple setup. Early one cloudy morning, I noticed that the light outside was lovely and diffused. Because of the available natural light, I made the decision to shoot outdoors that day.

I placed the brownie on a worn, brown wooden stool to complement the dessert's coloring. I placed a wrinkled white paper wrap under the brownie itself to provide a little separation between the brown of the food and the brown of the stool. I used one reflector to bump up the shine of the highlight ever so slightly. I then focused intently on the highlight in the delicious caramel topping. I shot from all angles and distances, and the shot in Figure 1-9 was my favorite by far. Dreamy!

Where to focus is your artistic choice, whether you're shooting for yourself, your own blog or cookbook, or for a stock photo agency. So play around with the focus when shooting foods, as I did in the photo shown in Figure 1-10. However, when working on photo shoots with clients or art directors, although you may have some input, where you focus is primarily their call.

42mm, 1/160 sec., f/8, 400

Figure 1-9: Focusing on the shiny highlight of a caramel rocky road brownie.

40mm, 1/200 sec., f/7.1, 200

Figure 1-10: Selective focus captures the delicious toppings on this Italian pizza.

When shooting for packaging, clients often request that the entire food subject be in focus to provide an accurate representation of the food inside. Food packaging clients can be very particular about how their foods are shot and composed!

Talking about the Technical Bits

As I mention earlier in this chapter, food photography is the joining together of the technical and artistic. In this book, I cover many of the equipment options available for both lighting and camera gear. The following sections serve as a small introduction.

Looking at lighting

As a photographer, you have a full palette of lights, lighting gear, and reflectors to choose from these days. The one constant when shooting food with studio lighting is the need to soften the lights via diffusers for a nice quality of light. In Chapter 9, I go into detail about the different types of lighting and diffusers, but basically the lighting used for food photography boils down to the following three types:

- **Strobe:** *Strobe lights* are like a flash system that syncs between your camera and your lights. These lights can be strobe lights that work with a stand-alone power source, or they can be *mono lights* — lights that contain their power source within the unit.

- **Continuous:** *Continuous* or *hot lighting* refers to lights that are always on when shooting. You turn them on, you leave them on, and yes, they get rather hot!

- **Natural:** Using natural light is an incredibly fitting choice for food photography. Figure 1-11 is a good example. An abundance of filtered natural light falling directly on a subject really caresses the food and shows it off to its fullest. This option requires less technical skill and is a really great look; however, counting on the weather to provide beautiful overcast light isn't the most reliable choice of lighting!

Considering camera equipment

In Chapter 2, I delve into the specifics of cameras and camera gear, including choosing a digital SLR to meet your needs. A lot of options are now available, with newer, better, faster, and higher-megapixel cameras coming out all the time. The key to choosing a camera really depends on what you need, what you can afford, and what you already have (or don't have).

35mm, 1/80 sec., f/4.5, 400

Figure 1-11: Natural light falls on fresh picked peppers.

Choosing a lens for food photography is a little different than choosing a lens for other types of photography. To show off the beauty of a food subject, I find that using a lens within the normal to slightly long range works best. I usually work within the 40 to 70mm range, with an occasional foray up to an 85mm lens. I suggest having two to three lenses (a mixture of fixed and zoom lenses) in your photo arsenal. Each lens provides a slightly different look for your images, so you want to make sure you have options.

Check out the discussion in Chapter 2 to narrow down the criteria for cameras and lenses for your food photography business — or glorified hobby, as it may be.

Uploading, Backing Up, and Naming Photos

After you're done shooting and uploading your images, the real fun begins! The first order of business is to protect your photos. Backing up your work right off the bat gives you a second set of images to work with (just in case).

Sadly, devices can sometimes fail. So to protect your photos, back them up in some way. Whether you back up to an external drive, the cloud, or CDs doesn't matter; just make sure to back up your work so you have duplicate copies of your images in two different places.

The next step is to choose the best images from the shoot. Is the subject in focus? Check. Exposure correct? Check. Is the composition looking absolutely delicious? Check! In Chapter 13, I discuss some simple ways to go about tackling the selection process.

After I select my favorite images, I use an easy naming convention for my photos. Doing so standardizes the names of the photos in my library and is uber-helpful for organizing and finding my images. I start with a four-digit date, such as 0412 (for April 2012), then add a descriptive title, and lastly, I leave the underscore and the original photo number at the end. So the image's file name looks something like 0412AppleCore_6723.

When reviewing your images, you may come across some really nice photos that are 97.3 percent great, but they have a couple of tiny imperfections, such as the image in Figure 1-12. Here's where photo-editing software, such as Photoshop, comes to the rescue! Photoshop has a host of easy-to-use tools that can correct most small flaws in your images. In Chapter 12, I go into detail about the various post-processing tools available and how to use them to perfect your images.

42mm, 1/20 sec., f/5.0, 400

Figure 1-12: Don't be afraid to use post-processing tools when you have a sauce spill that could use a little cleanup.

Working on the Business of Food Photography

Promoting your business begins with pulling together a gorgeous portfolio to show potential clients the magic you can do with a camera.

Once upon a time, portfolios consisted of a folder of selected prints that were carefully carried around town to present ceremoniously to clients. Although this option is still a good choice and is particularly appropriate in some urban markets, these days, a portfolio is more often a digital collection of images.

When you've made your portfolio decisions (such as whether to go digital or print and what photos to include), it's time to consider advertising. As a general rule, advertising your work leads to more work, so get on out there! The types of ads to consider include direct mail, magazine or newspaper ads, or those small Internet ads that display down the side columns of search engines or social sites, just to name a few.

And speaking of social, when it comes to marketing your work, go on and be social! Growing your business goes hand in hand with a large online presence (websites, blogs, social networks, and beyond).

So to get your business engines revving, check out Chapters 14 and 15, which provide a host of info on the business aspects of food photography.

2

Photography Know-How and Equipment

In This Chapter

▶ Understanding the differences in cameras and lenses

▶ Using a stabilizing device while shooting

▶ Making lighting adjustments both on and off camera

▶ Figuring out file formats and memory card capacity

A huge part of what you need for a food photography business is all the nifty, creative, and aesthetic stuff: the plates, linens, backgrounds, and such, which I discuss in Chapter 3. But in this chapter, I talk about the other part you need to make the magic happen: the equipment (camera bodies, lenses, memory cards, and so on).

Cameras and lenses run the gamut of quality. Low-cost *prosumer* digital SLRs are a cross between a professional camera and a consumer camera, and they may be perfectly fine for some stock or blog usage. But if you're serious about starting a food photography business, professional strength digital SLRs are the way to go. In this chapter, I outline a few areas to consider when purchasing a camera and corresponding lenses to fit your photography needs.

Using a tripod is a completely personal preference when shooting food. Some folks absolutely swear by tripods because they love the stability in low-light situations, among other factors. But many photographers shy away from traditional tripods for a number of reasons. Sometimes the weight or bulk of the tripod, or simply the lack of mobility when trying to capture the best shot, deters folks. If you're not keen on lugging around a bulky tripod but still need something to help stabilize your camera, I discuss other options in this chapter.

Also in this chapter, I explore some lighting options, how to work with the ISO setting on your camera, and a few file formats you can shoot and save your images in for the best possible quality in your food photos.

Cameras 101: Choosing the Right Camera for You

The heart and soul of your food photography centers on the camera you use for your images. If you're thinking about buying a new camera, what specifications are important to you? Is your main focus on the weight of the camera, how it feels in your hand, the megapixels, or a large image sensor? Or is it something else, like the quality of the brand or the design of the camera body? Or are you mainly concerned with the cost?

A new camera is quite an investment, so figure out those features that are most important to you and shop wisely. In the following sections, I discuss the benefits of a digital SLR and explore the differences in quality of point-and-shoot cameras.

Digital SLRs all the way

Deciding on a new digital SLR is a uniquely personal experience. Although an astounding number of cameras are available, I help you narrow down your choice by considering the questions in the following sections.

What's your favorite brand?

Many people start the process of buying a camera by identifying their favorite brand(s). You may already have a preference toward a brand that resonates with you. For example, do you lean toward Team Nikon, Team Canon, or Team Olympus? With about a dozen major brands in the field today, you can quickly narrow down the field by choosing one or two favorite brands and exploring the camera options in that line.

If you already have existing lenses for a camera, deciding on a new camera may be a little easier than you think. Many camera lines have lenses that are compatible between older and newer models and even between film and digital SLRs.

How much camera can you afford?

We currently live in an era where money is a weighty consideration for many of us. So the cost of investing in a big-ticket item, like a camera outfit, is a big deal. My suggestion is to figure out what you can afford and stick to it as you go through this comparison process.

Currently, prices for a prosumer digital SLR start at about $400, with a good, solid camera body running about $800 and up. The professional range starts a little higher in price, generally in the low four figures.

After you figure out your target camera budget, you can narrow down the choices even further.

If you're looking for a budget-conscious option but are set on a pro camera, a good choice may be to purchase a lightly used digital SLR from a reputable camera store. Doing so is a great way to get an awesome camera for a much lower price!

What features are important to you?

Cameras these days have a bazillion bells and whistles, and getting lost in the shiny objects and fancy features is rather easy, so try to keep things in perspective while on the hunt.

When you're looking at a new camera for food photography, shooting in near darkness isn't the most important feature. Nor is HD video capability. But megapixels and image sensor size? Heck yes! They affect the quality of the image and are very important when considering a camera (see the next section).

What about the weight of the camera? You betcha. Weight can be an important factor to think about, particularly if you shun tripods and the like. Also, the light metering, the focusing model, and comfort with the viewfinder are important features to consider.

How much do megapixels matter?

There are megapixels, and then there are megapixels. Just because a camera has a high megapixel number doesn't mean the camera will produce high-quality images. The size of the camera's image sensor (in combination with the megapixel count) is also a key factor in the quality and size of the image.

So whatever megapixel count you choose, the larger the image sensor, the better. A full-frame 35mm sensor is the optimal situation but is quite expensive. Digital SLRs with full-frame sensors start at about $2,000 and go up from there.

Sorry, penny pinchers, you can't use point-and-shoot-cameras

Point-and-shoot cameras definitely have their place in this world. They're the ever-present camera candy; they're cute, inexpensive, handy little cameras that capture snapshots of everyday life. Point-and-shoot cameras have decent quality and slim profiles, and many have a high megapixel count. But these cameras simply don't allow for a high enough image quality or provide enough control to create the images you need for your business.

Ever higher megapixel numbers are the major selling point for many point-and-shoot cameras, but the reality is that the quality of the images depends greatly on the physical image sensor size in a camera. You can have a slim point-and-shoot camera that proudly boasts its 12 megapixels, but it may have a miniscule image sensor that won't pick up anywhere near the image detail of, say, a 12-megapixel digital SLR with a much larger image sensor. So I encourage you to stay far, far away from typical point-and-shoot cameras.

Like with every great rule, there's always an exception. Okay, two exceptions in this case: The Leica D-Lux 5 (around $800) and its lower-priced counterpart the Panasonic Lumix DMC-LX5 (around $400; shown in Figure 2-1) will do quite nicely in a pinch — if you really can't go the digital SLR route. These point-and-shoot cameras boast a large image sensor, RAW capability, high ISO support, Leica optics, and manual settings options. Although you're limited to the existing zoom lens, the quality is quite beautiful because of the Leica optics within. These cameras are fine to use occasionally for smaller stuff, like some low to midrange stock agencies or for blog usage, but they're definitely not the type of camera you want to take on an advertising or packaging shoot.

Figure 2-1: The Panasonic Lumix DMC-LX5 is a quality point-and-shoot camera option.

Film: A flash from the past

I heart film. The truth of the matter is film was my introduction to photography, and I have a great fondness and respect for the traditional methods and images. And I just love the smell of photo chemicals in the morning!

But the reality is this: Several years ago, digital SLRs got to a point where the quality was so amazingly good, it didn't make sense anymore to shoot film. The digital quality plus the ease of use and not having to wait to see the images you shoot (as well as no required printing costs) won over the hearts and minds of most photographers. However, now I'm seeing a resurgence in film cameras, particularly with younger, 20-something photographers. Everything old is new again and all of that. This trend is refreshing and artistic, and I'm excited to see what comes of it.

For the most part, the info in this book leans toward digital SLRs because they're what nearly every food photographer is using these days.

Lenses: Figuring Focal Lengths

With so many camera lenses out there, how do you find the best ones for food photography? Well, I often think about photographing food as if I'm taking its portrait, as in Figure 2-2. As such, you want to have a lens or two (or three!) that shows off the beauty of your food subjects. For me, that means using a range of normal to slightly long focal lengths, centering in on the 40mm to 85mm neighborhood. This range produces amazingly delicious food images.

Although I occasionally shoot in the 38mm area, typically a super-wide shot of food just doesn't look very appetizing. And very long lenses? A 200mm lens is perfectly great for scenic shots but not such a good fit for shooting a grilled cheese sandwich.

85mm, 1/125 sec., f/5.6, 800

Figure 2-2: This "portrait" of a pair of cupcakes was shot with an 85mm lens.

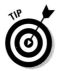

Whatever lens you shoot with, using a clear protection lens filter is a really important must for your lenses. These filters protect the surface of your lens from scratches, dust, fingerprints, and the like.

In the following sections, I delve in to a bit more detail about lenses, from making sure your lens is the right one for your desired result to comparing manual and autofocus lenses.

Finding the right lens for the job

An 85mm lens is about the longest lens I ever use for food photos. The longer length of this lens can create an awesome background blur for food images, but I do have to shoot much farther away from the subject than I typically want to. If the lens were any longer, I'd have to shoot my food dishes from across the room!

When you buy a lens, consider the focal length (mm), a fixed lens versus a zoom lens, and the f value of the lens. Generally, the lower the f value (such as f/2.8), the higher the price and quality of the lens.

Another factor to consider when shopping for a lens is the weight of a lens. Some beautiful lenses have magnificent optics and yield fabulous photos but

are difficult to hold for extended periods of time. So I tend to use the gorgeous heavier lenses for shorter periods of time, interspersed with a trusty, lightweight zoom that I use to handle a lot of images. Using several lenses throughout a shoot is something that works well for me.

Using manual versus autofocus lenses

A lens that has both a manual focus option and an autofocus choice is the best of both worlds. Having the flexibility to choose either focusing model really allows a photographer some leeway to hone in on the highlight in whatever way works best for a shot. But some lenses are autofocus only — a reflection of the ever more automated world we live in.

If you love the quality of a specific lens that's autofocus only, don't fret! Manually choose the focus points within your camera's focus settings to set the points exactly where you want the crisp focus in your food subject.

Stabilizing Your Camera

Keeping your camera stable to avoid focus problems in low-light or low ISO situations is an ongoing challenge for a food photographer. Some photographers avoid any type of stabilizing device because using one can somewhat infringe on the agility of movement. But others know that sometimes a little extra stability can really make the shot.

For those of you who are of the latter ilk, you have your pick of three types of stabilizing devices generally used for food photography: tripods, GorillaPods, and monopods. I expand on each of these devices in the following sections.

Tripods

You're probably quite familiar with a tripod (see Figure 2-3), which is a three-legged stabilizing device that supports a camera, usually used in a low-light or long lens situation. Tripods are generally made of aluminum or carbon fiber to keep them as lightweight as possible.

Personally, I don't use a tripod when shooting food because it restricts my movements when capturing the various tilts and angles of a food subject. When shooting foods, I need to be fairly agile and able to work quickly. But some folks love the stability, security, and image quality you can get from using a tripod. So the choice is a personal preference.

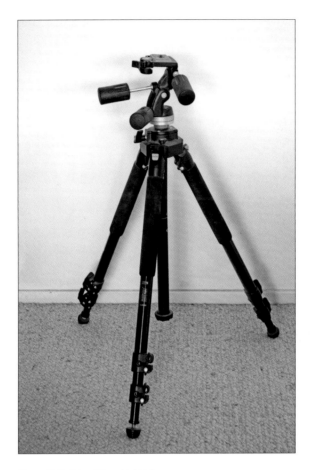

Figure 2-3: A traditional tripod.

If you decide that a tripod is for you, a good, quality one will run you about $100 to $300.

Stay far, far away from the flimsy $20 tripods found at low-price retailers. Sure, the price is amazingly cheap, but these types of tripods are simply not stable enough to use with a digital SLR.

GorillaPods

If you like the idea of a tripod but want a little more flexibility, a cool alternative choice is a Joby GorillaPod, shown in Figure 2-4. These unique and unusually limber tripods can grip, wrap, bend, and twist to provide a secure

and stable environment for your camera. A model that holds a digital SLR with a large lens runs about $50.

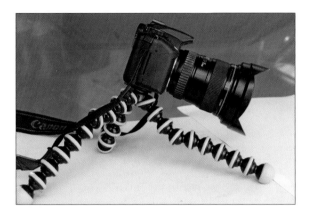

Figure 2-4: A flexible GorillaPod in action.

Monopods

Imagine, if you will, dismantling a tripod into three individual legs. Well, a monopod is kind of like taking one leg of a tripod and attaching it to the bottom of your camera (see Figure 2-5). This leg provides secure stabilization without the bulk and weight of a tripod. Several expandable sections in the monopod extend it to its full height, and rubber grips secure it in place. Overall, a monopod is less difficult to use than a tripod, and it provides more flexibility when shooting.

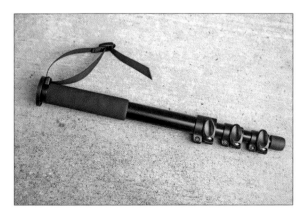

Figure 2-5: A monopod — my new best friend.

After holding out for years, I recently bought a pretty heavy-duty monopod to help with stability on some low-light shots. Wow! Why did I wait so long? Using a monopod has helped me capture some really beautiful, clear images that would otherwise suffer from my less-than-perfectly-steady hands.

Monopods come in a range of sizes, weights, materials, and pricing choices. They start less than $20 and can go on up to a few hundred dollars. You can get a really nice, quality monopod for around $50 to $60.

Lighting Things Up

Unless you've made the decision to shoot food solely in natural light, you'll need to invest in some lights. These lights can range from modest lights to high-end soft boxes (see Figure 2-6), but you'll need at least three lights with diffusers to serve as a main light, a filler light, and a back light. To make the most of your lights on a shoot, you'll also want to invest in some good reflectors and stands. I talk about all these tools in the following sections.

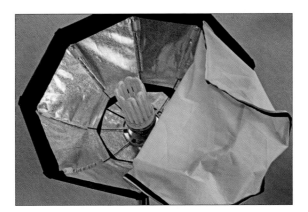

Figure 2-6: A multi-sided soft box light.

Lights

Before you decide on a lighting setup, you need to make one basic decision: Which of the two types of photographic lights are you going to use? Strobe lights or continuous lights? *Strobe lights* (see Figure 2-7) are essentially lights that function as a flash unit that's tethered to your camera. *Continuous lights*

stay on while you shoot (which is why they're also known as hot lights). A lighting setup for food is typically one type or the other, not a mixed bag of both. Whichever type of light you go with, these lights need to be good and diffused to create a soft lighting environment to best show off your food subjects.

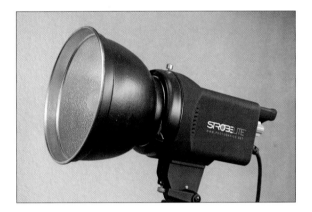

Figure 2-7: A strobe monolight.

In my typical lighting setup, I have one small light with a diffuser as the main light, one smaller (or farther away) diffused light as a filler light, and a tiny soft box shooting across the back acting as a gentle backlight. I go into more detail about lighting for food in Chapter 9.

Reflectors

Reflectors are cardboard or nylon materials with reflective surfaces that help you manage the way light falls on your food subject. Reflectors are also helpful tools to diffuse and lighten unwanted shadows. Having a couple different reflectors handy on a shoot allows you to capture the highlights and shadows you need to make your images shine. I discuss reflectors in detail in Chapter 9.

You can use a light-colored reflector, such as white, silver, or gold, to add a bit of light to a food subject. And you can use a black reflector to tone down a too bright area in a subject. The dark reflectors are also great for coaxing out a little depth and shadow in a very light colored subject, such as whipped cream.

C-stands

To support some of these tools, you may want to consider buying a *C-stand*. A C-stand is a handy and versatile piece of equipment with an extending arm that can hold clamp-on lights, reflectors, diffusers, backgrounds, or whatever is needed at the moment (see Figure 2-8). An alternative to a C-stand (at least for holding a reflector) may be an extendable reflector holder that can fit directly onto a light stand.

Figure 2-8: A C-stand.

Choosing Your ISO

In the old days, the ASA setting on a film camera allowed the photographer to choose a numerical value to adjust how sensitive the film was to light. The lower the ASA number, the lower the light sensitivity, and the higher overall quality of the image.

And now in the digital SLR world, the ISO number on a camera works in nearly the same way. With digital SLRs, instead of the film responding sensitively to the light, the camera's image sensor does. The ISO number for digital SLRs is basically the same idea as the ASA number for film cameras: the lower the ISO number, the higher the quality of the image.

A low ISO provides a nice, clean image, while a higher ISO, say, over 800 ISO or so, can display some *noise* in your image. Noise is also known as grain or, my favorite term, pixel dirt. You can see the noise speckles more easily when zoomed in. Sometimes a photographer uses his artistic choice and goes with a high ISO, but anything over 1,000 ISO generally isn't the best look for a food image. I tend to shoot in the 200 to 400 ISO range, which provides a really nice quality, rich exposure for my images.

In low-light situations, with no ability to change the existing lighting, bumping up the ISO to 800 or so is okay if you simply must get the shot. But know that you'll see a bit of noise with a high ISO, particularly when zoomed in on dark areas. As you can see in Figure 2-9, noise detracts from the overall look and quality of images.

Figure 2-9: Notice the noise in this zoomed-in image of a frosting applicator at 800 ISO.

The ISO setting is an important consideration for the quality of your images. If you decide to shoot for stock photography agencies, some agencies require a very low ISO for submitted images — as in the neighborhood of 100 ISO. Be sure to read the fine print on the submission guidelines, which vary from agency to agency.

Shooting RAW and Using Other File Formats

The *RAW* file format is just what it sounds like: It's raw, barely processed image information. You can select the option to shoot RAW in your camera's menu, as you can see in Figure 2-10. When you upload a RAW file to your computer and double-click it, the RAW converter dialog window opens. This option-filled dialog allows tweaking of all the various image adjustments for a photo, such as color balance and saturation.

Figure 2-10: Choosing RAW format in your camera's menu.

Why should you shoot RAW files when photographing food? Well, first off, RAW files produce a much higher quality starting point for your photos. And when you handle image adjustments within the RAW dialog, they're cleaner and more accurate than if you tweaked them after the fact as JPEGs in a photo-editing program. Although RAW files produce a larger file size, most

professional photographers absolutely swear by shooting RAW for greater quality and control.

JPEG is a *lossy* format, meaning it loses some image information along the way, particularly during repeated saves of a file. So although you may need to submit JPEGs to your clients or stock agency, you'll likely want to start by shooting RAW for the best quality. From there, edit the RAW file in the RAW converter dialog, and then save the file as a JPEG via your photo editor.

Some stock photo agencies or clients require high-quality TIFF files rather than JPEGs. TIFF is generally *lossless,* meaning it doesn't lose image information when saving as uncompressed. So the procedure for using TIFF files is to shoot RAW, upload the file, edit by using the RAW converter dialog, and save the image as a TIFF file.

TIFF files can be rather enormous in size, so be aware that you may need some extra hard drive space on your computer.

Sticking It to Memory — Cards, That Is

Memory cards, shown in Figure 2-11, are the tiny little chips you stick in your camera to hold your images. Currently, the sizes range from 2GB to 64GB, and the memory capacity of these little cards is growing ever larger all the time.

Figure 2-11: Memory cards are basically digital film.

When shooting, be sure to have several memory cards handy. Having these extras around allows you to switch one out when you encounter problems with a card and also when you fill one up (in the course of a daylong shoot, you're likely to fill several cards).

Memory cards are holding more and more information — up to 64GB at the moment! Now that's a lot of space for images! At the same time, the little cards have thankfully fallen significantly in price over the years. Prices generally range from around $12 to $75 or so for cards between 2GB and 32GB, but those very high capacity 64GB cards can run more than $200.

Although enormous 32GB and 64GB memory cards are now available, are they a good choice for a shoot? Well, possibly not. If you shoot a full day using one gigantic card and that card fails before upload, all the images from the shoot are lost and gone forever. To minimize your risk, using several smaller 2GB and 4GB cards for a shoot may be a better choice. If a smaller card goes bad, then not all the images from the shoot are lost.

For very important shoots, I don't erase the cards when I'm done uploading. I simply file them away as an extra, extra backup, just in case they're ever needed.

3

Your Stylist Toolkit

*T*o shoot and style food, you need to gather together a healthy assortment of resources that help you prepare the foods for your camera. A *stylist toolkit* is a collection of backgrounds, props, and tools you need to create beautiful settings to show off your food subjects.

Your stylist toolkit should allow both creativity and flexibility in your work. You don't need a lot of props at first but just enough to provide a good variety to mix it up a bit.

You can start with the basics: a small but good selection of white and off-white dishes, with a few colorful dishes thrown in for good measure. Add a few helpful backgrounds, linens, and other tools, and you're ready to get started.

In this chapter, I show you what you need to put together a stylist toolkit, where to find unique materials and ingredients for your toolkit, and how the different materials and ingredients you use can make your food photos pop or flop.

Setting a Mood for Food

When you have beautiful food to shoot, how do you frame it to show it off in the best way possible? Create settings, or little worlds, to surround and complement the food subject. In other words, you want to create a feeling, or mood, for your photos that draws the viewer in so she can almost taste the food you're shooting.

In addition to lighting, which I cover in Chapter 9, to create a setting for your photos, you need backgrounds, dishes, linens, papers, and other props. I discuss all these tools in the following sections.

Understanding background basics

When I talk about backgrounds, I'm really referring to two things — the backdrop hanging or propped up behind the food subject and what's sitting just under the food you're photographing. The background is really whatever falls behind your food in the shot.

What can backgrounds do for your images? Backgrounds can complement the food subject and enhance the deliciousness of your photo. And some backgrounds can isolate your food subject when needed. From a highly stylized raspberry mousse set on a shiny white acrylic to an earthy muffin sitting on a little wrinkled parchment, your background choice is an integral part of the overall image.

My favorite looks under food — plated or not — are papers, parchment, wax paper, cloth and linens, woods, and some metal pans. Note the metal cookie sheet in Figure 3-1, which is a unique choice for a background that seems to pull off both industrial and homey at the same time.

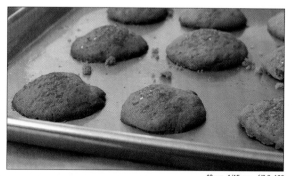

40mm, 1/15 sec., f/3.3, 100

Figure 3-1: A simple, metal cookie sheet provides a great background for these cookies.

Another cool option, particularly for bright, shiny foods, is using plexiglass or acrylic sheets or blocks. Setting your food or drinks on these types of backgrounds results in a modern image with significant reflections of the subject.

Other items to consider for backgrounds include interesting trays, tables, chairs, flower petals, lemon slices — you name it. Almost anything can work as a background for food.

Don't feel limited by using traditional types of backgrounds. In fact, thinking outside the box often produces the best results. And, yes, sometimes thinking outside the box can literally mean placing your food inside a box, as shown in Figure 3-2.

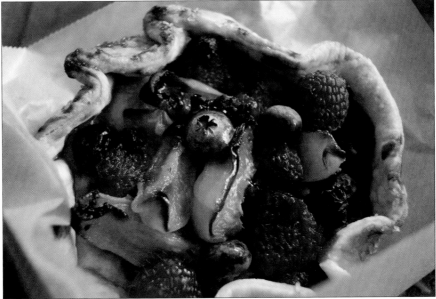

32mm, 1/13 sec., f/4.5, 400

Figure 3-2: Even a box with paper can provide an interesting background.

For Figure 3-2, I found a gorgeous fruit tart at a local farmers' market that I decided to shoot for stock. The vendor wrapped up the tart with a bit of wax paper and placed it in a box. When I got home to shoot it, I tried a few options, but my favorite look was the tart in the box with the wax paper surrounding it.

Gather up a healthy selection of backgrounds for your toolkit. Be sure to have several options available when you're shooting your food subject. I find it handy to *always* have a roll of white paper in my toolkit. No matter what happens with your other backgrounds, having the option to switch it around by using a white background is important.

I always try a couple of different backgrounds when shooting any subject. I like to mix it up and try to get a good variety of looks so I can provide different choices for my clients (or myself, if I'm just shooting for stock or my blog). If you use only one background and then don't like the end result, you may have to redo the shoot, which is a waste of time and money.

Exploring other background options

Three additional types of backgrounds commonly used in food photography are foam core boards, sweeps, and natural settings. I talk about each of these backgrounds in detail in the following sections.

Foam core boards

Foam core boards are strong, lightweight boards (not to mention, cheap and indispensable) that are typically white on one side and colored on the other with a layer of polystyrene in the middle. They can help you control your settings by blocking out any unwanted background items and replacing them with a solid color of your choice.

Having a few different colors of foam core boards on a shoot is always a good idea. You can generally find a full range of colors and sizes of these boards at your local craft store.

Not only can you use a foam core board to prop or tape up behind a food scene, but you can also cover a board with another type or color of paper, or even some material, for a brand-new look. Foam core is an extremely versatile addition to your toolkit.

Using foam core may show a line at the horizon, which can sometimes be the desired effect but other times not so much. When you're not keen on showing a horizon line in an image, using a sweep may be a better option (see the next section).

Figure 3-3 is a test shot done with a pink foam core background. For this look, I wanted a good differentiation between the table and the background. I used duct tape to tape the foam core to the back of the table so I didn't have much of a gap between the two surfaces. As you can see, the horizontal line where the table meets the background is subtle and blurred. Because of its subtlety, this background will enhance, not distract, from the food subject that will go into the bowl.

If you use this type of setup with a tabletop and background and notice that the horizontal line where the two meet is just too distinct, or too dark, all isn't lost. You can clean that up in postproduction by using a Dodge tool. I go into the specifics of dodging in Chapter 12.

Sweeps

When you want a clean background with no lines and little to no variation, you may want to go with a *sweep*. A sweep is a 90 degree curve of plexiglass, cloth, paper, or plastic that displays as a seamless background in your shots.

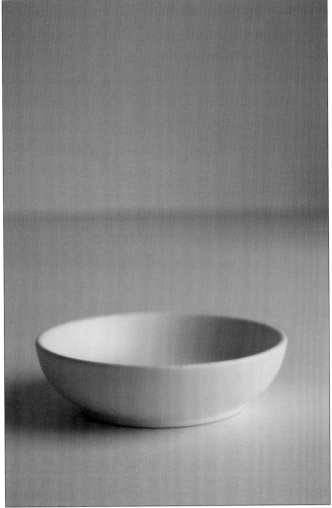

55mm, 1/250 sec., f/6.3, 640

Figure 3-3: This test shot uses a pink foam core background.

Sweeps isolate the subject from the background and put the focus squarely on the food. Sweeps are particularly useful for product or packaging shots but are great overall for everyday use.

You can find a full range of price levels for sweeps, from the paper roll that runs about a dollar, to shooting tables that cost upwards of a few thousand dollars.

Here are some of the various sweep options available to photographers:

✔ **Stand-alone shooting tables:** These tables (see Figure 3-4) usually consist of a metal framework with a plexiglass sweep attached via a clamp or other hardware. They can range in price from a few hundred dollars to a few thousand dollars and can be found online or at larger photography stores.

Figure 3-4: A shooting table.

✔ **Support stands:** Support stands are a smaller, tabletop version of a shooting table with a small metal support and an attached plastic sweep. They're lightweight, portable, and easy to use (see Figure 3-5). Support stands generally run well under $100 and can also be found at larger photography stores or online.

✔ **Paper sheet or roll:** This super-simple sweep is created by taping paper from a table up to a wall or background to create a curve (see Figure 3-6). Quick and messy, yes, but a simple roll of paper can provide exactly the look you need in a pinch. This low-cost option runs just a few dollars for a 3- to 4-foot length of paper.

Figure 3-5: A support stand in use.

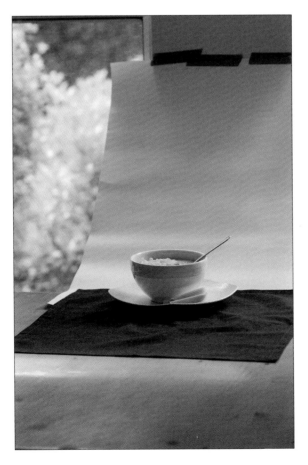

Figure 3-6: An inexpensive paper sweep.

✔ **Plexiglass sheet:** This sweep is another sort of homemade option. If you have a good, sturdy table, you can lay a flexible sheet of plexiglass over the tabletop and curve the back up at an approximate 90 degree angle (see Figure 3-7). You'll need some background stands, poles, or other framework and some heavy-duty clamps to attach the plexiglass. The clamps help keep the surface secure and in place. Plexiglass sheet prices run about $30 to $40, although pricing varies depending on the thickness of the sheet. You can find these sheets at specialty plastics shops or at some big box home improvement stores.

Figure 3-7: A table with a plexiglass sweep.

✔ **Light box tents or shooting enclosures:** A light box tent is typically a box or circle of white fabric with one side open or partially open (see Figure 3-8). Because of the small size and lack of openness, these tents are a little difficult to deal with for food photos, but I've used these

enclosures for some truly amazing images. They produce a nice, diffused quality of light. As far as price, these light box tents usually run in the $100 or less range.

Figure 3-8: A light box tent.

Natural settings

Foam core boards and sweeps are terrific background options, but what about a more natural setting? Natural, as in what you may typically find in a kitchen, such as a table and chairs, plus that nice window with light flooding in. If you're lucky enough to have good natural light in your studio, home, or at your client's space, take advantage of it. And if you have a good-looking table available, that's even better. Place your food on the table with a few complimentary linens and shoot away.

I've even set food in a rustic windowsill with a soft northern light falling on the food subject. This look is great for a food image, but it can get a little tricky with a narrow windowsill.

Playing with color

Using color in your food photos helps create a setting that complements your food subject, as shown in Figure 3-9. Color can also affect how people feel about a food image. The feeling can be soft and comfortable, bold and powerful, or perhaps somewhere in between.

55mm, 1/160 sec., f/6.3, 400

Figure 3-9: A pink background provides just enough color for these red currants.

Using the whitewashed look

My current obsession for food photos is using the whitewashed look. It's a great look for a food dish that's quite appealing and is well accepted today.

As you may have noticed, this light-flooded look is the de facto aesthetic standard for many food and lifestyle magazines. The look makes ordinary food appear a bit dreamy and altogether appetizing, as you can see in Figure 3-10.

The whitewashed look includes a very light-colored background, which may be coupled with light linens or dishes. These elements can be pure white, off-white, faded colors, or pastels. And a key part of the look is lots of beautiful light. Although you can use a good artificial lighting setup, which I discuss in Chapter 2, natural lighting is a perfect fit for this look.

45mm, 1/60 sec., f/5.3, 640

Figure 3-10: The whitewashed look is all about a light and dreamy feel.

Translating warmth

In general, warm colors are the yellows, oranges, and reds from the color spectrum. I'm talking about the more subdued versions of these colors, not the eye-popping bright colors, such as candy apple red.

Using soft, warm colors for backgrounds, dishes, and linens promotes the feeling of warmth and comfort in an image. A soft yellow napkin under warm apple compote or a subdued brown tablecloth under a dish of macaroni and cheese creates an image that defines comfort food.

Something I call the Rembrandt look uses a type of image with a primarily warm subject, a darker warm background, and one source of light. In Figure 3-11, the fruit pastry has a lot of soft reds and pinks in the subject but then

pulls the warmth in from the yellow and brown of the table. I created this image by using a single source of light from a small window.

35mm, 1/6 sec., f/4.5, 100

Figure 3-11: This photo of a fruit tart with marzipan creates warmth.

Making a bold statement

You can create some mighty powerful images by using bright colors in your settings. Strong, colorful backgrounds can really set off delicious candies or cocktails, sorbets, cupcakes, or the like. These images are graphic, bold, and really fun!

When working with strong, bold colors, make sure your food subject is neutral or every bit as bright as the colors in your props. A pale pastel subject with a popping graphic background can look a little mismatched.

Fine-tuning with tweezers

Many professional food stylists use exceptionally long metal tweezers (see Figure 3-12) to make clean moves with food and accents without disturbing the rest of the dish. These tweezers are great, and you should use them if you've got them, but they can be quite expensive and somewhat hard to find.

I recently found a great and inexpensive alternative to metal tweezers. Now you can find 4- to 5-inch long, thin bamboo tweezers that work great when placing accents. Food doesn't stick to them, they're easy to work with, and they're cheap, too. About a dollar a pop.

Curved tweezers are also very handy for getting into tight places without disturbing the other food on the dish.

Figure 3-12: A couple types of tweezers for food styling.

When shooting food images that have crumbs or other tiny garnishes, use your tweezers to carefully move those bits around in your subject until you feel satisfied with the look. Do check your work as you go, but most importantly, be patient! Your patience will pay off with a beautifully composed image for your portfolio.

Building a Housewares Library

A housewares library is a collection of dishes, glasses, utensils, and other accents to help you style your photographs. As you gather all the materials you need for your housewares library, set aside some space in your home or studio to organize and store your materials. Industrial metal shelving works well and lets you see everything at a glance, but a good closet shelf is a fine option, too. Use whatever space seems to work best for your particular setup.

When you start collecting your housewares, group like things together so they're easy to find. You can organize the materials by type, look, color, or even size. Doing so makes it easier to quickly pull objects as needed for your various shoots.

In some large, food photography operations, I've seen entire rooms filled with shelves full of tagged and cataloged items. I'm in awe of these types of

setups, but I don't quite have the luxury of a full staff to maintain my house-wares library. And honestly, I'm not sure if having that many options would work for most folks; it may be just too much of a good thing.

Collecting plates and linens

I *love* that part of my job as a food photographer is searching out and finding dishes and linens. Shopping around for that unique color, texture, or look of an item that I can use in my collection is so much fun.

When buying plates, bowls or linens, buy multiples of them. You can use the extras for repetition in images or stacking in the background. (I go into detail about repetition when I talk about composition in Chapter 8.)

A good percentage of your library will likely lean toward the lighter end of the color spectrum, such as white tablecloths, napkins, and plates. Using white (or off-white) is a great way to highlight just the food subject in a photo. Group different shades of white together for a medley of lightness that allows the viewer to appreciate the background, but then be sure to focus directly on the food.

A black dish or tablecloth can provide a dramatic setting for a colorful dish. I shied away from using black for years, but now I just love the power it can provide to a photo. And nicely colored dishes can complement a food subject like nobody's business. Figure 3-13 shows a variety of dishes. Each one of the plates can provide a uniquely different look for a food.

Steer away from using recognizable patterns in dishes. Using a well-known manufacturer's pattern encourages viewers to recognize and process the pattern in their mind. That action detracts from the food subject itself.

85mm, 1/50 sec., f/5.6, 400

Figure 3-13: Colorful plates provide variety.

One other item I suggest for your housewares collection is a clay or porcelain tray, which provides a beautiful presentation for food in a photo (see Figure 3-14).

55mm, 1/30 sec., f/5.6, 400

Figure 3-14: A porcelain tray is a great addition to any housewares library.

Using utensils

Nice silverware or utensils can be a beautiful and realistic complement to your photos. If shooting at a restaurant, generally you'll use the utensils the restaurant provides for the shot. But if you're shooting in your home or studio, you can get really creative with the various styles and finishes of utensils available. As you're collecting items for your housewares library, be sure to pick up a good variety of utensils.

One of my very favorite silverware options is heavy antique silver (see Figure 3-15). Antique silver has a unique, timeworn quality and can make a large impact in a food photo. Old silver or silver plate isn't too expensive and can be found at swap meets, auctions, or antique stores.

Sometimes you may want to use utensils that are logical additions to your images. For example, using a cheese grater, new or antique, in the background of a dish that uses cheese is a great addition to the shot (see Figure 3-16). The grater is a logical utensil in this photo because it relates directly to a food item. This small addition of a utensil in the background enhances the overall composition of the photo.

40mm, 1/25 sec., f/2.8, 100

Figure 3-15: Using antique silver creates a unique look.

55mm, 1/50 sec., f/5.6, 500

Figure 3-16: Using a logical utensil (like the grater) in a shot adds interest.

Be sure to watch the angles you use with silverware or other utensils. If a utensil is placed on or nearby a dish and is photographed at an angle where the utensil runs parallel to the horizontal or vertical sides of the image, it won't be pleasing to the eye (see Figure 3-17).

A good food image with a utensil is one where the utensil is placed or photographed slightly askew, as shown in Figure 3-18.

85mm, 1/250 sec., f/8.0, 400

Figure 3-17: Avoid placing utensils at a 90 degree angle.

85mm, 1/250 sec., f/8.0, 400

Figure 3-18: A better placement for a fork is slightly askew.

Decorating with doilies and other nifty accents

You may think that doilies are things of the past and that they're just frilly little bits of paper whose only purpose in life is to get stuck to the bottom of pastries. But I beg to differ! These tiny decorations can present foods nicely for the camera and can be the perfect little accent to an otherwise plain, and sometimes dull, setting.

If using traditional, frilly doilies just isn't your thing, or if you're looking for something new and fresh, check out some of these other paper options:

- ✔ **Paper napkins:** Paper napkins can often provide a nice pop of color or design for an image (see Figure 3-19). I recommend going easy on the patterns, but colorful polka dots and striped napkins make for some really cool graphic images. You can find an array of colors and patterns on paper napkins at supermarkets and party supply stores.

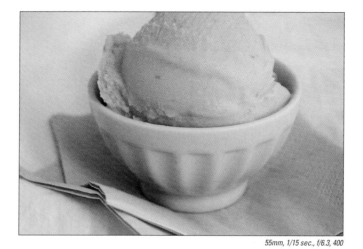

55mm, 1/15 sec., f/6.3, 400

Figure 3-19: These pink paper napkins provide a nice pop of color.

- ✔ **Parchment squares or circles:** These pieces are intended for use in cake and pie pans to provide a nonstick surface. However, I really like using them as a plain doily-like surface when photographing baked goods. You can find these parchment pieces at cookware stores and some upscale markets.

- ✔ **Wax paper:** What is it about wax paper? Perhaps it reminds you of your grandma, or maybe your mom used it when you were growing up. Whatever the case, wax paper lends a nice home-cooked quality to images, as shown in Figure 3-20. You can easily find wax paper at any supermarket.

55mm, 1/60 sec., f/5.6, 200

Figure 3-20: Wax paper brings a touch of home to an image.

Shopping for Treasures

I confess that part of the great fun of food photography is shopping for the props, the plates, and the trays — not to mention the food! (I talk about shopping for food later in this chapter.) Finding that one special item with a unique color or shape that's perfect in its own way can sometimes make a dull day exciting. Gourmet cookware shops carry a ton of great items, but also consider some of the other options I discuss in the following sections when collecting items for your housewares library.

Discount stores

Whether you're looking for pure-white standard plates, colorful items from Europe, or clean, minimalistic Asian wares, you can find these goodies and more at discount stores or closeout retailers.

I purchased the majority of my housewares library at closeout retailers. These places specialize in one-offs, which is perfect for the purpose of food photography. It doesn't hurt that they're inexpensive, either.

TIP

If you don't have many good options in your local area, go to your computer. You can often find discount stores online.

Antique stores

Antique stores can be a treasure trove of unusual housewares and culinary objects. Ambling about in a shop, searching for rich colors and unusual shapes that can add diversity to your collection is always a fun adventure.

Antique stores often carry distinct colors of dishes produced in the 1940s, '50s, '60s, and '70s that you just don't see these days. In Figure 3-21, note the beautiful 1940s blue color with the added bonus of a little chip. Adding a few of these colorful, imperfect items can provide impact to your housewares library and your images.

When shopping for antiques, think beyond plates and bowls. Old cookie sheets or bakeware can lend a wonderful sense of home to an image. Linens from the '40s and '50s can also provide a unique touch as can old appliances, like mixers or blenders.

35mm, 1/25 sec., f/4.5, 640

Figure 3-21: Antiques, like this blue bowl from the 1940s, add character to a food photo.

Finding Great Ingredients

Part of the fun of food photography is the hunt for new places to find great foods for stock or blog photography.

A gorgeous food photo starts with, well, gorgeous food. And you won't find a better selection of truly photogenic raw ingredients than at a farmers' market. The veggies are ready for their close-up, Mister DeMille.

Natural markets, bakeries, ethnic or specialty food shops, and delis all offer a large selection of ready-made foods for sale. These resources can provide fodder for amazing imagery for your portfolio. I explore each of these options in the following sections.

Farmers' markets

Farmers' markets are my very favorite places to shoot raw ingredients for stock and to find farm-fresh ingredients for dishes to create. The freshness and immediacy of earth-to-table really translates in photos. Check out the tomatoes in Figure 3-22.

55mm, 1/125 sec., f/5.6, 1250

Figure 3-22: Green heirloom tomatoes look fresh enough to taste.

Although a beautiful group of heirloom tomatoes can create a pleasing look, sometimes finding more rustic offerings can be fun. Searching out some unwashed fruits or veggies with bits of dirt attached can foster unique, striking photos, like in Figure 3-23. The earthier the better!

55mm, 1/250 sec., f/8.0, 400

Figure 3-23: Keeping it real with these dirty, rustic beets from the farmers' market.

Oftentimes, the booths at farmers' markets have white tents overhead that make for a lovely, diffused light falling on the fruits and vegetables, as shown in Figure 3-24. Hello, instant scrim!

55mm, 1/15 sec., f/5.6, 320

Figure 3-24: Zucchini blossoms from the farmers' market glow in a diffused light.

Farmer's markets aren't about only fruits and veggies these days. You may be lucky enough to come across some unique prepared foods that are beautiful to capture for stock or blog photos.

When traveling, grab your camera and check out the farmers' markets in the local area. The regional specialties, along with interesting display methods, make for some lovely and uncommon photographic opportunities, like the one in Figure 3-25.

55mm, 1/160 sec., f/6.3, 640

Figure 3-25: Farmers' market in Santa Margherita, Italy.

Bakeries

Bakeries are some of the best places to find gorgeous items to photograph for stock images. Okay, I admit, bakeries are also where I get to indulge my serious obsession with cupcakes (see Figure 3-26), but I won't go into that!

Doughnut shops, trendy cupcake stores, and traditional or ethnic bakeries can be huge resources for your stock photos. Many people have a sweet tooth and images of pies, cakes, tarts, petit fours, doughnuts, or even a good clafoutis now and again can evoke a positive reaction. Just take a look at Figure 3-27. Now don't you feel happier?

When purchasing items at bakeries, don't be shy about pointing out a specific baked good that you think looks the best in the group. You may get a few eye rolls from the staff, but if you explain what you're using the food for, people will generally be happy to accommodate your needs.

55mm, 1/25 sec., f/5.6, 250

Figure 3-26: A delicious cupcake makes an appetizing photo.

50mm, 1/50 sec., f/5.6, 400

Figure 3-27: These sugared jelly pastries look divine.

Specialty shops and prepared foods

Gathering prepared foods is a fun, easy (and delicious!) way to get some terrific stock or blog shots for your portfolio.

The recent explosion of large, health-conscious groceries, such as Whole Foods Market, provides a great starting place for your search. These types of natural food groceries generally offer a wide selection of beautifully prepared foods that are made just for photos (see Figure 3-28).

65mm, 1/40 sec., f/2.8, 200

Figure 3-28: Beautifully prepared foods are just waiting for their close-up.

You may also be able to find some unique specialty shops or delis in your area with prepared food to go. These smaller, specialty retailers can offer a great range of foods, including breads, salads, sandwiches, pizzas, pastas, honey, cheeses, and much more.

4

Dealing with Employers, Personnel, and Sets

In This Chapter

▶ Discovering the different types of venues for food photographers

▶ Working with chefs and art directors

▶ Creating sets for a shoot

*N*o man or woman is an island. When shooting food, sure, sometimes you may work alone, but you'll often work with a team to get the shots you need for the job at hand. In this chapter, I talk about the different types of food photography and how they relate to personnel you may deal with. The personnel you work with on a shoot most often include chefs and art directors.

Right now is an awesome time to be shooting food photography. Granted, the income isn't as high as it once was in many areas, but that's somewhat offset by the fact that photographers have many more venues to display and sell their photos. As a food photographer, you can shoot for stock, blogs, advertising, editorial, packaging, cookbooks, food product sites — you name it! But not all food images are equal. Some of these types of images, particularly packaging, require a slightly different approach when shooting.

In this chapter, I also talk a little about the cool world of sets and settings. From industrial and arty to cozy and comfortable, I cover how to create some uniquely different looks for your images.

Know What You're Shooting For

You can take a lot of different approaches when shooting food, depending on the type of food photography you're doing. And these days, food images are used in a lot of different ways, including the following:

- ✔ **Advertising:** Shooting food ads needed for restaurants, caterers, and specialty food items is often the core of a food photographer's business, particularly in these days of multiple group discount coupons and the like. When shooting ads, work with your clients (and perhaps an art director) to achieve the vision your clients are looking for. You can still be quite creative, but you need to incorporate the client's wishes and ideas in the photos.

- ✔ **Blogs:** Just about everyone has a blog or two these days. Blogs are ridiculously easy to create, using the currently available blogging tools. You may have a food blog to illustrate recipes or techniques, or perhaps you have a food photography blog to display a cool shot you took (see Figure 4-1). Blogs are such a good venue for food photos and require very little effort.

Figure 4-1: Shooting for a blog is a great way to display your talents as a photographer and maybe even a chef!

- ✔ **Editorial:** An *editorial* food photograph is a photo that can be placed with a story in a newspaper, magazine, or book. The editorial food image supports the text (see Figure 4-2).

85mm, 1/40 sec., f/3.2, 200

Figure 4-2: Editorial photography accompanies text in a newspaper, magazine, or book.

✔ **Packaging:** Now here's a type of food photography that can be a bit tricky. Depending on the client, when shooting for packaging, you have to be very conscious of the food's appearance and, perhaps, its placement in the frame. (See Figure 4-3.) What you see must be what you get, because packaging must always be true to the food you're shooting. Your client may be very particular, because the food may need to be portrayed in an exact way.

55mm, 1/30 sec., f/5.6, 400

Figure 4-3: Shooting for packaging is all about what the client wants.

✔ **Stock:** Stock agencies used to be the receptacles for a food photographer's seconds, the also-rans, and the images that didn't quite make the cut for a particular client's job. Photographers had on their hands a lot of very good images, and stock agencies were another way to get their photos out there and make some money. Figure 4-4 shows a typical stock photo.

42mm, 1/125 sec., f/5.6, 640

Figure 4-4: A simple stock photo.

Today the model has evolved from submitting leftover images to shooting expressly for a stock agency. Shooting for stock allows complete freedom on the subject matter. You must draw within the agencies' lines, as far as technical requirements go, but creativity is wide open for the most part. So don't limit yourself when shooting for stock.

In the following sections, I go into more detail about shooting for stock agencies, advertising, and packaging.

Shooting stock for fun and profit

Shooting stock is a great way to get your photos out there and make a little extra money. A simple photo like Figure 4-5 may earn you a tidy sum of money. You'll have to jump through a few hoops on your way to getting your images submitted to a stock agency, but it can be well worth the effort you invest.

32mm, 1/15 sec., f/2.8, 100

Figure 4-5: This simple photo of breads is a great example of stock photography.

The two basic types of stock agencies are *traditional* and *microstock*. Traditional agencies take a percentage of a sold image as their fee. Microstock is a discount model, in which images are sold for a very low rate in the hopes of selling more images.

If you decide to shoot stock for a traditional stock agency, you'll find many agencies to choose from. First, you'll have to do a little research to find an agency that fits with your vision. Here are some things to consider:

- ✔ **Fees:** Within the different traditional stock agencies, you'll find a full range of fees taken out (in percentages) and different types of payment schedules. Although rare, I've heard of at least one top agency that even charges to represent your photos. Only *you* can decide whether that type of arrangement works for you.

- ✔ **Quality:** All agencies evaluate photos for quality in several different ways, such as focus, dpi, size, and even creativity. Most agencies require a camera with a minimum number of megapixels. You'll find a great variance in quality requirements from agency to agency.

- ✔ **Rights-managed or royalty-free:** *Rights-managed* stock images are charged separately for each and every usage. Stock agencies consider various factors when setting prices for rights-managed images. For example, a purchaser may pay a set price for an image that will be in a ¼-page spread for a period of one month with a circulation of 10,000. Some rights-managed images can be licensed for exclusive use.

 Royalty-free images are images that are purchased for a one-time fee and can be used repeatedly by the purchaser. Basically, it's a flat rate for unlimited usage.

- ✔ **Submission process:** Some agencies request initial submissions via CD, some ask for the URL of your website or portfolio, many prefer TIFF over JPEG, some ask for you to do a specific photo shoot, and all agencies have size requirements for the images. Submitting to these agencies takes a little effort. Okay, sometimes the submission process can be a little grueling, but it can be well worth it in the long run.

When researching traditional agencies, you'll find some stock directories out there that aggregate most of the different agencies. The good news is now several agencies are specific to food, drink, and even vineyard images like the one in Figure 4-6.

Microstock popped on to the photography scene several years ago with a completely different type of agency model. Microstock is to stock photography as fast food is to food. Essentially, it pays you much, much lower prices for your photos than traditional agencies, although there'll likely be a greater volume sold.

The quality and size requirements used to be much lower at microstock agencies than at traditional agencies, but they've recently tightened up their requirements.

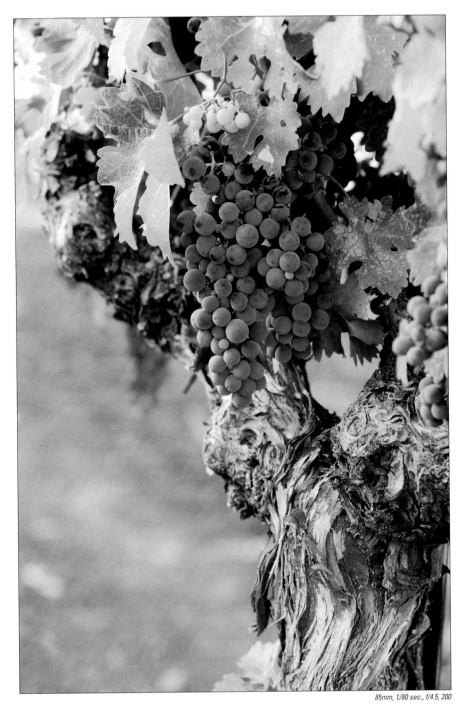

85mm, 1/80 sec., f/4.5, 200

Figure 4-6: Some stock images, like this vineyard shot, work great for specific agencies.

Whatever type of agency you choose, nearly all of them provide a URL of a gallery of your images that you can use as a portfolio. You can use this portfolio for marketing purposes, perhaps linking from your website, blog, or even a social site.

Stock photography allows photographers to exercise their creative muscles with little to no limits on their creativity. If you want to shoot some tomatoes for the heck of it, go ahead! The photo in Figure 4-7 earned me a few bucks. Creative freedom is a good thing, especially if you can earn money by contributing to a stock agency.

55mm, 1/160 sec., f/6.3, 640

Figure 4-7: Shooting for stock agencies allows you to be creative and earn a few bucks in the process.

Taking photos for advertising

Shooting a food advertisement for a restaurant, bakery, caterer, or other food provider is a great experience. Your images may show up in newspapers, magazines, websites, mobile phones, or even on billboards!

When shooting advertising, confer with the client before the shoot to solidify her vision and find out any specific requirements she may have. You also need to know how the client intends to use the images. If the images are slated for a small ⅛-page black-and-white ad in a newspaper, you may shoot differently than if you're shooting for a large, color poster or a billboard. The quality for the small black-and-white ad should be good, but the quality for a billboard shoot must be excellent, including spot-on color and saturation, high dpi, low ISO, and areas of focus as specified.

Clients typically allow the photographer a certain amount of creative free-dom when photographing the food. The client provides you with the best-possible food subjects and trusts you to tweak them and rearrange as needed to show off their full potential.

When shooting for advertising, some clients may want to pay you solely via free food, essentially making a trade of sorts. Taking this type of deal is up to you, of course, but don't sell yourself short. I recommend charging your normal day rate (which I go into detail about in Chapter 15) or a combination of a lower rate and some free food credit.

I once shot for an elegant restaurant that was a little over an hour away from my home and studio. The restaurant was terrific to work with, so I opted to be paid a little lower than my usual day rate with a huge food credit as the second part of my payment. The food was amazingly delicious at the restau-rant, but it was tremendously inconvenient to get there. In the end, the food credit was essentially a waste of money because the restaurant was too far away to get to, and I just didn't use up the credit. In hindsight, going for my usual day rate would have worked out better for me. So be aware of proxim-ity and convenience when accepting food credits from restaurants.

Capturing images for food packaging

You won't be allowed as much creativity when shooting food packaging images as when you're shooting stock or advertising. The client will likely have a specific idea or a specific need for the packaging you shoot. And, as you know, the customer is always right!

Communicate with your client before the shoot to find out exactly what he's looking for. Doing so will help you figure out any props you may need to bring along and will also get you started thinking about how to achieve the images your client requires.

Packaging can be a bit of a different animal. Your client may require you to be very particular in how the foods are shot. Seriously. You may even have a client specifically ask you to wrap 19 French fries in a cone of off-white paper, keep everything in focus, and shoot on a particular red background. Depending on the situation, you may also be asked to incorporate negative space in your images, as in Figure 4-8, which ensures proper placement of the image on the packaging and allows space for text and information.

When shooting packaging, I shoot even more images than normal. I want to provide a lot of options for my clients within their framework. Packaging images have the potential to be around for a long time, so invest the time and energy to really showcase the foods.

70mm, 1/40 sec., f/5.6, 400

Figure 4-8: When shooting for packaging, you'll often need negative space in an image.

Working with Personnel at a Photo Shoot

Although you'll often shoot food by yourself, on the occasions when you're a part of a team, it can be a wonderful experience.

One person you may work with on that team is an art director. The art director is responsible for the creative vision of the shoot; as the photographer, you're responsible for implementing that vision.

You may also have to work closely with the chefs who've prepared the food you're shooting. Although you're essentially in charge of the set, you and the chef will have to work together to put the best-looking dishes forward.

In the following sections, I clue you in on some tips and tricks to working with a team at a photo shoot. Whether you're working with an art director or discussing dishes with the chef, you have to have confidence and control of the shoot.

Getting in tune with an art director

When working with an art director, communication is important, so ask questions and get the vision solidified well before the shoot. Discuss what the art director is looking for in the shoot: Is it a dreamy romantic shot, an accurate portrayal, or a modern graphic look? Also find out what sort of props and lighting you'll need.

At the shoot, your job is to first create the basic setup, including backdrop, linens, plates, glasses, and silverware, with no food present in the shots. Let the art director arrange the scene as needed. After the set is solidified, light the setup and take some test shots. Confirm with the art director that your test shots are on target for the artistic vision.

When the food arrives, the art director will work with you to perfect the scene. In these situations, I always take a lot of different shots, many more than usual, using different lenses, tilts, angles, and distances from the food. Having a lot of options for the client and art director to choose from is always a good idea.

Bonding with chefs

A food photographer has a uniquely symbiotic relationship with a chef. Just as the photographer wants the dishes to look beautiful, so does the chef. Great minds think alike, you know. Chefs are quite motivated to put forth their best work so you can make it shine for them.

The photographer is responsible for the initial setup, including backgrounds if needed and lighting. After the chef brings out the food, you may need to tweak the food slightly, perhaps moving some greens or accents with tweezers.

When working on a set with a chef and no art director, I encourage you to channel your inner MacGyver. You just need to be able to handle whatever needs to be done for a successful shoot. My motto in this situation is to speak softly and carry a big roll of duct tape.

Truly, the key to working with chefs is to plan ahead for the dishes they're preparing and to manage the shoot as soon as the food is ready. I show you how to do both in the following sections.

Planning for the dishes

Although you may not always have the luxury, knowing in advance what types of dishes chefs are preparing is helpful. Talk to the chef or the restaurant manager, and see what's on his mind.

The props you bring depend on the type of food you're shooting. For example, a rustic food like the quiche in Figure 4-9 needs complementary rustic dishes, backdrops, and so forth. And the tabletop scene in Figure 4-10 uses more refined props, such as pure white plates, white linens, and stemware. Put a little thought into what props you may want to use ahead of time. Think of props that may match the foods and some that contrast to mix it up a little.

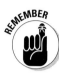

Always, always bring a basic white backdrop (either paper or material) on a shoot. When you try out your new aubergine tablecloth and find that it's just not working for the setup, you know you have a clean white alternative at the ready.

55mm, 1/10 sec., f/8.0, 250

Figure 4-9: Rustic foods, like this quiche, need rustic dishes and backdrops.

Managing the shoot

When working with a chef, especially if multiple dishes are in the shoot, you need to clearly manage the timing for when you need the dishes brought out. If you don't know, just play it by ear. Shoot the first dish and judge the rest of the timing from that.

I typically work on one dish for about 30 to 60 minutes. This amount of time allows me to get all the photos I need for a food subject. It's typically enough time to set up several different looks or settings and use many different tilts and angles. Some photographers, particularly for large magazines, shoot one dish for the better part of a day.

You also need to know that after the dish is presented to you for the shoot, you're responsible for taking the chef's work and presenting it in the best possible way for the camera. If that means taking out your tweezers and moving around some microgreens, so be it. You're ultimately responsible for the look of the final images.

55mm, 1/15 sec., f/6.3, 200

Figure 4-10: When working with a more refined food, your dishes and backdrops should match the look.

Creating Worlds: Sets and Settings

One of my favorite things about food photography is creating the sets on which to shoot the food. The sets are essentially little worlds, consisting of backgrounds, linens, utensils, and dishes that you pull together in order to show off the food you're photographing.

If you're shooting something elegant, you may want to go with a refined look for your set. Replicate something you may see in an upscale restaurant in a large city.

When creating a casual set, you can build a replica of a warm and inviting country kitchen. This type of set is cozy, fairly rustic and suits comfort foods very well. Think pie — lots of pie.

The clafoutis shown in Figure 4-11 is a delicious French comfort food. This shot uses simple dishes, a faded and mussed up linen, and worn silverware with bits of the food on it, all set on a rustic wood table.

85mm, 1/50 sec., f/3.5, 400

Figure 4-11: Backdrops, plates, utensils, and food accents are just a few ingredients for an appetizing set.

In the following sections, I outline a few of my favorite set types. But be aware: These sets are just the tip of the iceberg. Don't feel limited by these suggestions because you can create many other looks as the food and the venue require.

Prim and proper

The prim and proper type of setting is really quite elegant, clean, and upscale. This look may include some starched napkins and a white or black tablecloth. The caviar on blini shown in Figure 4-12 uses this type of setting. A clean white plate set on a white tablecloth allows the exquisite appetizer to shine.

48mm, 1/100 sec., f/5.3, 200

Figure 4-12: An elegant dish fits perfectly in the prim and proper setting.

This look can possibly call for a sweep (see Chapter 3), or maybe it can use the table itself. If using the table at a restaurant, some options include showing the immediate environment, like including some other tables in the background. Or perhaps you prefer a solid background behind the table.

 To create a solid color background behind a table, use duct tape to secure a large section of foam core at the back of the table. The foam core is so amazingly light, the tape should hold it in place very well.

Another part of this look is using quality silverware or utensils. Adding stemware with wine may also be a logical addition. Overall, the look of this set should be one of very high quality.

A red wine, such as cabernet or merlot, often photographs as a very dark brown and shows up too dark to see any of the lovely red color. When shooting red wine, cut the wine with a little water (up to 40 percent or so) until you can see a lighter looking red in the glass.

Casual and cozy

As you may notice from many of the photos in this book, casual and cozy is my favorite look for a food photo. The elements of this look are quite simple: a nice quality of light, an imperfect look that's sometimes just a little messy, and maybe even a cool prop, such as a cake stand like the one in Figure 4-13 or an antique wood slat with some worn paint. This look represents warmth and home.

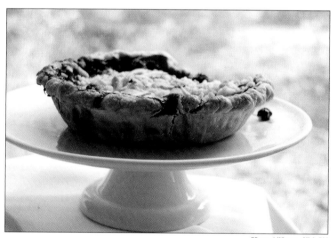

55mm, 1/25 sec., f/5.6, 500

Figure 4-13: A berry pie near the window just oozes warmth and comfort.

To create this style in your photos, start with selecting your background. A more natural background is best, so choose something like a worn wood table or a cutting board. Add some white or colored plates, bowls, or other props that suit your subject and color scheme. Linens, a tablecloth, or cloth napkins in subdued colors complement this look nicely. And perhaps some rustic utensils can complete the setting.

Food as design

A set that focuses on design, treating food as art, is an interesting alternative look for a shoot. When shooting with this intent, if your subject is already very arty, you can pare down the set to simply a white-on-white scheme as in Figure 4-14.

35mm, 1/125 sec., f/5.6, 400

Figure 4-14: Food or art?

You can also opt to go industrial. I've seen some cool patterned metals used that really suit a graphic-looking food subject. To design that type of set, place a patterned metal on a sweep or table. Be aware that a distressed, tarnished surface will reduce excessive shine in the metals.

Slate is another good background for this look. Add some graphic linens and sleek modern dishes and voilà — you have the basis of an uber-arty set for a food shoot.

Part II
It's All in the Presentation (Styling)

The 5th Wave By Rich Tennant

"It's called architectual cuisine; that's why I'm garnishing it with Legos."

In this part . . .

Dressing up your food to look its very best involves a little crafting and styling to complement the food and show it off to its fullest potential. In this part, you find out about all the tricks of food styling, including how to pack and prepare for an off-site shoot, how to make a food look super scrumptious for the camera, and what to do with those quirky foods that just don't want to behave.

5

Preparing for an Off-Site Photo Shoot

*I*n this chapter, I talk about thoughtfully planning your food photo shoot. Why is an entire chapter on planning needed, you ask? Well, the pitfalls of winging it and getting to a shoot without being prepared are pretty big. If you forget a key piece of equipment, don't have extras of the basics, or if a significant misunderstanding occurs between you and the client, future business with that client most likely won't bode well.

So by taking some basic preparatory steps, you can prevent any small (or large!) crisis that may arise, and you help things run smoothly during your shoot.

The info in this chapter relates particularly well to an off-site shoot at a restaurant, commercial kitchen, bakery, or other studio space. When shooting on location, you need to bring a lot of items with you. You not only need to bring the basic gear you'll be using, but you also need a lot of extras and some different options for the settings and backgrounds.

So how can you ensure that you remember everything you need for an off-site shoot and can get it there without having to rent a U-Haul? In this chapter, I give you the details on what you really need and how to pack and transport your gear in as streamlined a way as possible. And I share some creative ways to remember all your items with a handy checklist for your shoot.

Planning for the Shoot

When you're preparing for a shoot, it's time to think like a scout. Take that "be prepared" motto to heart, and you'll avoid many potential problems.

The first order of business is communication. You need to discuss the details with your client to clearly understand the expectations for the shoot itself. Take a little time to get to know your client and really foster communication so you can avoid *mis*communication on the day of the shoot.

A great way to dodge surprises on the day of the shoot, and to better prepare an appetizing photo like the one in Figure 5-1, is to check out the restaurant, commercial kitchen, or other space beforehand. Forewarned is forearmed in this case. An advance visit gives you an idea of what you'll be working with as far as space, light, colors, and ambience. And you may also be able to do a helpful meet-and-greet with the staff at that time.

In the following sections, I go into detail about these two preparation tactics so you can confidently show up with your camera in hand, ready to take amazing photos.

38mm, 1/80 sec., f/4.8, 200

Figure 5-1: Knowing what to expect from the location of a shoot allows you to capture the perfect lighting and ambience.

Communicating with your client

Before you start planning a shoot, discuss with your client the basic details of what he's looking for in the imagery. Communicate with him about the overall look and feel of the shots. Exactly what are his expectations? Should

the shots have some negative, or empty, space to accommodate text? And what about the aesthetic for the food? Is he looking for a very light, white-washed look or a dark, richly saturated look for the food? Should all parts of the food be crisply in focus, or is selective focus the better choice for the food subject(s)?

Also make sure to talk about sizing. Will the images be blown up to billboard size, or are they intended for a small magazine ad? Knowing the size the images will ultimately be displayed in helps with planning how you shoot the subject as well as your postproduction needs, including dpi and file size.

Now it's time to get down to the good stuff. What kind of dishes will be prepared? Are the chefs creating a rustic dish, like the baked pasta in Figure 5-2? Or something a little more refined, like oysters on the half shell? Having this information allows you to figure out what kinds of backgrounds and props to bring along for the shoot.

38mm, 1.30 sec., f/4.8, 500

Figure 5-2: Having the right backgrounds and props for the dishes in the shoot makes all the difference.

Another key piece of information you need to know before the shoot is whether the restaurant or commercial kitchen will be open or closed at the time of the shoot. If it's closed, you can more easily take photos and possibly include a portion of the venue (and its ambience) within a shot.

Be very clear on the time and location of the shoot. If it's your first time working with this client, arrive a few minutes early and map out the directions beforehand. Allow a little extra time for traffic if you live in a traffic-prone area.

Discussing these details right off the bat with your client creates a good, level playing field where everyone can get on the same page. Following the discussion with an e-mail that outlines the expectations can also be very helpful.

Considering the space

I almost always visit the space I'll be shooting in before the day of the shoot so I can really get a feel for what I'll be dealing with ahead of time. Taking a look at the space itself and getting a sense of the ambience within is a great way to prepare for the shoot and figure out what tools and equipment you may need.

First, consider the lighting in the space. Is there an opportunity to shoot in natural light, or should you plan to bring lights in?

If possible, do the previsit about the same time of day you'll be shooting. Doing so gives you a more accurate idea of the light within the space at a specific time of day.

Next, consider the size of the space. Is it wide open? Or is it in a small, closed dining room? As you can see in Figure 5-3, the size of the space affects the amount of lights and equipment you can bring to a shoot.

And speaking of lights and equipment, now's the time to check the electrical outlet situation. Older restaurants or spaces may be completely lacking in power outlets. Pay close attention to the power availability, so you know just how many extension cords to bring to the shoot.

Look at the colors of the space. Is it all white tablecloths, wine country rustic, or colorful kitsch? Does the client want a specific portion of the background in the shots? And what about the look of the tables? Are they large wooden tables or small round ones?

Considering all these different aspects of a space and more helps you successfully prepare for an upcoming shoot.

Creating a Checklist

I'm a huge fan of creating lists, particularly before a big shoot. Although it may seem silly, if you're anything like me, a checklist is the only way to remember absolutely everything you need for a big shoot.

So grab a pen and start figuring out what you may need (see Figure 5-4). Consider supplies such as batteries, extension cords, memory cards, and

light bulbs. Then move on to set basics, such as backdrops and linens. Then jot down the lights, stands, scrims, lenses, reflectors, diffusers, and anything extra you may need for a photo shoot.

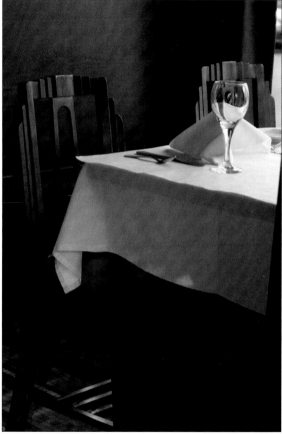

55mm, 1/13 sec., f/5.6, 200

Figure 5-3: Checking out a space before the shoot gives you an idea of the lighting, size, and colors of the space.

For each shoot, you may need to bring along some unique props. For example, some shoots may call for antique silverware or utensils, worn pots or pans, specific plates or items, like the well-used cookie sheet in Figure 5-5.

I've even brought a series of glass bottles and jars to a shoot to try to create a unique background for a shot. Breakable items like the bottles in Figure 5-6 require some careful packaging for transport, though (see the next section for packing tips).

Figure 5-4: Example checklist for a shoot.

66mm, 1/60 sec., f/4.0, 200

Figure 5-5: A well-used cookie sheet is a nice touch for a more rustic look.

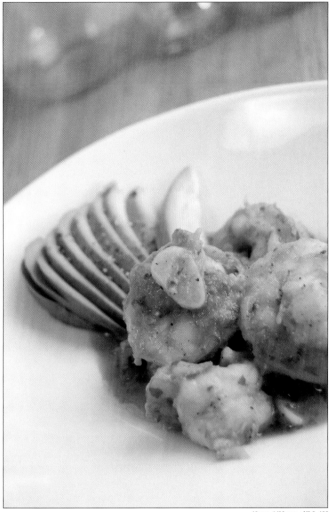

46mm, 1/60 sec., f/5.3, 400

Figure 5-6: Glass bottles can create a unique background.

When writing your checklist, try to consider every aspect of the upcoming shoot. The more comprehensive the list, the better.

Packing and Transporting Your Gear

Before you can begin shooting images at any off-site shoot, you have to pack up your gear and transport it. That's where the discussion in the next sections comes in. I share the ins and outs of choosing a camera bag to fit your style, show you how to downsize your equipment needs so you're not bringing your entire studio with you to the shoot, provide tips for packing your equipment so it arrives safely, and clue you in on a few extras that you definitely don't want to forget.

Protecting your camera

The purpose of a camera bag is to essentially protect your investment in your photo gear. Numerous types of bags are available on the market today designed to transport cameras, lenses, and other small items. The bags range in size from small ones, snugly fitted to a digital SLR, to very large ones, designed to handle several camera bodies and lenses, a battery grip, and much more. Some cases attach around a person's waist (see Figure 5-7) and others go over the shoulder.

Figure 5-7: A camera bag designed to fit around the waist.

What I like best about the larger bags are the walls of thick padding that you can rearrange to accommodate all your camera equipment. The straps and handles are typically padded as well, which provide added comfort when carrying your gear.

I myself am a big fan of the camera backpack. For me, carrying the camera, lenses, and so forth on my back makes transporting my photo equipment to a shoot a little easier. Camera backpacks tend to also be very well padded, both inside and on the straps.

Whatever option you choose for a camera bag, make sure it's waterproof. You don't want to get caught in a downpour and take the risk of harming any of your valuable and cherished equipment.

Downscaling for agility

You may have a lot of lights in your studio or home, including some super large, bulky soft boxes that don't transport easily. Or you may like to have a choice of lenses at your fingertips to get a lot of variety in your shots, but when shooting off-site, cull down your equipment to the very basics.

So instead of taking all your lights to an off-site shoot, choose a subset of your lights to bring. Honestly, two small lights and maybe one medium light is all you really need.

My preferable modus operandi is taking two Lowel Ego lights (see Chapter 9) with one medium soft box. These three lights allow me to set up a key light, a fill light, and a back light with minimum effort and transport angst. Another good choice may be two small soft boxes and a diffused spot shooting across the back of the scene. Or simply two lights with a reflector may work just fine.

Lenses can also be downsized for transport. Pick one or two lenses that will serve you well for a shoot. Perhaps start with a zoom, maybe something like an 18 to 55mm or a 24 to 70mm, and maybe one slightly long fixed lens (a 60mm or even an 85mm will do). When shooting food images, normal to slightly long lenses are typically used, as is the case in Figure 5-8, although a wide shot now and then provides a unique alternative look. (See Chapter 2 for more on lenses.)

Lenses can be quite heavy, depending on the glass. Because of their weight and the transport considerations, I limit the number of lenses I carry with me. I rarely bring more than two lenses along to an off-site shoot.

In case you're wondering, you won't need your 200mm f/2 lens for a food shoot, so leave that puppy behind!

55mm, 1/10 sec., f/9.0, 250

Figure 5-8: These red mini guavas were shot at 55mm.

Packing like a pro

After figuring out exactly what you need for your camera and equipment, it's time to pack all those items efficiently (because you likely don't have tons of time or space) and carefully (because the last thing you want to happen is have something break on the way to the shoot). So here are some packing tips to consider for some of the equipment you'll likely take to the shoot:

- ✔ You can box up lights in any heavy-duty box and collapse the light stands (for the most part). I generally use a large plastic tub to transport lights.

 Soft boxes are the one exception to packing lights in a box. I bring at least one small-to-medium soft box to almost every shoot. I've found that collapsing the soft box and disconnecting it from the lights and stand can sometimes get a little tricky and time-consuming, so I collapse the stand to its smallest size but keep the soft box connected to the light.

- ✔ You can collapse pop-up reflectors and carry them in their small round cases, as Figure 5-9 shows.

- ✔ When packing breakable items, such as plates or glasses, wrap them in extra linens and fabrics that you're also bringing to the shoot. Doing so keeps the breakables safe without having to deal with the extra bulk of packing material.

Hiring an assistant

A shoot at a restaurant or kitchen is inspiring and awesome, but it still requires a significant amount of work. It involves several hours of transporting and setting up equipment, creating the sets, and (provided you're working on your own) styling the food before and during the shoot. Then, at the end of the day when you're fairly well-tuckered out, you have to break down your gear and schlep it back to your car or truck and, finally, to your studio or home. At a certain point, hiring a competent assistant to help starts making a lot of sense.

Assuming the cost is affordable, hiring an assistant can ease the burden of the more physical aspects of a shoot and allow the photographer to focus on the lighting and more creative aspects. Over time, an assistant can also act as an apprentice, learning your photographic techniques and eventually helping you in all areas of your business, including postproduction and maintaining blogs and social sites.

Figure 5-9: Reflectors collapse in their cases, making them easier to transfer.

Bringing extras along for the ride

Continuing with the be-prepared bent of this chapter, a great way to leave no doubt in your mind that you're truly prepared for an off-site shoot is to bring extras of all the little things you may need. Having the redundancy of lenses, batteries, memory cards, and bulbs allows a photographer to feel confident about being able to handle most any technical issue. And after the technical issues are under control, the creative aspects can move to the forefront.

Here are a few items you'll want to make sure you have extras of as you prepare for a shoot:

- ✔ **Batteries:** Wherever and whenever you're shooting food, you should always have extra batteries with you. *Always.* Being smack-dab in the middle of a great shoot and suddenly having absolutely no juice for your camera is rather embarrassing! This situation can be easily prevented by charging a couple of batteries beforehand and tucking them in to your camera case.

 If you're planning a particularly long shoot, you may find it handy to bring a battery charger along for the ride. Just in case you burn through a couple of batteries, you can be secure in knowing that your charger is nearby.

- ✔ **Lenses:** I generally shoot with a normal to long lens for food. And, as I mention earlier in this chapter, I rarely bring more than two lenses (one zoom and one fixed). Having that second lens is a must, though. If a sudden problem occurs with the lens you're shooting with, you need to have a backup close at hand.

- ✔ **Light bulbs:** It's a fact of life that bulbs burn out. And they usually burn out when it's most inconvenient. So remember to pack a few extras of each type of bulb when going to an off-site shoot.

- ✔ **Memory cards:** When on a shoot, taking a lot of photos is helpful because you want to approach the food from every angle and switch up the backgrounds and settings. You'll likely need a couple of memory cards to hold all the images. Bringing extras is always a good idea anyway so you have a backup just in case you encounter a problem with a card.

And now for the non-technical extras. Although you don't need to bring a lot of extra linens and backgrounds, having several different options on a shoot is extremely helpful. Extra linens, backgrounds, and props provide a variety of alternative looks you can try with the food dishes being prepared. (I discuss creating alternative looks in Chapter 4.)

Bringing along a white tablecloth or surface to a shoot is always a great option. If you've cycled through all your looks and nothing strikes your fancy, opt for the white background. A white tablecloth or other surface is a fresh, clean look that takes the focus off the background and puts it smack-dab on the food.

6

Getting the Yummy to Translate on Film

*T*he food is prepared and plated, and now it's time to shoot. So how do you create photos of this masterpiece that actually stir the appetite and emotions of the viewers? Discovering how to evoke a response isn't as difficult as it may seem. Following certain guidelines can help make your photos shine.

Many of the guidelines deal with just becoming aware of what's going on with your subject matter. Do you notice a reflection over here, a nice highlight over there, or wow — do you see that curly bit of parsley? Is the image a little bland colorwise; does it need a little something to perk it up? Would an accent of fresh greens or a little lemon peel look just right over there?

In this chapter, I explain some basic guidelines you can use to enhance and create delicious images for your business, food blog, or just for fun. I also explore options for accents and textures that can help add interest and depth to your image and give you some tips on how to fake the look you're going for when the real thing just doesn't cut it.

Focusing on the Drool Factor

In food photography, much of the focus is on, well, where *you* focus. Knowing how to identify the most interesting part of your subject is key to producing a mouthwatering photo.

A client that has a food product will likely want you to focus directly on its product. However, when working with a restaurant or catering client, you may have a little more leeway with how you shoot the dish. A restaurant owner may give you free rein to do whatever it takes to make the food look beautiful, which may involve using selective focus, linens, food accents, or other enhancements.

If you're shooting for stock or your food blog, the sky's the limit! Here you can use whatever angle, styling, and focus strikes your fancy. When working with stock agencies, you're free to experiment as long as you keep within their basic requirements. These requirements generally include using a high *dpi* (dots per inch) and some type of focus guidelines, although they vary from agency to agency. (See Chapter 14 for the ins and outs of stock agencies.)

All these clients are ultimately looking for successful food images that really spark the appetite. In order to understand how to make that happen, start with finding the unique beauty within your subject.

Take a moment to really look at the food and identify what stands out to you. Where is your eye drawn? Is there a top edge of a biscuit that's perfectly golden brown? Is there one little area in a plate of pasta where the Parmesan cheese is melting just beautifully? Are there some *specular highlights* — bright, shiny areas — that are picking up the illumination from your lights? Use your instinct to select what area looks best to your eye. Your audience will likely respond in the very same way.

Not every image needs a specular highlight. In some situations, you'll have a gorgeous *matte* or non-shiny subject, such as some breads or mushrooms. In these situations, you can focus on an interesting area of the composition, as well as lighting, to emphasize the texture or color of the dish.

Back in the days of film (non-digital) cameras, professional photographers used Polaroid cameras for test shots to check the lighting and composition. These days, I use the camera on my cellphone, which is quicker and easier than using my digital SLR, to do much the same thing. Taking test shots is a handy way to identify areas of interest, as well as problem areas, before picking up your digital SLR.

In the following sections, I guide you through narrowing in on these focus areas by showing you how to create and identify when a drip of juicy sauce is genius rather than flaw and how to close up the space between food and lens.

Capturing highlights and drips

Highlights and drips are two areas where food photography differs a little from non-food photography. Traditional commercial photography tends to shy away from the harshness of specular highlights and the messiness of drips and imperfections.

Specular highlights are sometimes just a smidge too bright and distracting in a photo, but these glistening highlights are a great enhancement to some food photos, as shown in Figure 6-1. They give the images depth and form and, when controlled, can make a good image spectacularly appetizing.

32mm, 1/25 sec., f/2.8, 100

Figure 6-1: The glistening highlights on this fruit tart make for an appetizing treat.

Drips are traditionally treated as flaws or accidents. But when photographed, the imperfection of a drip really translates and evokes a gut-level response from the viewer.

In the next sections, I show you how to take advantage of, and even create, the perfect highlight or drip for your photo.

Honing in on the highlights

Generally speaking, a *highlight* is the lightest area of an image, and a *specular highlight* is a highlight with shine and sparkle.

To create or increase highlights in a particular dish, try these ideas to bump up the shine:

- ✔ **Brush a small bit of oil on your subject.** This technique is particularly appropriate for meats or fish (see Figure 6-2). The key here is restraint. Too much oil just looks greasy, so be sure to use only a small amount of oil and cover only part of the meat. A small brush is the best tool for this technique, but a paper towel works just fine in a pinch.

38mm, 1/160 sec., f/6.3, 400

Figure 6-2: Oil brushed on scallops gives extra shine.

- ✔ **Spray a little oil on your food.** Using a spray oil product can have an awesome effect as well. The spray produces a nice, even highlight that doesn't look greasy. Remember to use just a little, though.
- ✔ **Ladle a little sauce over, under, or around your food.** Using a sauce in your photo can create a nice highlight *and* add a color accent — bonus!

- ✔ **Spray water on produce to create water droplets**. This trick is an awesome way to make produce look *fresh!* Buy a small (less than 6 ounces) empty spray bottle at your local drugstore. You can use plain water, or you can mix it with a bit of glycerin to provide staying power under the lights. If you decide to use glycerin, create a mixture of ⅓ part glycerin to ⅔ parts water. Use the spray sparingly on the front part of your subject. Be sure to not go overboard and drench the produce in water drops.

- ✔ **Smear a little water on your subject.** For this look, you can use a small pastry brush, or even just your finger. Smearing water on your food subject creates a nice, rough highlight on your food, as illustrated in Figure 6-6.

All these techniques create new highlights and draw your eye directly to the subject. Keep in mind that highlights generally pick up the color of the light source or reflector, rather than the color of the food or dish.

So what do you do if you have an over-the-top highlight? You can tone down and control highlights that are just a little too harsh by using different techniques with your lighting setup. Lighting distance is key here. Bringing your filtered lights (soft box, umbrella, or other translucent material) in a little closer can soften and mute a too-bright highlight. (See Chapter 9 for a detailed discussion on lighting.)

Decidedly delicious drips

Believe it or not, drips are desired in food photography. A drip of frosting slowly edging its way down a cake makes the cake look even more inviting, even sensual. The imperfections and messiness of food can seriously bump up the delicious factor in a shot. An image with a drip or two takes what would ordinarily be considered a flaw (Eek! The frosting is melting!) and turns it into the main focal point.

When a drip happens by accident, work quickly to capture that serendipitous event. A drip falling from, say, a teriyaki glazed burger is a phenomenal point of interest that makes the viewer want to chow down with vigor.

Staging a drip isn't easy, but you can encourage a drip by using just a little too much topping right at the edge of a surface. Set up your shot before spreading the topping. (Setup includes plates, napkins, any necessary props, and lighting.)

For the example in Figure 6-3, I spread jam evenly over a thick piece of toast and then piled up a bit too much jam at the edge. I took a few test shots to check the composition and lighting, and then I gave the jam a nudge and let gravity do its work. Yum!

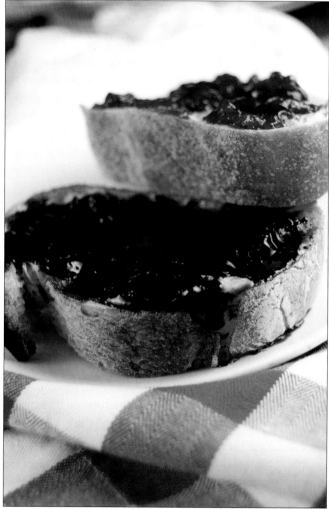

38mm, 1/125 sec., f/4.8, 400

Figure 6-3: A little too much jam creates a delicious drip.

Warming up a sandwich with cheese in a panini press, oven, or frying pan can also provide a scrumptious drip opportunity. Create your sandwich, including a little extra cheese, add heat, and then prepare to capture the delicious, gooey drips, as shown in Figure 6-4.

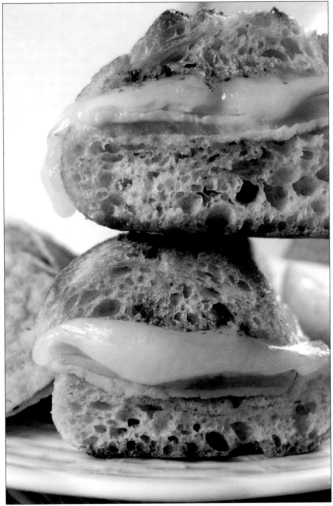

32mm, 1/60 sec., f/2.8, 400

Figure 6-4: Melting cheese on a Panini makes the mouth water.

Getting up close and personal

Don't be afraid of shooting close-ups. Close-ups give the viewer an intimate look at the food you're photographing (see Figure 6-5). Although close-ups aren't an appropriate look for every image, getting a close perspective can seriously enhance the yum factor of your images.

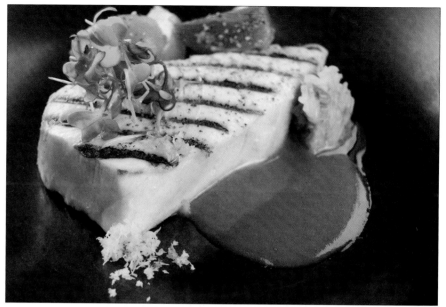

55mm, 1/200 sec., f/7.1, 400

Figure 6-5: A close-up shot focuses on the star of the dish: grilled escolar.

In some cases, you may shoot close-ups out of necessity. Perhaps you need to shoot close because you don't have the right props to fill up the background for a wider shot. Or maybe the black plate the chef placed the fish on is too darn shiny around the edges.

These days, however, taking a close-up shot is often a look the photographer deliberately chooses. A close-up enhances the look of a food and makes the dish appear distinctly more delicious, as illustrated in Figure 6-6.

I use a lot of close-ups when shooting for stock or blogs, but the look is generally less appropriate for a restaurant shoot. At a restaurant, I typically work with the manager or art director to get a feel for the ambience of the place with a bit of a wider shot that also features the linens and other accents (see Figure 6-7).

55mm, 1/25 sec., f/5.6, 400

Figure 6-6: This close shot of rainbow carrots captures their rustic beauty.

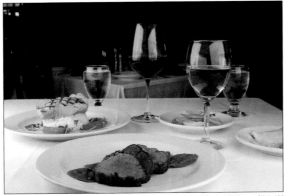

27mm, 1/250 sec., f/6.4, 400

Figure 6-7: Use wider shots for restaurants.

Jaunty Accents: Making Your Dishes Look Interesting

When the food alone isn't creating the drama or intrigue you want, using little tidbits, or *accents,* of color, shape, or texture can give your images the extra impact you're looking for. Accents are enhancements to the food subject, and, although they serve the purpose of perking up the food, they're certainly not the main focus of the image.

The key to using accents well is knowing what accents to use, how to use them, and where to place them. You also want to make sure that they don't steal the show from the main food subject. Don't worry, though, I show you the ins and outs of using accents in the following sections.

Introducing accents to your images

When placing decorative accents on a food, variety is key. You don't need a variety of types of accents — one type will do nicely — but you absolutely do want a variety of angles and sizes of the accent you place on the dish. You can also bump up the color factor by using garnishes in a contrasting color to enhance the main color of the food.

When using accents for your photos — either food or non-food accents — be sure to keep the following tips in mind:

- ✔ **Get creative with non-food accents.** Sometimes an image calls out for an accent that's related to the food but isn't food. These accents can be as simple as a curling ribbon or a few small birthday candles next to a birthday cake.

- ✔ **Keep it fresh.** When using fresh greens for accents, make sure to keep the greens chilled to increase the overall look of freshness within the image. No limp greens, please.

- ✔ **Use curls for fun and profit.** A few nicely placed curls of chocolate atop or alongside a chocolate mousse can really knock an image out of the park. The same goes for adding curls of Parmesan cheese sprinkled on an Italian dish.

- ✔ **Use different colors for your accents.** Try using accents that are a good, colorful contrast to your main subject, such as green dill with red tomatoes (see Figure 6-8).

- ✔ **Vary the angles.** Make sure each accent has its own unique angle. If you have two or more accents with the same angle, you may notice that it just doesn't look quite right. When you place accents at the same angle, they can make a photo look unnatural and staged.

 Also, don't place accents directly horizontal or vertical. Always keep your accents slightly askew.

- ✔ **Vary the size.** Varying the size of your accents is always a good idea because you want to avoid the look of sameness. Each accent should have its own unique look.

Make sure the accents you purchase for use are as perfect looking as possible. Pay close attention to the shape and color and identify any flaws that could be visible.

55mm, 1/80 sec., f/5.6, 400

Figure 6-8: Fresh green accents add a nice contrast to cut red tomatoes.

Don't forget about accents when photographing beverages. You can choose from many creative accents for drinks, such as citrus peels, star anise, mint sprigs, plastic straws, and beyond. These accents can take an ordinary drink image and elevate it to high art.

When using accents for drinks, going a bit larger with size is okay. Drink accents are generally a greater part of the image than accents you use with food, as you can see in Figure 6-9. A plain drink can photograph as too simple or too plain, and it may need to be dressed up for a successful shot.

55mm, 1/320 sec., f/5.6, 400

Figure 6-9: Citrus wedges and fresh mint sprigs adorn this beverage.

Placing small accents in your images

Now it's time to channel your inner food stylist. A food stylist's responsibility is to make the food look fresh, interesting, and appetizing for the camera. Part of this responsibility involves placing the food accents for the dish or setting.

When working with accents, think small. Simpler is better, less is more, and a little goes a heck of a long way. Also, as you begin using accents, make sure to have your stylist toolkit at the ready. (See Chapter 3 for a list of styling tools to help you place the accents.)

Take a look at the images in Figure 6-10. The image on the left has some accents placed on the same exact angle, as well as one on a 90 degree angle, which frankly looks a little peculiar. The human eye generally doesn't read these kinds of images as appetizing. The image on the right mixes things up a bit. Accents are on different angles, and none of them are 90 degree angles. Overall, the image looks decidedly more delicious.

Figure 6-10: Changing the angles of the accents can affect the overall look of the image.

Steer away from using accent shapes that are too similar to your subject. For example, using long, thin accents when photographing roasted asparagus is too alike and doesn't provide enough contrast.

Crafting the perfectly folded napkin

As I discuss in Chapter 3, linens are a huge part of food photography. Although I often use tablecloths or placemats for a shot, cloth napkins are small and easily adjustable, and in addition to the food subject, they can really set the artistic tone of an image. The linens you choose can make a shot look homey and comfortable, powerfully graphic, or upscale and elegant.

You can open up cloth napkins and use them as a background, as I mention in Chapter 3, or you can use them in a more traditional way as a prop for a food shot.

When using a napkin as a prop, the goal is to make the napkin look naturally placed. You can have a napkin under the main dish or set out in a formal place setting. It can be unfolded, folded with one fold, slightly rumpled, and so on. You can even use napkins stacked up as part of a cool background for a shot, as in Figure 6-11. For the most part, the napkin prop should be a hint, not the main focus of the image. Depending on the subject, too much napkin showing can detract from the shot.

25mm, 1/50 sec., f/5.0, 400

Figure 6-11: Stacked napkins in the background give this shot of steaming oatmeal a homey feel.

I prefer the relaxed look of a casually folded napkin. Just a simple cotton napkin peeking out from under a plate can add a sense of warmth and home to your food shot.

Notice the simple bunching of the yellow cotton napkin in Figure 6-12. A couple of gentle folds create lines that lead your eye to the pasta. The yellow in the napkin also complements the warm tones in the pasta.

I tend to lean toward using more subdued colors for napkins when placing them under plates. Brightly colored fabrics may look great in a more graphic shot, but unless you're shooting a graphic food subject, such as a bright orange sorbet, powerful colors can negatively affect the image.

48mm, 1/100 sec., f/6.3, 400

Figure 6-12: A folded napkin creates warmth under a pasta dish.

Another interesting possibility when working with napkins is to shoot foods set directly on a napkin that ordinarily don't belong there. For example, toast may look like it belongs on a napkin, but sautéed green peppers with olive oil and garlic probably doesn't. The texture of the fabric shows through while the subject, accents, and any sauce used complete the image. Messy and imperfect, perhaps, but it produces a successful food image.

Managing Reflections in Your Food Photos

Understanding reflections is the first step to managing them. Reflections affect a photo in two distinct ways: unwanted reflections on your subject and producing extra light when needed. A highlight in your food subject can (and will) pick up the colors in your immediate environment. And when you need to add a little extra shine to a food, reflectors are the go-to tools to use.

Blocking unwanted reflections in your shot

Say you're taking a photo near a window with a lush, green garden outside. If your subject has some shine, you may unintentionally pick up some green reflections in your foods. If you're using a stool for the shoot that has a strong color, that color can also be picked up in your reflections.

 Be aware of your surroundings and control your environment as much as possible. You can block out many extraneous objects in your environment by covering them with white sheeting or other fabric. Covering or blocking a distracting object from view can remove an unwanted reflection or color cast in an image.

If you're not using natural lighting, close any curtains or blinds, which can let outside light in, to help reduce reflection. You can also use a *scrim* — a large panel of translucent material that acts as a light diffuser — and place it between your food and the window.

Adding light with reflective materials

Another facet of reflections to consider is using reflective materials to beef up the lighting in your subject, as I discuss in Chapter 2. When you need a little extra lighting in a shot, position a piece of aluminum foil as a reflector to shine a little bounced light on the area that needs a little boost, as I did in Figure 6-13. I really like using foil for its reflective qualities and flexibility.

Figure 6-13: Use a reflector on a set to add extra light.

Alternatively, using a small mirror can serve the very same purpose. I generally have a couple of mirrors with me anytime I shoot food so I can enhance the lighting setup.

And having a white bounce card also helps when you need a little extra light on your subject.

Exploring Textures for a Unique Feel

What can texture do for a food photo? A textured background can be an important element of the overall image. Texture can enhance the quality of the image, provide it with a feeling of age, and make it interesting. When you use a textural background, you don't necessarily see the texture at a granular level, but you do get the perception of a little something extra. Something tactile. Something deeper. I'm not talking about your basic, plain white, plastic background here. Using weathered woods, nubby fabrics, or wrinkly paper provides great texture and interest to any subject, and I walk you through each of those materials in the following sections.

Creating interest with weathered woods

In Chapter 3, I talk about perusing antique stores for unique finds. If you're lucky (or persistent), you may be able to find some truly unique wooden cutting boards or trays to add to your housewares library. You can then use these treasures in your images to add to the feeling of quality, realism, and home.

Check out the cool background under the cupcake in Figure 6-14. The background is an old tray I found with different-colored milk paints on the slats. The texture of the weathered wooden tray, combined with the subject, provides a sense of old-fashioned Americana. Also, the blues in the tray really pop the blue sprinkles on the cupcake.

The worn breadboard used in Figure 6-15 conveys a feeling of history that truly complements the subject, an old Chilean recipe. The wood ties right in with the warm color scheme of the photo.

55mm, 1/40 sec., f/5.6, 200

Figure 6-14: The faded colored wood tray under this cupcake adds interest.

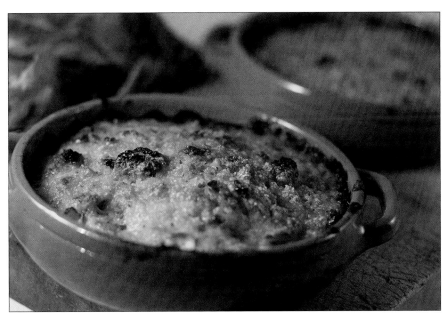

50mm, 1/250 sec., f/3.2, 400

Figure 6-15: An antique cutting board adds a sense of history to this South American dish.

Going modern chic with wrinkly paper, nubby fabrics, and more

Wrinkling up a bit of white paper can add an unusual, modern look to your images. This paper can be a great base under cookies or the like, or you can use it as just a hint in the background.

I'm currently enchanted with using textured Japanese papers under or behind a food subject. As you can see in Figure 6-16, I used a gold sheet behind the eggs to provide a bit of depth to the background. These papers come in a full range of super-rich colors and are generally quite inexpensive. You can often pick up these papers in Asian dollar stores or find them online at The Paper Studio (www.paperstudio.com).

Truth be told, when searching for an interesting environment for a shot, I sometimes pass over traditional backgrounds and grab whatever's currently at hand. I've been known to wrinkle up a humble brown paper bag to provide an awesome textural background for sandwiches or baked goods. It provides a just-unwrapped feel to the photos.

55mm, 1/10 sec., f/5.6, 320

Figure 6-16: A cardboard carton adds texture and the colored background adds depth to this shot.

Working with cardboard can add a lot of depth and texture to an image. Cardboard can be corrugated, pressed, bumpy, or smooth. Personally, I'm pretty keen on the bumpy look, as in the egg carton found in Figure 6-16; it makes for an image that you feel like you can reach out and touch.

I'm also a big fan of 1950s-style worn fabrics. One need only look as far as America's reigning style maven to see how the faded look of fabrics and linens has influenced the current look of food photography today. These types of fabrics create the overall look of home, wholesomeness, Grandma, and apple pie.

You can take that look one step further with the use of burlap. Burlap has become rather chic with the foodie set lately, and using burlap as an accent in an image really provides a unique earthiness to a shot.

Faded, earthy fabrics and materials are great accents for some shots, providing a wholesome look, but they're not for elegant and upscale shots.

Alternatively, there's much to love about a refined white linen setup. When you can see the starch in the white napkins and tablecloth, it provides a pure and elegant setting for an upscale shoot.

The Big Fake Out: Using Non-Food Items in Place of Food

When shooting foods, I lean toward keeping things real. But sometimes real foods simply don't translate correctly when captured in pixels or on film. If you've ever tried to shoot a bowl of cereal with milk, you know what I'm talking about here — gray milk isn't so pretty! Sometimes you just need a little something extra to create a successful photograph. Well, you're in luck: In the following sections, I disclose some common, everyday materials — though not food — that can make your food and drink photos more appetizing than the real thing.

Dressing up drinks with acrylic ice cubes and other fun illusions

Preparing drinks for a shot is usually a straightforward task. Pretty backgrounds, nice lighting, clean glasses, gorgeous liquids, and an accent or two all contribute to creating a great beverage shot.

But what if the drinks need some ice? If you photograph a drink with real ice cubes, the ice cubes won't look clear and transparent. As you can see in Figure 6-17, the ice looks white and not so refreshing. In order to avoid this

problem, you can use artificial ice cubes made from hard plastic or acrylic, like the ones in Figure 6-18. Yes, I know it sounds odd, but these cubes are used all the time in commercial drink photos.

Acrylic cubes used to be quite difficult to find and were always super expensive, but these days, some good, basic cubes are widely available. A 2-pound bag will run you just about $25. Very reasonable!

If you need to, you can buy the high-end cubes in different shapes: crushed ice, melting ice, chipped ice, and formed ice. These handmade bits of perfection are exquisitely realistic and run between $30 and $40 per cube. Because of the expense, you may want to rent these cubes from a good prop company.

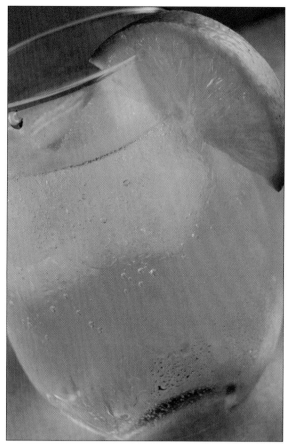

52mm, 1/160 sec., f/8.0, 400

Figure 6-17: Real ice cubes can look white and boring.

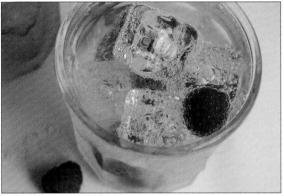

55mm, 1/40 sec., f/5.6, 640

Figure 6-18: Artificial acrylic cubes make this drink appear more refreshing.

Fooling the eye with inedible foods

I'm generally a food purist and try to keep things mostly edible in my photos, but some tricks can help create the perception of delicious foods out of some not-so-delicious ingredients. Here are a few of my favorites:

> ✔ **White glue for milk:** Shooting real milk can be a bit of a problem. On camera, milk essentially looks like thin, gray water. Not the most appetizing! To get the right look for a dish with milk, food photographers often use common white glue to give the "milk" the look of, well, milk! Check out Figure 6-19.

55mm, 1/80 sec., f/5.6, 320

Figure 6-19: Glue replaces milk in this cereal. Yum!

✔ **Brown shoe polish for meat:** Use a paper towel or small cloth to rub just a little brown shoe polish on a beef or poultry roast. Doing so really brings out the brown in the meat with a nice added subtle shine.

✔ **Blowtorch for meat:** Need more browning? Use a cook's blowtorch for browning turkey or burger edges. This technique can enhance the look of any meat.

✔ **Cardboard for sandwich or pancake separation:** Little pieces of cardboard work great as an anti-smushing solution for foods with layers. As you can see in Figure 6-20, a small square or circle of cardboard can lift and separate the layers of a sandwich, burger, or pancakes. Using this trick makes for a nice, tall stack of pancakes and a much beefier-looking burger.

52mm, 1/60 sec., f/5.6, 400

Figure 6-20: Cardboard separates the layers of pancakes.

✔ **Cotton balls or wet paper towels:** When you're a little low on ingredients, wad up a few damp paper towels or cotton balls and place them at the bottom of your bowl or container. Evenly distribute your ingredients over the false bottom to give your dish a look of more, even when you have less.

✔ **Dry ice, steam chips, or a steam iron for steam:** Photographing real steam can be one tricky operation. Timing is crucial, and you must move quickly to capture the wafting steam. Truth be told, real steam photographs a bit on the wimpy side. So to gain a bit more control over the unruly steam, you can try a few great options:

 • *Steam chips* are small bits of chemical goodness available from most high-end photo supply stores. They generally come in granular form, and you mix them with water to generate the steam.

- You can also try a small bit of dry ice to get a constant flow of steam going for your photo.

- Some folks swear by using a steam iron. I've used a compact steam iron on foods, and the steam does hold long enough to get some good shots. I generally aim the steamer toward the back of the dish, so the heat doesn't affect the look of the food at the front.

When photographing steam, your background needs to be dark enough that the camera can properly distinguish the steam from the background. Steam is just too subtle to capture with a light background.

✔ **Motor oil for maple syrup:** Who'd have thunk it?! Take a look at Figure 6-21. Although I love the shot with the real maple syrup on the left, the motor oil shot on the right has a slightly more robust, golden sheen to the "syrup." The motor oil also pours a little slower than real maple syrup, and because of that extra level of control, some food photographers and stylists prefer working with the oil.

55mm, 1/60 sec., f/5.6, 400

Figure 6-21: Pancakes with syrup (left) and with motor oil (right): Which one looks more appealing?

✔ **Soap bubbles in drinks:** Stir just a tiny bit of dish soap into coffee or another hot drink. The soap provides a little crop of bubbles near the edge of a cup. These bubbles increase the realism of the image and can help you achieve that successful hot-drink look.

The Ice Cream Is Melting! Problem Solving for Tricky Foods

. .

In This Chapter

▷ Sprucing up tired-looking produce

▷ Managing temperatures

▷ Keeping meat and seafood looking fresh and tasty

. .

*U*nto every situation, a little rain must fall. In food photography, that rain can sometimes take the form of unruly foods that just aren't behaving as expected. Whether you're dealing with produce that wilts, chocolate that's slightly too warm or too cold, dairy foods that melt, or meats, fish, and poultry that dry out, don't let these tricky foods get the best of you. Just a little preparation can go a heck of a long way.

In this chapter, I discuss several types of foods that can be tricky to work with in food photos and provide suggestions for how to handle them, along with some stand-in substitutions.

The Problem with Produce

Fruits and veggies should appear as fresh as possible in your photos. But, unfortunately, you can run in to some problems when shooting produce.

When produce is happily growing out in a field or garden, the water evaporating from the plants into the atmosphere is replaced by the water sucked in by the roots. When the produce is picked, that cycle breaks and

the produce soon starts the wilting process. At that point, the clock starts ticking on the freshness factor. Time can take its toll quickly, particularly with very thin or very delicate produce, like leafy greens.

On the fruit side of things, cut fruits can dry out quicker than you'd think. Melons and citrus fruits can look a bit sickly after just a little time under the lights, and cut apples can discolor quickly.

Hardier types of produce, such as cabbages, are much easier to shoot. These veggies have thick, waxy leaves and take a long time to wilt. See Figure 7-1 for an example of fresh, leafy produce that actually looks fresh in the photo. Swiss chard is a sturdy vegetable that, if refrigerated, will keep nicely for a couple of days until you need it for a shoot. But that's not the case with most types of produce, so in the next sections, I discuss some problems that may occur during a shoot and provide some helpful solutions to help you deal with persnickety produce.

55mm, 1/200 sec., f/7.2, 1250

Figure 7-1: Fresh Swiss chard ready for action.

Stuff wilts

Say you have an important shoot coming up on Monday. On Sunday morning, you visit your local farmers' market to pick out the very freshest produce, perhaps some accent herbs and greens to complement the subject you're preparing to photograph. You stick the greens in your refrigerator to wait for your shoot the next afternoon.

At the shoot, you work under continuous light for an hour or so and suddenly you notice that you're working with a bunch of less-than-perky greens. As you can see in Figure 7-2, limp, wilting produce is fairly noticeable in photos.

28mm, 1/125 sec., f/5.6, 500

Figure 7-2: Wilting accents can ruin a shoot.

To solve the problem of produce wilting, be sure to refrigerate delicate produce until ready for use, and use the produce for photos within five or six hours of purchase. Work quickly when shooting with delicate produce, and if possible, limit its time under the lights. If you're using continuous lights for the shoot, turn them off when you're not shooting.

Veggies aren't the only foods that wilt. Fruits can also take a great toll under the lights. Cut apricots can shrivel; watermelon can get mushy; bananas, well, bananas just start looking a little like mud.

Keeping produce looking fresh

As a food photographer, you need to be aware of a few simple tips and techniques to combat the wilting problem. As it is, even very fresh items get a little droopy under continuous lighting, or any type of warm conditions (see Figure 7-3), so using the absolute freshest ingredients possible and handling them well is the best way to work with produce.

35mm, 1/13 sec., f/4.5, 200

Figure 7-3: After shooting under the lights, your produce may end up looking lackluster.

Of course, the first order of business is getting the freshest possible produce. Purchase fruits and veggies the day of the shoot if you're able to. Doing so really makes a difference in your photos, particularly with leafy vegetables. A farmers' market or an upscale market, such as Whole Foods, is typically the best place to buy quality produce.

When you're ready to shoot, try some of the following tips to perk up your produce and keep it looking fresh:

- ✔ **Keep a fresh cut:** Some fruits and raw veggies are surprisingly susceptible to fading fast. Sitting next to other vegetables, cut tomato wedges can look tired rather quickly. Keeping a fresh cut — meaning you may have to cut fruits and veggies more than once — on your produce provides a fresh surface so it looks its best.

- ✔ **Undercook veggies:** For cooked vegetables, undercook by several minutes. After you remove the veggies from the heat and drain them, blanch them with cold water to really make the color pop (see Figure 7-4). Fully cooked and overcooked veggies often look limp and somewhat off-color in images.

- ✔ **Keep it chilly:** Freshly wash and chill your raw fruits and vegetables in the refrigerator. Keep any excess in the refrigerator so you can bring out fresh chilled fruits and veggies when your initial batch is fading. Always have extras available to swap in when your first string is looking a little peaked.

- ✔ **Manage the moisture:** Rinse your raw fruits and vegetables with water to help renew the moisture content. If your fruits and veggies are fine and you need only the illusion of moisture, use glycerin and water spray (see Chapter 6). Water droplets like the ones in Figure 7-5 give the aura of just-picked goodness in your images.

55mm, 1/13 sec., f/5.6, 400

Figure 7-4: The colors of undercooked and blanched vegetables really pop in food images.

55mm, 1/20 sec., f/5.6, 400

Figure 7-5: Water droplets on tomatoes help make them look fresh.

✔ **Spritz some lemon juice:** Cut apples, some pears, and even bananas can discolor rather rapidly, which isn't a good look during a shoot. Mix equal parts lemon juice and water in a squirt bottle. As soon as you slice your fruits, give them a good spritz to help keep them looking fresh.

✔ **Take an icy plunge:** Peels, such as carrot curls or celery, can be immersed in ice water to make the thin-cut veggies appear super fresh.

Regulating Temperatures for Sensitive Foods

Working under too warm or too cool conditions when photographing already difficult foods can add insult to injury. Despite your best efforts, the temperature can seriously affect the food you're trying to shoot.

Take chocolate, for example: It's delicious as heck and that can translate so well in photos, but sometimes chocolate is a bit challenging to shoot, and certain types of chocolate can be highly dependent on external conditions. Also, when shooting chilled dairy foods, such as whipped cream and ice cream, the key factor to keep in mind is the temperature of both the product and environment.

In the next sections, I explore ways to keep temperature-sensitive foods, like chocolate, whipped cream, and ice cream, from melting and causing some messy problems during a shoot.

Cooling and heating chocolate

Working with chocolate can be a little tricky, so when photographing chocolate candies or cakes, you have to consider a delicate balance of temperature. On one side of the spectrum is chilled chocolate that can produce some unfortunate beads of sweat, and on the other side is slightly warm chocolate that shows every touch and threatens to melt over everything. You want to try for somewhere in the middle.

Don't use your fingers when moving or placing chocolate for a shoot. Our bodies are warm as it is, so when shooting under hot lights, even a gentle nudge can put an unwanted fingerprint on the chocolate, as shown in Figure 7-6. If you need to move the chocolate, use a spatula, spoon, or tongs.

55mm, 1/50 sec., f/6.3, 200

Figure 7-6: A fingerprint on chocolate can ruin an otherwise delicious image.

When working with heated chocolate, such as the fondue in Figure 7-7, make sure to warm it periodically in a fondue pot or double boiler. If the chocolate gets too cool, it can start to solidify quickly and form an unattractive crust.

Melted chocolate can be so shiny that it clearly reflects every light source. Be aware of how the reflections appear through your viewfinder. Natural light streaming through a window or a nice, white soft box looks wonderful as a reflection.

Combating the perils of whipped cream

Shooting with whipped cream can be a mixed blessing. If you're able to move fast enough to get the right shot, it looks absolutely gorgeous. When it works, you get light falling on the delicate swirls or dollops of goodness that can really translate beautifully to an image. When it doesn't work, however, you very quickly get a slippery, sliding mess that melts, separates, and bubbles and won't hold the structure of your food.

When shooting with whipped cream, make sure the room temperature is as cool as possible to maintain the food's structure for as long as possible. If the room is too warm, the whipped cream is an instant mess.

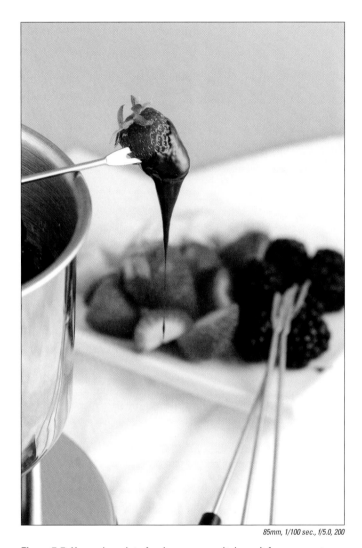

85mm, 1/100 sec., f/5.0, 200

Figure 7-7: Keep chocolate fondue warm so it doesn't form a crust.

In Figure 7-8, I stacked shortcake layers with whipped cream and berries. Between each layer, I put a small piece of cardboard to help separate the layers, a technique I discuss in Chapter 6. In addition to the cardboard circles, I placed a few berries around the perimeter of the cardboard with a swirl of whipped cream to top off each layer. I finished off the look with a huge swirl of whipped cream on top of the shortcake, along with a few more berries strategically placed on the very top of the creation.

After literally 60 seconds of working under the lights, the whipped cream went into epic fail mode. Berries and whipped cream came sliding down the sides of the shortcake.

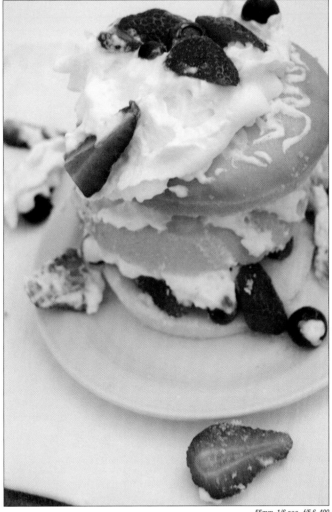

55mm, 1/6 sec., f/5.6, 400

Figure 7-8: Whipped cream melts quickly under hot lights!

Here are a few suggestions for dealing with whipped cream desserts in your food photos:

✔ **Change your lighting:** Instead of using heat-inducing continuous lighting, as discussed in Chapter 9, natural or strobe lighting may work best in this situation. It makes for cooler conditions that extend your shooting time.

✔ **Substitute sour cream:** Sour cream is a great alternative to using whipped cream. Sour cream is a fairly robust food double that can handle light and heat like a champion. In Figure 7-9, the more delicate whipped cream is replaced with sour cream. The image looks creamy and delicious with none of the adverse effects of working with whipped cream.

85mm, 1/80 sec., f/4.5, 200

Figure 7-9: Using sour cream as a whipped cream stand-in provides the same look without the melting mess.

✔ **Try tiny toppings:** If you're using fruits or other toppings, try to make them whisper thin. Doing so shows them as beautiful toppings but without all the weight of the chunkier portions.

✔ **Use a dollop:** Use a dollop of freshly whipped cream, rather than squirting from a whipped cream can. These spoonfuls are less delicate and hold out longer for your photos.

✔ **Work quickly:** One of the key factors to remember is to work very fast when shooting whipped cream. You have only a few minutes to get the needed shots.

Working with ice cream

My favorite food photography challenge is working with ice cream. I say ice cream here, but the advice in this section goes for any similar frozen treat,

like sorbets, frozen yogurts, and gelato. Working quickly with these desserts is key, and some photographers choose to use substitutes instead.

Improving your speed

Ice cream and other frozen desserts look absolutely gorgeous in images, but you have to work fast and be prepared when dealing with the frozen goodies. The following tips can help:

- **Buy the right tool:** Invest in a good ice cream scoop. The top of the line can be had for just under $20. The scoop should have a handle release to scrape the ice cream out cleanly. Before scooping, dip the scoop in absolutely clean water; lukewarm is best.

- **Consider your lighting:** When working with the tricky frozen desserts, use natural or strobe lighting rather than hot continuous lights.

- **Extend your shooting time:** After removing the ice cream from the freezer, keep it on ice. Try placing the dish of ice cream on a bed of ice covered with a thin surface, such as a cloth or napkin.

 Another way to extend shooting time is to shoot a full container of chilled ice cream, or even gelato, as shown in Figure 7-10. The sheer volume of the tray of gelato (about 5 pounds) self-chills and allows the top to stay frozen a bit longer while you shoot.

55mm, 1/30 sec., f/5.6, 400

Figure 7-10: A tray of glossy gelato helps extend shooting time.

✔ **Set up everything else first:** Lay out your set, your backgrounds, your props, your accents, your lighting — the whole shebang. Take test shots with an empty cup or bowl. You can also use a wadded-up paper towel or napkin to act as a stand-in while you check your shot.

✔ **Super-chill the ice cream:** Turn the temperature down in the freezer to achieve maximum frostiness. If possible, use a full fat ice cream, as shown in Figure 7-11. Full fat is a much hardier ice cream that melts significantly slower.

✔ **Work fast:** Now that you're ready to shoot, the key here is speed. You need to work quickly to get the images you need from the ice cream before the inevitable melting starts.

52mm, 1/25 sec., f/6.3, 400

Figure 7-11: A fresh scoop of homemade cherry ice cream.

Using a stand-in

To overcome the time constraints when shooting ice cream, some photographers use an ice cream substitute made of various concoctions. I've seen a playdough-based mixture, mashed potato–based, powdered sugar–based, frosting-based, and so on; a lot of different recipes for ice cream substitutes are out there. All the recipes have a similar doughlike texture that mimics ice

cream's appearance but won't melt under the lights — just check out the ice cream substitute in Figure 7-12. These substitutes give you all the time in the world to get your perfect ice cream shot.

Provided you're not shooting packaging for an ice cream product (for packaging, what you see *must* be what you get), trying a substitute is generally fine if you're not having any luck with real ice cream (or if you just want to have some messy fun!).

50mm, 1/15 sec., f/5.6, 200

Figure 7-12: Strawberry ice cream substitute looks like real ice cream. Yes, really!

I use mashed berries in the following substitute recipe (shown in Figure 7-12) to give it a really fresh look:

Berry Ice Cream Substitute Recipe

⅓ cup instant mashed potato flakes

1 cup vegetable shortening

4-plus cups powdered sugar

2 tablespoons light corn syrup

About ¼ cup of mashed berries

Using a hand or stand mixer, mix the shortening with the mashed potatoes. Add in the powdered sugar 1 cup at a time. After adding 3 cups, mix in the corn syrup and the berries. Continue adding the powdered sugar until the mixture starts to form a doughy texture.

When you can touch the mixture and it isn't sticky, you know you've mixed in enough powdered sugar. Now knead the dough for about a minute (right in the bowl is fine). When you have a smooth ball of the dough, you can start scooping away!

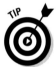

If the dough is a little too dry, mix in another tablespoon of mashed berries. If it's too sticky, mix in a bit more powdered sugar.

Although you can easily create an ice cream substitute, when shooting a cup of glossy gelato or a frosty sorbet, you're going to have to use the real thing. I have yet to see any artificial stand-ins for these gorgeous desserts. For those items, just keep to the dual mantras of fast and cold.

Shooting Meat, Poultry, and Seafood

Meat, poultry, and seafood are less temperamental than other foods, but they can still be a bear to deal with from time to time. When shooting these foods, a few problems can crop up that may put a dent in your shooting experience.

First off, these proteins can dry out very quickly, particularly under hot lights. When shooting these foods, be sure to always have materials on hand to deal with this lack of moisture.

When proteins, particularly poultry items, are overcooked, a gelatinlike substance can flow from the bones. Yuck! Keep your eyes peeled for this problem.

Luckily, these particular issues are fairly easy to handle for photographs, with a few simple solutions, as I discuss in the following sections.

Keeping proteins from drying out

When working with proteins, you may have only a few minutes to shoot before your food starts looking less than fresh under the lights. After that, you'll have to replenish the liquid content of the food, and water won't do the trick. To combat the foods from drying out, have the following liquids nearby:

- ✔ **Oils:** A small dab or brush of oil can truly rejuvenate your tired proteins. Any oil will do — olive, canola, walnut, or even baby oil will do in a pinch. The oil moisturizes the proteins and gives them a lovely little shine (see Figure 7-13). Just remember not to munch on the proteins after the shoot!

- ✔ **Sauces:** Spoon a little light sauce over your proteins. The sauce doesn't have to be meant for the dish, but the look of the sauce complements the protein. Neutral color is better in this case. Remember that you're just going for the moisture and shine of the sauce, not really the decorative aspects here.

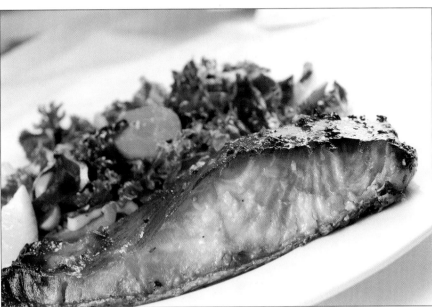

70mm, 1/50 sec., f/9.0, 500

Figure 7-13: Seafood brushed with oil creates a juicy, appealing food image.

Either of these choices enhances the look of the foods and helps you create some wonderful images.

Removing the goo: Dealing with meats that congeal

When working with poultry in particular, sometimes congealed goo suddenly appears on the skin, as shown in Figure 7-14. If the protein is cooked very well and is standing for quite some time cooling off, the natural juices of the bird solidify and congeal. A bit of gelatinous goo isn't a pretty look for a food photograph.

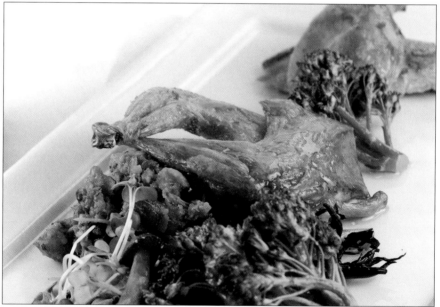

32mm, 1/125 sec., f/5.6, 400

Figure 7-14: Poultry with congealed goo is far from appetizing.

To address this problem, consider the following options:

✔ **Apply heat:** Use a blowtorch to reheat and melt the goo. A hair dryer also works just fine in a pinch.

✔ **Remove and conceal:** Remove the congealed juices by using a small utensil to scrape off the goo. Then brush the poultry with a little oil to smooth things out.

✔ **Switch it up:** Substitute the old poultry with a newly heated portion. Having extras at the ready is always a great idea.

A culinary blowtorch can be your very best friend when working with meats. You can purchase this handy item at any gourmet cookware shop. Not only can you use a blowtorch to reheat your proteins to solve any congealing issues, but also you can add a lovely brown color to your meats. The browned meats translate nicely in a photograph.

Part III
Shooting the Food: Techniques with the Camera

The 5th Wave — By Rich Tennant

CAMERAS

"I want a lens that's heavy enough to counterbalance the weight on my back."

In this part . . .

Composing a tantalizing food image isn't just about the placing of the food and the settings. Sure, these things play a huge part, but equally important is where you decide to focus, what type of lighting you use, the distance between the camera and the food, and more. This part covers these truly important aspects of shooting an appetizing food photo.

Chapter 8 explores some composition basics to help with arranging the food within the frame. Chapter 9 guides you through the different types of lighting tools and techniques that can help you in your quest for gorgeous food images. In Chapter 10, you discover how approaching the food subject from various angles and using tilts can provide some truly unique looks. And in Chapter 11, I hone in on the current focus techniques for food photography.

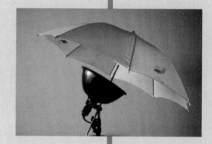

8

Composition Basics

*C*omposition, or the arrangement of elements, in food photography is slightly more complex than in some other types of photography. So many factors need to be considered, such as distance, focus, shape, color, highlights, lighting, props, tilt, angle, and so on.

But composition is nothing to get stressed about. It sounds like a lot to consider, but you just need a basic understanding and awareness of the various elements you're dealing with while shooting. As you shoot, check your images often to confirm that you're not overlooking some key aspect of the composition.

If you notice that you're overlooking something, get on in there and change things around. Be sure to shoot enough different options (I shoot more than 100 images per dish sometimes) so you have a lot of variety in looks for a given subject. After you've shot some basic solid images, don't be afraid to try new and different ideas in your compositions. Experiment with different props, angles, distances, and so on, and you may find the perfect composition for your photo.

At a food shoot for a client, you may have a food stylist or an art director calling the shots and providing the settings for your photos. This situation may call for a little less experimentation on your part, but you'll still have a significant amount of input in the overall composition of the images. Your job here is to work with the team within the given framework to provide the desired result for your client.

In this chapter, I talk about the basics of composition, such as the distance between you and your food subject, and how perceptions can change when your camera moves closer or farther away from your subject.

I also cover the fundamentals of using repetition and echoing different elements in a shot as well as overall food placement, graphics, and *leading lines* — lines that draw your eye into the image.

Going the Distance: Shooting Close-Ups and Beyond

Probably the biggest factor in the composition of a food photo is the relative closeness of your eye to the food subject. Changing the distance between the camera and the food can really transform the story, or the feeling, of a photo.

In Figures 8-1 and 8-2, notice that the food subject is the same, but the change in distance generates completely different feelings about the two photos. How you compose the food subject (and distance is a *huge* part of composition) really does affect how a viewer perceives your image.

The image in Figure 8-1 shows the tray of baklava in its entirety, with a portion of the table and various other backgrounds. Figure 8-2 shows a close-up of the baklava on a tray. It's the very same food, the very same tray, but the story of the two photos changes with the decrease in distance. Which image looks more appetizing to you?

85mm, 1/50 sec., f/3.5, 400

Figure 8-1: Baklava on a tray from a distance looks appealing.

55mm, 1/25 sec., f/5.6, 400

Figure 8-2: A close-up of the baklava really entices the viewer.

Getting up close and personal

I shoot rather close to my food subjects most of the time. It's my style, and it looks best to me when shooting food images. I want to see the textures, the colors, and the imperfections in my subjects (see Figure 8-3). I want to zoom in very near to the dish and shoot an intimate view that's so close I can almost taste the food.

50mm, 1/80 sec., f/5.6, 400

Figure 8-3: This close-up of ripe autumn figs draws the viewer into the shot.

Close-up images of food are definitely appropriate for stock photos, websites, food blogs, and the like. However, close-ups aren't everyone's cup of tea. Close-ups may not be particularly appropriate when shooting for restaurants, packaging, or other food industry images. Of course, whether close-ups are appropriate for some clients really depends on the situation and the client, so you have to be flexible.

So what are the realities, the specifics, the dirty little secrets of shooting food close-ups? The following sections offer details.

Focus

Sometimes focus can be an issue when getting in so close, although it really depends on the setup, the lighting, and the aperture on your camera. (I talk more about how aperture affects focus in Chapter 11.)

When zooming in close to your subject, carefully focus on the most interesting part of the dish. Is it where the fork touches the cake? Is it the shine on the sashimi?

Depending on the situation, your camera's autofocus feature may not always allow you to focus perfectly in close-up situations. Because you're shooting so close to your subject, you may want to rely more on manual focus for these types of shots.

If your eyesight isn't perfect, some issues may crop up from manually focusing on close-ups. Contact lens wearers have the advantage here, but for those photographers who need to wear glasses (guilty!), manually focusing for extended periods of time can be difficult. Eyes get tired and eyeglass frames press uncomfortably on your forehead. I know art is pain and all, but really?

When shooting in conditions, such as a warm commercial kitchen or studio, eyeglasses can fog up big-time, just when you need to see very clearly. These factors can all be very frustrating when trying to get the perfect shot for your client.

Whether you wear glasses or not, take advantage of the *in-focus indicators* — the visual and audio focus feedback cues available on most digital SLRs — which can confirm that an area is in focus. Pressing down lightly on the shutter to focus your camera triggers these cues. On some cameras, you may hear a beep when your selected point is in focus, or a visual indicator may change color. These types of indicator cues can assist with your focusing.

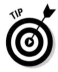

Another way to handle focus issues for glasses-wearers is to use a *diopter,* which is essentially a corrective lens attached to the camera's eyepiece. Diopters are often incorporated right into a camera's viewfinder, but if not, you can purchase a diopter that easily attaches to your camera. These

add-on diopters are inexpensive, generally running less than $20. Different models are available that handle various levels of nearsightedness and far-sightedness. Diopters allow precise manual focusing (as in Figure 8-4) just when you need it most.

55mm, 1/250 sec., f/13, 640

Figure 8-4: A crisp focus is just one element to good composition.

Lenses

Many food photographers use a slightly longer lens when shooting close-ups. I shoot with a long-ish lens from time to time, usually my trusty 85mm, which slightly flattens the subject and provides the effect of nicely separating the food from the background. This look can really show off the food subject and spur great compositions. Shooting close-ups of food with an 85mm requires a fairly large subject to fill the frame because the length of the lens demands that you shoot quite a distance away from the food.

I like to get really close to the food I shoot, so for the majority of my close-up work, I use between a 35mm and 55mm lens. Slightly wide lenses, like a 35mm, allow a photographer to get in super close to the food. These lenses can provide a bit of a warped perspective in an image, but I covet the slight distortion of the wider shots.

Don't overlook the "middle child" in the lens family — a 50mm or 55mm lens in the normal range. This lens can have beautiful optics, and like a 35mm, it allows a photographer to get in quite close to a subject. A normal lens can produce some beautiful food photos with a natural-looking perspective.

It's really up to you to decide which lens works best for you when shooting close-ups.

Placement

When shooting close-ups, keep the basic composition of the image in mind. Look through the viewfinder and place your food subject somewhere in the center area, as in Figure 8-5. Imagine a broad oval target in the frame, and try to keep part of the main subject within that target area for a nice-looking image.

26mm, 1/2 sec., f/9.0, 400

Figure 8-5: Fresh beans and sesame seeds use the center space of a frame.

Having strong horizontal or vertical lines in your subject when you're in so close isn't generally a good idea. The strong lines can read as just too intense when shooting in such a small area. Think soft curves and subtle lines, and keep foods and accents slightly askew for a more pleasing image.

Backgrounds

Hey, who needs backgrounds? Well, we all need them in food photos, but when you're shooting in so close, you may see only a tiny bit of the background, if it shows at all, as is the case in Figure 8-6. So make sure that if a portion of the background does show, the color or texture complements the subject.

32mm, 1/100 sec., f/6.3, 400

Figure 8-6: Backgrounds still peek through in some close-up shots.

Bits

Every photo has a certain amount of bits in it. The good bits are crumbs, powdered sugar, tiny basil leaves, sesame seeds, and their ilk. And the bad bits include dust, tiny stray particles, small fibers, or even eyelashes (yuck!). When you shoot close-ups, you need to watch for and be aware of both types.

With the good bits (the accents, crumbs, and such), less is more, particularly in close-up shots (see Figure 8-7). Giant basil leaves can overpower a subject, where tiny ones complement. (I go more in depth about accents in Chapter 6.)

With the bad bits, well, what can I say? Be on the lookout and try to catch them early. Use tweezers to remove, if possible, so you don't disturb the rest of the food composition. If you don't catch them when shooting, or if there's no way to cleanly remove the bit, you can always work it out in postproduction cleanup. (See Chapter 12 for cleanup tactics.)

55mm, 1/160 sec., f/8.0, 400

Figure 8-7: Good bits enhance this close-up.

Pulling back from the tableau

Getting a greater distance between you and your food subject is appropriate for any type of shoot but particularly for restaurant shoots. Many times, restaurant owners want to get a sense of the ambience of the place included in the shots. Sure, sometimes they like the close-ups of their foods, but getting a little distance can make for an extraordinary restaurant shoot.

When you have a lot of elements in your photo, zoom out and allow the different elements to fill the space in the frame, as shown in Figure 8-8.

You can also have a small amount of food in a wide open space. A really cool look is the look of less, such as one small sandwich placed on an otherwise empty table.

When you're working in a wonderful setting, perhaps an old weathered table next to some large windows, pull back and place a lone item on the table. The ambience of the place really comes through, and it's a great way to show off a small dish. Sometimes less really is more.

32mm, 1/80 sec., f/4.5, 400

Figure 8-8: This wider shot of fresh milk on the B&B table at breakfast provides ambience.

When shooting these tableaus, including tall verticals with primarily horizontal foods can be challenging. Sometimes I have to include wine bottles, or portions thereof, with a low dish of food in photos for a client. Wine glasses are generally not so tall and aren't much of a problem. Wine bottles are taller and can be an issue. In these types of scenarios, build up your background with other elements, and then work with tilts and angles to get the right look for your photo. (I talk about tilts and angles in Chapter 10.)

Using Repetition for a Pleasing Look

Repetition, or the echoing of a food or prop, is a modern concept that can accentuate the graphic impact of a photograph. Well, perhaps I should say it's a mid-century modern idea. I personally think the amazing artist Wayne Thiebaud started it all with his beautiful paintings of repeating cakes and pies.

Just as sometimes less is more, sometimes more is more. In the following sections, I show you how to use repetition with foods, props, and backgrounds to add interest, depth, and a bit of pop to your images.

Echoing the main food subject

The idea of repeating or echoing a food is a good one. Using repetition of foods invokes a strong graphic aesthetic that can come shining through in your photos. The following are some basic ways to use repetition by echoing foods:

✔ **Repetition of plated foods:** One of the top techniques used in food imagery these days is the echoing of a food subject. The repetition of a food can happen on one large plate or on several smaller plates. This technique provides a real graphic arts feel for an image. Focus at the front or at the most interesting point in the subject and let the rest fall out of focus and echo your main subject (see Figure 8-9).

This technique is highly artistic and really impacts a photo. As photographers, we're artists who can be heavily influenced by others, such as Wayne Thiebaud, who are equally enamored with creating artistic food images.

55mm, 1/100 sec., f/5.6, 400

Figure 8-9: This image of Kobe beef sushi uses repetition.

✔ **Repetition with raw food ingredients:** When shooting a slice of something interesting, like the Meyer lemons in Figure 8-10, having just a hint of the same subject off in the background increases the interest in the photo. If the image consists of solely the front-most lemon slice (although graphically powerful), the image itself may be a little too plain, too simple. Having that little bit of subject repetition really enhances the photo.

40mm, 1/25 sec., f/2.8, 100

Figure 8-10: A small hint of a second lemon provides interest in this photo.

With some other fruits, I like to have the front-most piece angled straight at the camera, with another piece or two at a distinctly dissimilar angle off in the background (see Figure 8-11).

40mm, 1/25 sec., f/2.8, 100

Figure 8-11: Vary the angles in your repetition for a different look.

✔ **Repetition of drinks:** I love the look of a nice cocktail with its various accoutrements repeated and shot with a good tilt. This repetition shows off the beauty of the beverage.

Adding multiple dishes

If you feel your food needs a little something and a plain background isn't cutting the mustard, consider adding multiple dishes under your food.

Using multiple dishes under a food subject can provide just a little extra *oomph* to an image (see Figure 8-12). It's a slightly unusual, artsy look, but when keeping with the setup's color palette, it's a really nice addition to a photo.

Multiple dishes allow you to play with both color and texture to provide a setting that allows you to really show off a food.

55mm, 1/20 sec., f/5.6, 400

Figure 8-12: Multiple dishes under a food subject provide an artsy look.

Stacking linens and other housewares

Although a little unorthodox, creating a wall of linens or other housewares can really be a cool background for a photo that not only creates a graphic element for an image but is also pretty easy to put together. The difference between stacking linens and dishes in the background and using multiple items under a food is that the latter simply provides a little color, shape, and texture enhancement to the main subject while stacking creates a more graphic look. Just check out the stacked linens in Figure 8-13.

35mm, 1/800 sec., f/4.5, 400

Figure 8-13: Stacked linens in the background create a graphic interest.

In Figure 8-14, the South American chivito sandwich is the subject, but the stacks of dishes provide a great graphic repetition in the background that complements the composition.

50mm, 1/60 sec., f/1.4, 800

Figure 8-14: Stacked dishes in the background complement the food subject and the overall composition.

Placing Your Subject in the Frame

You've probably heard of the *rule of thirds,* but for those of you who haven't, it's essentially this: When looking through your viewfinder, divide the visible space into three parts vertically. Then, divide the space into three horizontal parts as well. The four ideal points to place the most interesting part of your composition are ⅓ over and ⅓ down (where you see the stem in Figure 8-15), ⅓ over and ⅔ down, ⅔ over and ⅓ down, and ⅔ over and ⅔ down, as indicated in Figure 8-15.

You can use the rule of thirds as a guideline, but your placement doesn't have to be exact. Approximate placement works just fine, too.

Figure 8-15: Use the rule of thirds to place your subject in the frame.

If you're not using a *sweep* (a seamless background) and aren't shooting extreme close-ups, you may have a line where a table or other surface meets the background. If you're shooting without any tilt (more about tilts in Chapter 10), positioning this meeting line near the ⅓ or ⅔ point up the horizon can provide a pleasing look.

As I mention earlier in the chapter, I often try to keep much of the food placed within a large oval target area somewhat centered in the frame. But when I shoot a subject, I rarely place the full dish in that center oval area with background surrounding the dish on all sides. Occasionally, that may be a cool look, but more often than not, I cut off at least one edge or part of the subject in the frame, as shown in Figure 8-16.

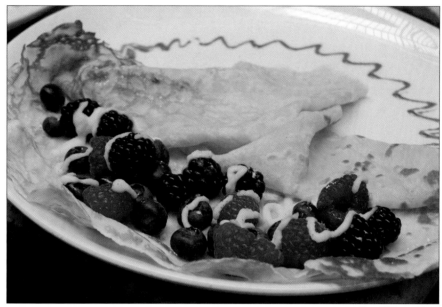

55mm, 1/250 sec., f/8.0, 640

Figure 8-16: Cutting off edges in the frame makes the image look more vital and active.

Food subjects with an edge or two (or three) cut off in the frame tend to look a little more vital and more active than those subjects with no edges cut off.

Drawing Your Viewer in with Leading Lines

Leading lines are lines in an image — from the napkins, patterns, textures, papers, or the food itself — that draw the viewer's eye directly to the food subject. When using leading lines, make sure the point of the subject you're leading into looks interesting and is in focus.

Leading lines can be anything that leads your eye to the focal point of the food. These lines visually create a path the user can follow to find the main story of an image. In Figure 8-17, two delicious little pieces of bruschetta on a plate provide the leading lines for this image. The front bread is angled and draws your eye into the most interesting part of the image, where the tomatoes and herbs are nicely in focus.

TIP

Although leading lines are tools that help with the narrative of the composition, they do need to be positioned in a graphically pleasing way. These lines should be positioned slightly askew, not at a 90 degree angle to either side of the image.

55mm, 1/100 sec., f/5.6, 640

Figure 8-17: Leading lines draw your attention to the focal point of the food.

Using Graphic Components in Composition

Graphic components, such as shapes and patterns, can pull your image together. When composing your photographs, be sure to consider these elements. I discuss shapes and patterns and how they can complement your photos in the following sections.

Patterns

Patterns on props are good graphic elements when used in moderation. One, or maybe two, complementary pattern is probably enough for any image. In

Figure 8-18, I illustrate a good use of a patterned cloth to complement the colors of the fresh blueberries on the table. The blue pattern is softly out of focus and fits the rustic feel of the image.

Bad things can happen when too many or conflicting patterns are used in an image! You want to carefully consider the subject of the photo and make sure any patterns you use complement the food, not contrast with it.

46mm, 1/25 sec., f/5.3, 640

Figure 8-18: Patterns complement the colors of a food subject.

Shapes

When shooting foods, round shapes or shapes with a lot of curves lend themselves fairly easily to the composition of great images. Some square foods, like bread, can be handled with ease as well.

Of course, not all food shapes are so easy to deal with. When working with thin straight foods, such as string beans, composition can get tricky. You can bend the beans into a somewhat curved composition. Or you can use these types of angled foods as leading lines into a focal point, which may be as simple as a topping on the far end of the food.

Someday, you may find yourself struggling to shoot a mixture of shapes that don't appear to go together at all. Maybe you're tasked with shooting skinny asparagus spears alongside whole giant eggplants with a glass of merlot on the side.

When shooting several different types of shapes for an image, take your time to physically position the foods and props into a pleasing group first, and then take a few test shots to check your work. Use distance, tilt, angle, and skew until you see an appealing image showing through your viewfinder.

9

Lighting, Lighting, Lighting

In This Chapter

▶ Discovering lighting options

▶ Figuring out how to arrange lights for a shoot

▶ Demystifying hand-held light meters

▶ Working with reflectors

*F*ood photography is all about the light. Sure, in this book I talk about many other aspects of shooting food, but the absolute core of what makes a good food photo is how well the food subject is lit. You can have the freshest produce and the most beautiful composition, but if the lighting isn't right, your image won't look its best.

When it comes to lighting, you have three basic options: natural lighting, *continuous* (or hot) *lighting* (lighting that stays on while you shoot), and *strobe lighting* (essentially an off-camera flash).

Many photographers don't stick to only one type of lighting. In fact, for a photographer to vary between using natural and strobe lighting or natural and continuous lighting is pretty common.

In this chapter, I discuss the different types of lighting setups and touch on where to place your lights to get the best results for your photos. I also explore the benefits of using a hand-held light meter and provide tips for controlling contrasts in your photos.

While I'm talking about light, I encourage you to avoid using your on-camera flash for food photography. Really. On-camera flash is great for some things, but food just isn't one of them.

Exploring the Beauty of Natural Light

It's true: I'm absolutely obsessed with natural light for food photography. Overall, I shoot a little more than half of my images using natural light and a little less than half using traditional lighting. I've heard of several amazing food photographers who shoot using only natural light.

When you use natural light, you can take an everyday subject, like the lowly burrito in Figure 9-1, and elevate it to a higher status.

70mm, 1/40 sec., f/9.0, 500

Figure 9-1: This burrito looks much more appealing in natural light.

Natural light provides a quality of light that can't be replicated. You can come very close with soft boxes (see the "Soft boxes" section later in this chapter), but natural light falling on a beautiful food subject in a shoot? Well, the results can take your breath away (as evidenced by Figure 9-2).

42mm, 1/20 sec., f/9.0, 320

Figure 9-2: The quality that natural light provides is difficult to replicate.

Natural light gets even better when you're shooting near water, as you can see in Figure 9-3. Water droplets in the air create a natural diffuser of the light. Coastal areas have such an exquisite natural light, but a river, lake, or canal can provide many of the same qualities.

Because natural light is unique to location, I always bring my digital SLR camera with me when I travel. Local foods are wonderful new food subjects, and I find that, when I can visit a locale near water, shooting au natural is so much better.

If you ever find yourself in Amsterdam or Paris, enjoy shooting in the most exquisite natural light I've ever seen (see Figure 9-4). I guess those old masters were really on to something.

55mm, 1/500 sec., f/5.6, 200

Figure 9-3: Natural lighting near a body of water looks exquisite.

35mm, 1/40 sec., f/4.5, 500

Figure 9-4: This simple bowl of cherries near a window captures gorgeous natural light.

Choosing Artificial Lights

Many different factors to consider when choosing artificial lights include portability, cost, and quality.

When it comes to hauling around your lighting setup for a shoot at a restaurant or a commercial kitchen, you want something easily manageable for one or two people. I have a few phenomenal large lights that I adore, but carting them around to different shoots can be a little much.

Today, I keep the uber-lights in the studio, but when on the road, I use a much smaller, more portable lighting setup. I get great results from the smaller lights, and I don't mangle my back by carrying big lights and stands.

As far as pricing, continuous lights start out as a less expensive option than a full strobe lighting setup (I discuss both options in the following sections). And, of course, you can't get much more reasonable — or portable, for that matter — than natural light (see preceding section).

Continuous lighting

The type of lighting setup you decide on comes down to personal preference, but I'm a huge fan of continuous lighting for food images. I find that continuous lighting is easier to deal with than strobe lighting. Having the lights set (and on) allows me to be secure in the knowledge that the lighting is handled, so I can focus on moving around the food subject itself. Using continuous lighting releases me from a large technical consideration so I can focus on the artistic composition.

When choosing a continuous lighting setup, you have a lot of lights and diffusers to choose from, which I outline in the following sections.

Halogen lights

Halogen lights produce a clear, warm light, which is great for food photography, and they're super useful in a studio setting. Halogen bulbs have a fairly long bulb life (about 350 hours or so).

Many brands of halogen lights and kits are available for purchase. They can be a little more expensive than other choices, but the quality of light is usually worth it.

Don't handle halogen bulbs with your bare hands. The oils from your fingers can interfere and affect the bulb itself, which can cause the bulb to eventually pop or burst when turned on. *Always* use gloves or a cloth when handling the bulbs. If you accidentally touch a halogen bulb with your fingers, you can use a small amount of rubbing alcohol to clean the oils off the bulb.

Tungsten balanced photoflood lights

Photoflood lights can be significantly cheaper than other studio lighting options, but they also run very hot to the touch, which can be a problem when shooting food in a studio. Your food will likely be affected by the large amount of heat generated by continuous photoflood lights.

The color of light from a tungsten bulb is a warmly hued light (leaning toward yellows and reds), although it can sometimes run just a bit too much on the warm side for my taste.

If you decide to go with a photoflood lighting setup, be aware that although the bulbs may be cheaper, you may have to replace them more often than other continuous light bulbs because they don't last very long (average bulb life is only 4 hours).

Fluorescent lights

Fluorescent photo bulbs (see Figure 9-5) have progressed to an advanced state these days. Gone are the days when fluorescent meant a noisy, blue-tinged, flickering light. Today, the light from the daylight temperature fluorescent bulbs produces a nice, accurate daylight color, which is really awesome for food photography.

You can also purchase fluorescent bulbs that have the color qualities of tungsten bulbs, should you prefer a warmer look for a specific food subject.

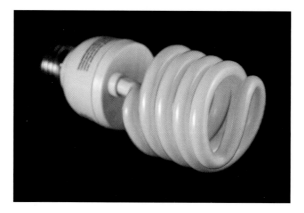

Figure 9-5: An advanced fluorescent photo bulb does away with the noisy, blue-tinged, flickering lights of the past.

Fluorescent bulbs have an excessively long bulb life; they can last up to 10,000 hours!

Diffusers and umbrellas

Whatever type of continuous lights you go with, you'll need some type of *diffuser* — an absolute must for food photography. As you may expect, a diffuser diffuses the light and provides a soft, even quality of light for your food subject.

Diffusers include traditional *scrims* (as I discuss in detail in Chapter 2), which are made of fire-retardant material or translucent plastic and are placed between the lights and your food subject. These diffusers can be part of a lighting kit, or they can stand alone, held in place by a stand, a clip, or an assistant.

For a different way to soften light, you can use one of two photographic umbrellas: a *bounce umbrella* and a *shoot-through umbrella*.

In a bounce umbrella setup, you use an umbrella that's dark on the outside and has reflective material on the inside. The umbrella attaches to the light stand, as shown in Figure 9-6. The bulb is pointed away from the subject and straight into the reflective material inside the umbrella. The light bounces off the reflective interior and provides a soft, diffused light that falls on the subject.

A shoot-through umbrella is similar to a scrim. It's basically a diffuser placed between a light and the food subject.

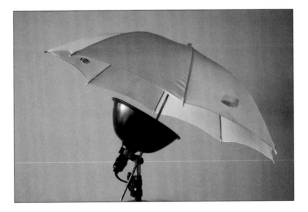

Figure 9-6: A bounce umbrella on a light provides a soft, diffused light.

Strobe lighting

Strobe lighting is a system of lighting that essentially acts like an off-camera flash (see Figure 9-7). The camera is synced with the lights via a sync cord, so when you press the shutter, the lights fire.

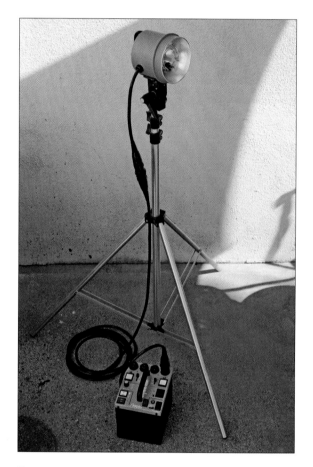

Figure 9-7: A strobe light setup acts like an off-camera flash.

Many photographers prefer strobe lighting for food photos. The primary benefit of strobe lighting is the lack of hot lights, so your food is far less affected by heat.

The cost of a strobe lighting system is generally a little more than a continuous lighting system, but some starter packs can be quite reasonable. You can opt for mono lights with the power pack present on the lights themselves or

lights with a separate power pack. Bulbs for strobe units can last a very, very long time, because they're used only when firing.

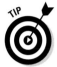

Set up your subject beforehand by using the *modeling light* — an incandescent light bulb within the strobe unit that remains on — so when the strobes fire, you know exactly what you're going to get. This light provides a general idea of where the light will fall on a food subject.

Soft boxes

Soft boxes (see Figure 9-8) are halogen, fluorescent, or tungsten lights contained within a flexible frame that can be used in both a continuous lighting and strobe lighting setup. The frame is covered with a flame-retardant material and anchored on a solid lighting stand.

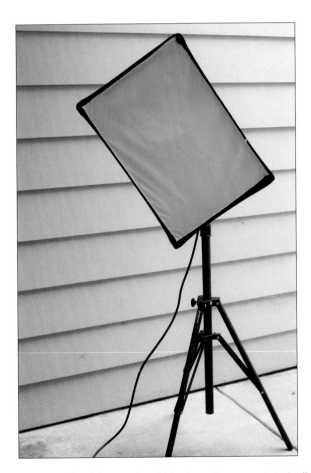

Figure 9-8: A soft box works with both continuous and strobe lighting setups.

Inside the frame is where the magic starts. The interior of a soft box has four or more walls surrounding the bulb(s). These walls are covered with a highly reflective aluminum-like material to bounce the light around. At the front of the enclosure is a diffuser made of a flame-retardant fabric. The bounced light shoots through the diffuser to create a truly awesome soft light for your photographs.

Soft boxes are available in many different sizes, from around 14 inches to around 6 feet across. They have one or more bulbs in the units, depending on the type and brand of soft box.

Soft box units replicate natural light but offer far more control for the photographer. You can position the lights to get exactly the right look for your foods, as opposed to natural light where you're at the whim of the elements.

The highlights from a soft box have a beautiful and light quality, as you can see in Figure 9-9.

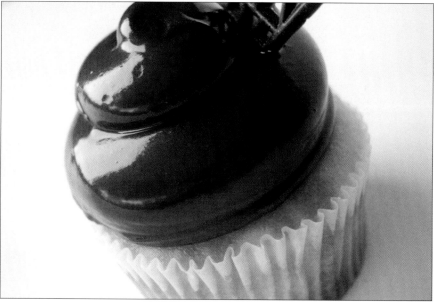

42mm, 1/50 sec., f/5.0, 400

Figure 9-9: Highlights from a soft box provide a close duplicate to natural lighting.

Another soft box lighting setup that's low cost and really works well for food photography is a Lowel Ego light (see Figure 9-10). This type of light isn't

your traditional soft box, but it's a fluorescent photo light (daylight color) enveloped in a sheath of diffused plastic, which provides an amazing soft light for food photographs.

The Lowel Ego light is lightweight and super portable and is a great option for smaller shoots. Figure 9-11 is an example.

Figure 9-10: A Lowel Ego light is a type of soft box.

Placing Lights for Your Setup

Placing lights in just the right spots is a key ingredient to a successful food image. If two of the very same lights are placed on either side of your subject, exactly the same distance away, you may get a flat and dull look in your image with no subtle highlights or shadows. Not so appetizing!

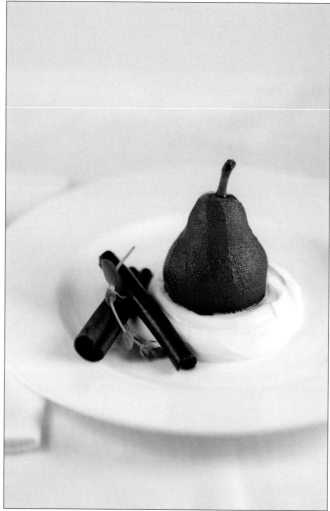

85mm, 1/1000 sec., f/2.0, 250

Figure 9-11: Lowel Ego lights are great for smaller shoots.

Knowing where to place lights for your shoot can really benefit the look and quality of your photos. Check out the following options:

✔ **Key light:** A *key light* is the main or principal light that provides the majority of light for your setup. I usually place the key light in front and to the side, making sure I get some good reflections in my highlights.

Using only a key light produces an image with intense light on one side and dark shadow on the other, which is a very dramatic look (see Figure 9-12). Although the look may be great for a portrait of Iggy Pop, it's rarely used in food photography because it's just a wee bit too contrasty.

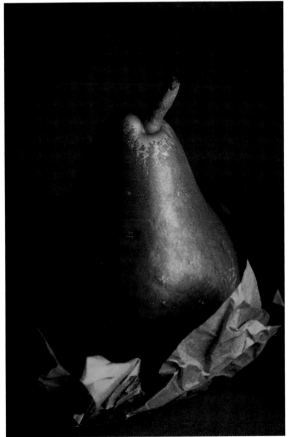

145mm, 1/60 sec., f/5.0, 500

Figure 9-12: Using only a key light creates a dramatic contrast.

- ✔ **Fill light:** A *fill light* is a light that's either lower wattage or placed farther away from the subject. The purpose of a fill light is to fill in and shape the light in a food subject. It's a secondary light that decreases and controls the contrast when shooting.

- ✔ **Back light:** A *back light* shoots across the very back of a setup. The back light provides a little smidge of light that allows a slight distinction between the subject and the background.

In Figure 9-13, I set up the one key light on the left of the quiche and had a reflector just a few inches away on the right. Some nice, subtle shadows show on the right, giving the image good depth and substance. But overall, the image isn't too contrasty. A nice balance exists between the areas of light and shadow.

55mm, 1/50 sec., f/5.6, 250

Figure 9-13: A key light on the left and a reflector on the right give this photo a good balance of light.

The setup in Figure 9-14 is a pretty common placement for lighting. The key light on the left is closer in and stronger, and the fill light on the right is farther back and more subtle.

Figure 9-14: This photo uses a key light set closer in and a fill light farther back.

In Figure 9-15, I added a small backlight shooting across the back of the scene. This backlight creates a slight separation of the subject and its background.

85mm, 1/100 sec., f/5.0, 200

Figure 9-15: Adding a subtle backlight provides slight separation of the subject and background.

Measuring Light with a Hand-Held Meter

A *hand-held light meter* (shown in Figure 9-16) is a small device that can accurately measure the light reflecting off or falling on the subject. Using a hand-held meter when shooting foods can help you get properly exposed images.

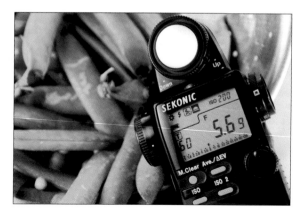

Figure 9-16: A hand-held light meter measures light reflecting off and falling on a subject.

Some people are unfamiliar with or intimated by a hand-held meter. I confess: I was in the latter category for quite some time. (I blame that on an embarrassing event suffered in film school!) Well, it turns out, working with a hand-held light meter isn't so scary after all. And if you need that precise level of accuracy for a shoot, it can be a most important addition to your photo gear.

In the following sections, I describe different types of hand-held light meters and their specific uses.

Types of meters, including the one built in your camera

Light meters come in various brands and types, and, depending on the model, they can measure light in three ways: *reflective, incident,* and *spot.*

Reflective metering measures the light reflected off your subject. Incident metering measures the light falling onto your subject. Spot metering (using reflected light) allows you to pinpoint very small areas in your subject to take exacting measurements.

So why should you use a hand-held light meter? Even though most cameras generally have an onboard, through-the-lens light meter, a hand-held light meter is better. Provided you're not shooting completely manually, the internal metering system takes an average of the light values reflected off

the subject you're shooting. In other words, it takes an averaged *reflective* reading, which is often okay but can provide difficulties when, say, shooting a dark-colored food subject on an all-white background or the like. The internal meter averages things out, and the results can be less than great, such as an unattractive cast to the image.

Best meter for food photography

For food, I suggest using an incident meter. Incident metering refers to measuring the light falling onto your subject rather than the light reflecting off your subject. It works by using the little globelike *photosphere* at the top of the device (refer to Figure 9-17).

After you enter your ISO/ASA into the device, you can start to meter the food subject. To measure the incident light, you place the meter right next to the subject, as you see in Figure 9-17. Measure the light falling onto your subject by facing the globe (actually a light-sensitive cell) away from the subject and toward your camera. Read the information from the light meter, adjust your settings, and voilà! A richer, more accurately exposed image is yours to enjoy.

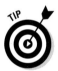

If you're using strobe lighting (flash mode) you can connect the light meter to the strobe unit with a sync cord for handy access.

Managing Highlights and Shadows

Working with highlights and shadows in your images can be a somewhat challenging task. The first step is to just be aware of the issues when you take test shots or check your shots. If you see a highlight that's just a little too glaring or notice a far-too-dark shadow, you know where some potential problems lie in your setup.

Sometimes your image may need a small boost of light somewhere in a food subject. Maybe the highlight on the front scallop needs a little extra *oomph* to look super mouthwatering. A subject that needs a lighting boost is a fairly common issue to encounter when shooting food.

Reflectors and diffusers are one great way to handle these types of problems when shooting, as I discuss in the following sections. A variety of reflective solutions are on the market, and I explore a few of my favorites.

Creating and toning down contrast

Contrast is typically defined as the difference between the levels of blacks and the levels of whites in an image. *High contrast,* in this context, means rich blacks and bright whites with very little grays in between. *Low contrast* is the opposite, with various medium grays, but little-to-no pure blacks or whites.

Color contrast is the difference between two or more saturated colors — the more opposite, the better. Think pink guava ice cream shot in front of a bright green background. Now that's a popping image!

You can also have a combination of these contrast types, such as bright red raspberries on a pure white plate.

Absolutely nothing is wrong with high contrast in any form, but sometimes, high-contrast images can read a little on the unappetizing side in food photography. If you want to tone down the contrast in your food subject a bit, try the following solutions:

- ✔ **If whites are too white:** If you're losing the details in some of your whites, aim a dark or black reflector at your subject to subtly tone down the whites and release some of the details.

- ✔ **If shadows are too dark:** If your lighting setup is creating deep, dark shadows, bring a white reflector in closer to soften the shadows and make them less contrasty. A fill light brought in closer can also help if a reflector isn't enough to counteract the shadows.

- ✔ **If colors seems overly saturated:** Diffuse, diffuse, diffuse. Place an additional scrim between your lights and the subject to soften and tone down the subject.

- ✔ **If your images seem over- or underexposed:** If your exposure is causing problems with contrast, adjust your exposure by modifying your ISO, aperture, and/or shutter speed.

If you overlook some contrast issues while shooting, rest assured that you can adjust the contrast a little during postproduction. See Chapter 12 for tips on modifying the contrast of images with Photoshop.

Playing with light using reflectors

So you have your key light and fill light set, but you notice that the very front of your scene is just a bit too dark. What to do? You can grab a reflector and aim it at the food subject to provide a little more light to that too dark area.

Reflectors come in a variety of sizes, materials, and colors. The job of a light-colored reflector in food photography is to reflect, or bounce, some light

onto the food subject. Doing so creates a nice, diffused light that can brighten things up as needed, as well as decrease contrast.

The closer a reflector comes to your food subject, the lower the contrast. If you have a distinct shadow in your subject, you can easily see this concept at work. Take a white paper or card and keep your eye on the shadow as you move the white card closer to the subject and then farther away. When farther away, the shadow is more distinct and higher in contrast. When closer in, the shadow is less distinct with less contrast.

The following sections describe a few of the basic types of reflectors available today.

Bounce cards

Good, old-fashioned bounce cards are typically made of cardboard or foam core. They can come in any color but are generally used in this way: White cards add a little more light into a scene, and black cards take away a little brightness and add a little depth and dimension to a subject that's photographing too light. A black or dark gray card can provide subtle lowlights that can bring out nuances of whipped cream swirls, frosting, or the like.

Pop-up or collapsible reflectors

These reflectors are circles of material with a stiff yet flexible outside rim. They open for use and then collapse down to fit in a much smaller carrying case. The pop-up reflectors are based on the same concept of pop-up tents.

Pop-up and collapsible reflectors come in a range of sizes from a variety of manufacturers. I use some cool small reflectors that are only about a foot in diameter. They're really handy little tools that are just the right size for shooting food.

- **Black reflectors:** Black reflectors can help you control the light when you're having trouble distinguishing details in a very light subject. A black reflector tones down the lightness just a bit so you can see those elusive details.

- **Silver reflectors:** Silver reflectors provide a nice light, but they can be a little contrasty. They'll certainly reflect light back onto your subject, but it may not be the very best look for your food.

- **Soft gold reflectors:** These reflectors provide a warm light that can enhance the look of a food subject. They're really suitable for some foods (particularly comfort foods), but soft gold isn't an appropriate look for every food.

- **White reflectors:** These reflectors, like the one in Figure 9-17, are the most useful for food photography. They provide a diffused, even light for your subjects.

Figure 9-17: A small, 12-inch white reflector.

If you don't have an assistant to hold a collapsible reflector, you can get a stand or holder with telescopic arms that can secure the reflector for you. And if you don't have a stand handy? Well, there's always duct tape!

Folding the collapsible reflectors back into their carrying case can be a little off-putting at first. Essentially, you have to grab both sides of the circle; the key is to twist forward with one hand while you twist backward with the other. Keep the twist as you bring your hands closer together, and then just fold the reflector onto itself and voilà — it collapses to about ⅓ of its expanded size and fits right into the carrying case. Now, just don't get me near any pop-up tents . . .

Mirrors

Some folks swear by using mirrors as reflectors. When using a mirror, sure, light is reflected back onto the scene, but unlike a card or pop-up reflector, mirrors don't provide any lessening of the contrast. A mirror can be another source of light but rather strong and undiffused. However, if you aim the mirror directly at a diffuser, you get a diffused light reflecting back.

You can spray the mirror with hair spray to provide a touch of diffusion for the reflected light.

Aluminum foil

As I mention in Chapter 6, you can use aluminum foil as a reflector as well. Wrinkle it up and use the duller side for the reflector. This option can be a little bit contrasty, but it works pretty well in a pinch.

10

Working with Tilts and Angles

In This Chapter

▶ Matching angles to your food subjects
▶ Using tilts to make your images more interesting

What makes one food photograph better than another? Many elements come in to play in an image, such as lighting, sets, focus, styling, and so on, but one of the key factors in a great photograph is the angle at which the food is shot.

How you approach the food with your camera is every bit as important as how it's lit and how backgrounds and props are used. The angle and tilt of your approach truly affects how your image is perceived.

In this chapter, I introduce a few angles that give you the look you're going for, whether it be head-on, slightly up and over, or directly above the subject. I also discuss how to tilt the camera to provide the right approach to the food that draws viewers in.

Understanding the Angle of Approach

To understand the *angle of approach,* think about how a tripod works. The up and down tilt of a tripod head loosely translates to the up and down motion of your neck. Couple this with a little lean in over your subject, and you have your angle of approach over your food. Your eye, camera, and body tilt up and down as you shoot different angles of your food. You can see some angles of approach depicted in Figure 10-1.

Although perhaps a bit surprising, the angle of approach in a food image is directly related to the perceived yumminess of that image. The human brain responds most positively to seeing food approached from just up and over the subject. Why is that? Most likely, it has to do with our actual angle of view when we sit down at a table to eat.

No bad angles exist in food photography, but you quickly find that some angles look far more appetizing than others. This varies from food to food, so trying multiple angles for a shot is always a good idea.

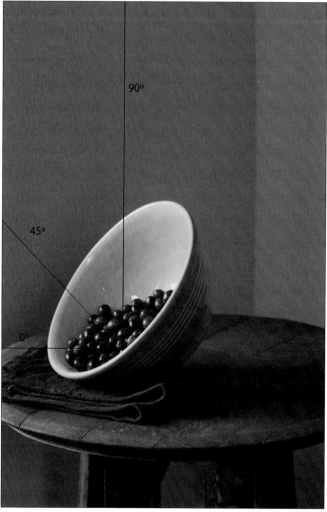

85mm, 1/30 sec., f/5.6, 400

Figure 10-1: Different angles of approach affect the yum factor.

In order to create delicious images for your portfolio, you need to understand the angle of approach by listening to your gut (literally and figuratively). Often your eyes and your stomach can tell you whether an angle is appetizing. If the angle of the food image doesn't draw you in and have you begging for a bite, try a different one.

Although I use degrees to describe various angles, keep in mind that they're general guidelines to start from. No need for strict adherence, no need to get caught up in the degrees; you just need to be in the general ballpark.

To understand how angles impact your photos, set up a food subject on a table and experiment with shooting various up-and-over angles in the mid-range. Go ahead: Play with your food! Try some shots from overhead as well. View the images as you go by using the LCD monitor on your camera. Note how some angles look strikingly different and much better than others.

You can get a better playback view by hooking your camera up to a larger screen. Connect your camera's AV cable to a television set or computer monitor. When you press playback on your camera, it shows the images on the TV monitor, rather than on your camera. I find that viewing images on a monitor as you shoot is much clearer than simply looking at the camera's LCD. I go into detail about using this playback method when I talk about editing in Chapter 13.

Trust your gut instincts when viewing your images. If a particular angle looks really outstanding to you, you've probably got a successful photograph for your portfolio.

The following sections walk you through the various camera angles you can use to approach your food subject.

Eye-level angle — 0 degrees

An *eye-level* angle — a baseline or snail's-eye view — can be an interesting perspective, but it's completely dependent on the subject. Generally speaking, a very low angle doesn't make for the most appetizing food images. But with close-up images, an eye-level angle can sometimes work, particularly with taller, vertical subjects.

Another cool way to use the eye-level angle is to shoot a food that looks super interesting and delicious from the side. I've shot some extraordinary foods this way, focusing on what I think is the most interesting part of the image.

When it works, an eye-level angle is a wonderful, intimate look for a food (see Figure 10-2). When it doesn't work, the viewer is left in the lurch, wanting to see what's up higher.

38mm, 1/50 sec., f/4.8, 400

Figure 10-2: An eye-level shot creates an intimate look.

Just-above angle — 5 to 20 degrees

Shooting just above, or between 5 and 20 degrees, means positioning the camera just slightly above the horizon line (check out Figure 10-3). This angle is an interesting approach that can work well with, say, a close-up shot of smaller foods, but it may or may not do the food justice. A successful image that uses the just-above angle is dependent on the subject and many other factors, such as distance from the camera lens. In some cases, this approach may not be a high enough angle to satisfy the eye (or stomach) of the viewer.

Up-and-over angle — around 20 to 45 degrees

The *up-and-over* angle — around 20 to 45 degrees or so — is generally considered the most appetizing angle, with the directly overhead angle (covered in the next section) as runner-up.

42mm, 1/320 sec., f/5.0, 400

Figure 10-3: Camera angled just above the food works well for some small food subjects.

The angle range of the up-and-over angle really is the sweet spot for food photography. A slightly elevated angle makes the food look delicious and inviting, as you can see in Figure 10-4. This angle is close to how you see food in the middle of the table ready to be served. Hopefully, the angle in the image makes you want to grab a serving spoon and dig in. Coming in for landing! Nom!

The up-and-over angle of approach is also particularly appropriate for *selective focus* images, in which a selected foreground portion of an image is in focus, but the background is quite soft.

Figure 10-5 shows an image that uses an elevated angle approached from the side for a pleasing composition. Selective focus is also in play here, with the focus being on the front area of the lobster roll and the back area of the roll and the background falling slightly out of focus. (I go into depth about focus issues in Chapter 11.)

55mm, 1/200 sec., f/7.1, 400

Figure 10-4: The 45 degree angle in this shot invites you in for a bite.

42mm, 1/20 sec., f/5.6, 400

Figure 10-5: Selective focus brings your attention to the foreground — in this case, the lobster roll.

Overhead angle — 90 degrees

The 90 degree angle is getting a little more popular in the food world these days. It generally doesn't lend itself to the softer, selective focus look, but it's a great alternative look for images and can provide an interesting angle to display certain dishes, like the one in Figure 10-6.

27mm, 1/60 sec., f/5.6, 400

Figure 10-6: Using an overhead angle provides a sense of design to food images.

When shooting from directly overhead, the top of the food is generally all in focus if it's on the same plane. This angle is often more about design than making the food look super delicious, although I've seen some absolutely scrumptious photos shot from overhead.

Sometimes the overhead look is better suited to a tableau, where a large number of elements are in the composition. The angle may not be appropriate for one lone peanut butter sandwich shot from overhead, but it's a great option for a grouping of foods, such as a large dish of pasta with cheese, fresh basil, and maybe a little salad on the side.

Because of the focal plane, be aware that the backgrounds show much more in an overhead shot than in a 20 to 45 degree angle shot. So you may as well use something interesting for your background. Lately, I've become rather partial to old, painted wood boards because they lend such character to a photo, but many options are available, as I discuss in Chapter 3.

Tackling unusual angles for a different look and feel

Using any of the angles mentioned in the previous sections can provide a different look and feel for your images. The key is to play around with the different angles and then focus in on the food. I narrow in on two angles that provide contrasting looks in the following sections.

Shooting at eye-level for fierce food focus

Shooting an eye-level angle from the baseline can be an appealing look for dishes on the tall side because this angle focuses on the height of the subject. Along those lines, stacks of foods look approachable and inviting with the eye-level model. A tall tower of sandwiches, savory stacks of tomato, basil, and mozzarella, or a pillar of cookies are examples that work well with this camera angle.

You may also consider using this angle for foods that are a little more interesting from the side than the top, such as a slice of berry pie. Focus on the front-most area of the food, or just beyond, and see how it looks for your food subject. This view can create an intimate mood for a food, akin to the food porn look that I discuss in Chapter 11.

In Figure 10-7, the focus is on the main subject, the stack of cookies, with the milk set far behind as a secondary part of the story. Your eye is drawn directly to the cookies, and the angle works well in this vertical context.

With an eye-level angle, you want to stay away from low-plated dishes because you can't get a proper sense of the food. With this angle, you may not even be able to see the food peek over the edge of the plate.

Elevating the eye for an enticing image

When shooting at an angle that's a smidge more elevated, around 5 to 20 degrees, you may want to remain close in to the subject. Although not a perfect look for every food, using a camera angle that's slightly above eye level when working with close-ups of smaller foods can really work for some food photographs.

Because this angle lends itself toward getting in close to a smaller food subject, you may want to use a slightly wide to normal lens to capture the image. Doing so allows more delicious real estate to show in your food photo than if you use a longer lens.

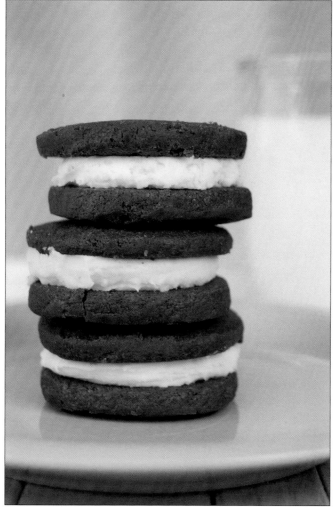

52mm, 1/40 sec., f/5.6, 200

Figure 10-7: Cookies are the focus of this eye-level shot.

In Figure 10-8, the up-and-over angle allows focus on the most interesting part of the cream puffs — the amazing swirling goodness of the cream filling.

As a food photographer, you have choices to make when shooting your foods. Choosing angles that show off your food subject in the best way possible is all part of the fun. Each food shoot is different, so you must determine what works best for your foods in the given setup.

48mm, 1/100 sec., f/5.3, 400

Figure 10-8: The up-and-over angle provides enough elevation to see all the yummy goodness of the food subject.

Working with Tilts to Spice up Your Subject

Tilting the camera from left to right is an extremely important factor in food photography. A tilt skewed slightly toward the viewer invites him in. A tilt away is also intriguing, drawing the viewer in and inviting the eye to follow the food subject. Figure 10-9 says, "Follow me down the path of deliciousness!"

When shooting, notice that as you tilt you camera to the right, the image of your food subject tilts to the left. A tilt shifts the horizon line, so stay aware of how the tilt affects your overall image. Consciously using tilts takes a little getting used to, so check your work often.

Because you see the food tilted toward you in Figure 10-10, the food in the image looks like it's being presented to you. The story behind the image is, "Hey, look at me! Look how beautiful my colors and shapes are." Okay, I'll just say it. This is kind of a glamour shot for food.

42mm, 1/60 sec., f/5, 400

Figure 10-9: Luscious red velvet cupcakes tilt away from the camera

40mm, 1/4 sec., f/2.0, 100

Figure 10-10: A tilt toward the camera presents the food to the viewer.

Sometimes a straight horizontal shot with zero tilt is fine, as you can see in Figure 10-11. Having no tilt is perfectly appropriate in some cases, and you may find that some clients prefer this look. However, when you're not bound to any client requirements, you can use tilts to really increase the appeal of an image.

For each food subject you shoot, make a conscious effort to try as many tilts as possible. Shoot a few frames with a flat horizon line to start because sometimes that's the right look for the shot, and the level image provides a good baseline. Next, look through the viewfinder and start shooting while tilting very slightly to the left and right, then move to a slightly larger tilt left and right, and then gradually move to a really large left to right tilt (see the sequence in Figure 10-12). All the while, be mindful of what you see in the viewfinder and keep your eye on the composition!

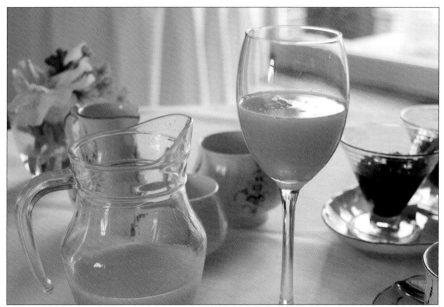

32mm, 1/25 sec., f/4.5, 400

Figure 10-11: Use zero tilt for a straight-on look.

I typically shoot as many as 30 or 40 (or more!) tilted versions of one dish. I shoot *a lot* at each shoot because, first, it increases the possibility of multiple good shots, and, second, I'm just really curious to explore the subject from every possible tilt.

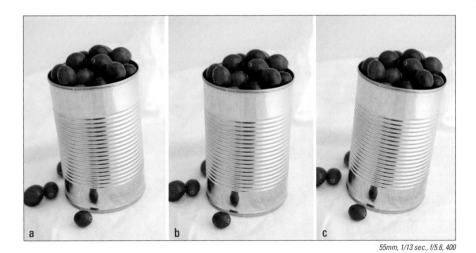

<div align="right">*55mm, 1/13 sec., f/5.6, 400*</div>

Figure 10-12: A tilt sequence going from a tilt left (a) to a nearly zero tilt (b) to a tilt right (c).

Pulling It All Together

Combining all the geometric factors — angle of approach and tilt — can make for one delicious image (see Figure 10-13), but getting there takes work and flexibility.

Photographing food is a very active experience. When at a shoot, I'm generally not sitting at a tripod, waiting for just the right moment to occur so I can capture a perfect image; shooting food is a little messier than that. I'm moving my body around — left, right, up, down, and sideways — to shoot every possible tilt and angle combination that may look right for a specific subject.

As I mention in Chapter 2, tripods can be a bit tricky when shooting food. Although some situations may work with a tripod — perhaps a large tableau or an eye-level image in low light — being tethered to a tripod can be a bit limiting for exploring tilts and angles.

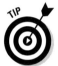

If you need a little something to anchor you while shooting, try a *monopod* —a one-legged metal camera support. A monopod provides added stability while shooting, but you can still be agile and try out many of the tilts and angles in your repertoire.

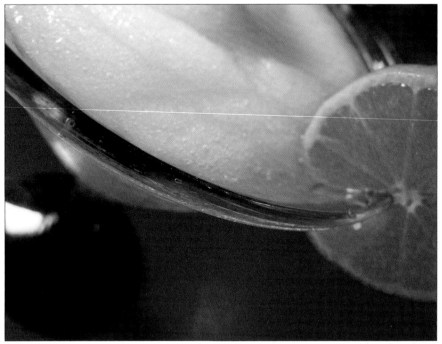

40mm, 1/8 sec., f/2.8, 100

Figure 10-13: Combining just the right angle with the perfect tilt creates a look that's almost good enough to eat — or drink.

Exploring Focus

*I*n food photography, the area of the food subject where you decide to focus really sets the tone for the look of the overall image. You can use *selective focus* and have one small area of the image in focus, or you can use *deep focus* and have close to the whole thing in an acceptable focal range. Or a third option is to use *soft focus,* where the subject isn't crisply in focus, thus creating a dreamy look. When you shoot food, many other factors are involved, but how you use focus in your images is key to how your images are ultimately perceived.

In this chapter, I describe the various focus types and explain *depth of field* — essentially the range of distance in focus within a given shot. Depth of field is a fairly simple concept that can be tricky for some photographers to grasp, but I make it easy to understand.

I also talk about a couple of current looks in food photography that rely on specific types of focus. First, and most notorious (but fun!) is the *food porn* look, which calls upon selective focus, among other factors, to make a delicious-looking image (see Figure 11-1). And to counter, in between selective focus and deep focus lies what I call the *crisp and clean* look. This style has more of the image in focus than a selective focus shot and less than a deep focus shot. It's essentially a happy medium.

A lot of style options are available when it comes to focusing on your food subjects. I encourage you to experiment with focus as much as possible. How you choose to approach a given shot can really affect the look of the final image.

55mm, 1/20 sec., f/5.6, 500

Figure 11-1: The focus in this image is on the front-most subject: candied oranges.

Focusing on the Point of Interest

Of the different focus models typically used for food photography, selective focus is one of the primary looks these days. As you can see in Figure 11-2, the look draws the viewer's eye directly to the very point of the subject that the photographer deems most interesting.

Deep focus is the look in which all, or nearly all, the image is in focus. Although deep focus isn't used quite as much as other focus models, it can look quite nice for your shots under certain circumstances.

When you're going for a soft and dreamy look for a dish, allover soft focus is the way to go. Ethereal images can really fit well with some food subjects, although you have to choose your subject well. Soft focus probably isn't the right look for a hefty platter of pork chops, but you never know!

In the following sections, I delve deeper into these three focus models and provide ways to achieve the look you want, whether for a client, blog, or stock.

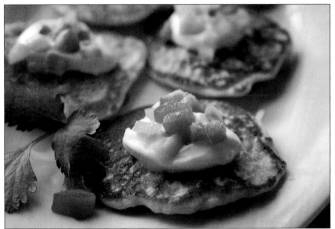

38mm, 1/60 sec., f/5.6, 400

Figure 11-2: Selective focus draws the viewer's eye to a specific point.

Selective focus

The popular trend in food photography these days is using selective focus, which allows the chosen focal area to *pop,* or stand out (see Figure 11-3). This focus model nicely separates the area that's in focus from the blurry background or foreground. We can thank Martha Stewart and her minions for making this style so popular.

45mm, 1/50 sec., f/5.6, 400

Figure 11-3: Selective focus on these peppermint candies makes them pop.

If you're shooting for a client who makes a particular food product, selective focus is one way to make your client's product really shine. You can have a crisp focus on the client's product and let the other portions of the image fall out of focus for a nice blur of color in the background.

When shooting for stock or your blog, you generally have complete flexibility with how you shoot your subject. For these photos, choose an area of the dish that looks super appetizing. Then, use selective focus to really center in on that most interesting part of a subject, such as the juices of a seared scallop, or a drop of water on an apple, or that amazingly curly noodle smack dab in the middle of a plate of pasta.

If your image has a nice highlight, such as a white glowing highlight from a tomato or the glistening shine of a mushroom sauce on a steak, capture that sucker! Use your camera's focusing mechanism to focus directly on that shine, as I did in Figure 11-4. Creating sharp focus on a highlight can really enhance the look of a food image.

You may decide to have a larger portion of a dish in focus and just *blow out* (blur) the background. Blowing out the background (and even the foreground) is pretty typical for the glossy magazine look these days.

Technically speaking, you have a few things to consider when shooting with selective focus:

- ✔ **Amount of light:** For more control when shooting selective focus, switch your camera to aperture or manual mode. Select a smaller numbered aperture (which provides more light) somewhere in the f/1.x to f/5.6 range. You need a fast shutter speed as well for this technique.

- ✔ **Distance:** The distance of the items in your image plays a big part of the look. Items placed farther back in the image display as just a hint or a suggestion of the actual item (refer to Figure 11-1).

- ✔ **Lens length:** A slightly longer lens is the easier way to achieve this look. Normal lenses are useable as well. A wide angle lens isn't optimal in this case because it lends itself to having more of the frame in focus.

Deep focus

When you need to have much of the entire image appear in focus, the deep focus model is the one you want, as shown in Figure 11-5. Honestly, this look is a slightly older aesthetic — food photography in the 1970s and 1980s relied heavily on it — but sometimes that's just what your client prefers. And you know your client is always right!

48mm, 1/20 sec., f/5.6, 640

Figure 11-4: Use selective focus to capture highlights on a food subject.

Figure 11-5 feels a little uncomfortable to me. Why? Perhaps it's too real, it doesn't tell a story, or it's just a record of a moment in time. The image is a little boring from my perspective. This image could be made stronger by moving to a selective focus model and focusing solely on the middle of the chowder.

Shooting directly over your food with a 90 degree angle can facilitate a cool use of deep focus, as seen in Figure 11-6. Here, much of the corn salad is in focus, but the shot doesn't look at all boring from this angle. If you're not

using a 90 degree angle, you can achieve deep focus by using a higher num-bered aperture (such as f/8 or higher). (Check out Chapter 10 for more on shooting with angles.)

85mm, 1/30 sec., f/5.6, 200

Figure 11-5: Use deep focus for a slightly older aesthetic.

Soft focus

Allover soft focus is another choice that may be appropriate for some images. When you (or your client) are aiming for a dreamy food image, con-sider using soft focus with perhaps a pastel color palette. (See Figure 11-7.)

85mm, 1/80 sec., f/3.5, 200

Figure 11-6: Deep focus shot from 90 degrees provides a fresher look.

Soft focus isn't a flaw or an error; it's an intentional style appropriate for some food images, the more glamorous the better. Soft focus is generally geared toward images used for stock photos or blogs because the subject isn't crisply in focus, but some advertising clients prefer this look as well. It just depends on the artistic look they're going for at the time.

You can achieve a soft focus look in many ways, including the following:

- ✔ **Adding a diffusion filter:** You can screw a soft focus filter onto your camera lens. These filters are readily available for purchase in several different grades of softness.

- ✔ **Coating a UV filter:** For a do-it-yourself option, rub an extremely tiny amount of petroleum jelly onto a UV filter. Another trick is to spray a slight layer of hair spray onto a filter. The tiny beads of hair spray act as a great homemade diffuser.

- ✔ **Using a nylon stocking:** You can shoot through a bit of stretched nylon stocking to diffuse the image. This technique may be a little unsightly, but it works like a champ!

Any of these options will do the trick, but if you're able to manually adjust the focus on your lens, using your focus ring to get the desired effect is just as easy. Keep it simple whenever possible!

52mm, 1/6 sec., f/5.6, 200

Figure 11-7: Using soft focus creates a dreamy look.

Understanding Depth of Field

Depth of field is a basic premise of photography. It's the range of distance that's in focus within a given shot. In other words, depth of field is the distance from the closest point to your eye that appears in focus to the farthest point away from your eye that still seems to be in focus.

A *shallow depth of field* has only a small distance range in focus. Figure 11-8 illustrates a shallow depth of field via a row of nectarines. The depth of field range starts just in front of the first nectarine and ends very close to the stem of the fruit.

Does this concept sound familiar? A shallow, or limited, depth of field is the same general idea as selective focus (see the earlier section on selective focus).

If you want to increase the separation between the subject that's in focus and the background that isn't, use a longer lens. Basically, a longer lens helps get the background a bit more blurred out to make the subject in the focus area even more distinct.

Figure 11-9 has a much greater depth of field — a much greater area of the image is in focus. How much of the field of view is in focus affects the look and feel of the photo.

In the next sections, I explore the part that aperture plays in controlling depth of field.

Adjusting aperture

Focal control is primarily affected by the aperture (f-stop) setting on your camera (and your focusing mechanism, of course). Because *aperture* regulates the amount of light that falls on your camera's sensor, it affects what will be in focus. For example, a wide open shot, such as f/2.8, allows the maximum amount of light to fall on your camera sensor. This wide open shot, coupled with a fast shutter speed, provides a narrow depth of field. The subject is in focus, but the background is blurred.

Increasing your aperture number, or *stopping down* your lens, decreases the amount of light that falls on your image sensor. A bigger aperture, such as f/9, has a much greater depth of field, and much more of the image is in focus, as illustrated in Figure 11-9.

Controlling focus in your images

These days, many photographers use the program or auto mode on their cameras to automatically set the aperture and shutter speed for a photo. Using these modes is extremely handy when shooting and produces some lovely, properly exposed images. The downside to this approach is that you don't have as much control of your focus area as you may want. In food photography, having this control is so important because you may need to create a specific look or focus on a specific area of a dish for your client.

40mm, 1/30 sec., f/5.0, 400

Figure 11-8: A shallow depth of field focuses on a shorter distance.

42mm, 1/4 sec., f/9.0, 400

Figure 11-9: Greater depth of field broadens the focus of the image.

To get greater control of your focus, switch your camera's shooting mode to aperture priority mode, which allows you to select the aperture manually and wrestle focus issues to the ground.

More light = lower f-stop number = tends toward a shallow depth of field, or selective focus. Less light = higher f-stop number = tends toward deep focus (greater depth of field).

Considering the "Food Porn" Look

Although this look may be called food porn, don't fear: It's actually rated PG. A million different ideas exist about what food porn really is. To me, *food porn* means a delicious-looking image with a crisp focus on a very sensuous part of the image. That focus can be on a drip, a tear, or something that makes viewers catch their breath.

Food porn images lean toward messiness and imperfections. They're generally not too tidy or orderly.

Another part of the food porn look is abundance, as you can see in Figure 11-10. For this look, the image should have a large amount of food, topping, or sauce. This is a great way to indulge your inner hedonist!

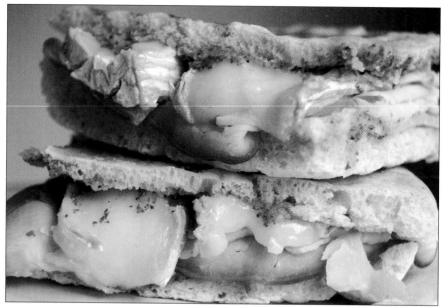

48mm, 1/15 sec., f/5.3, 400

Figure 11-10: The abundance of gooey, melted cheese in this image fits with the food porn look.

Although it's not an absolute necessity for a food porn shot, an awful lot of food porn images are taken of extremely high calorie foods (see Figure 11-11). This look is appealing to many of us who seem to be on perpetual diets. We're living vicariously through food porn images!

In the next sections, I explore what creating food porn images is all about — believe it or not, it's not *all* about the food.

Nailing down the technical aspects of the look

What does it take to create a luscious food porn image? Technically speaking, several elements come in to play. To achieve the food porn look for your images, keep these factors in mind:

 ✔ **Distance:** You want to be up close and very, very personal for food porn images. Get in as close as you're able to because you want a really intimate view of the food.

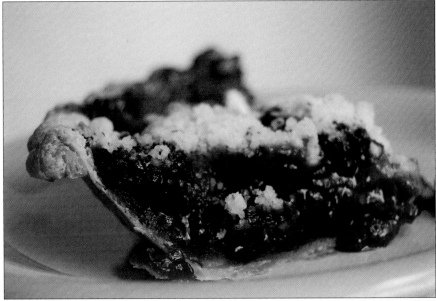

48mm, 1/60 sec., f/5.3, 500

Figure 11-11: Food porn often means high calorie foods.

- ✔ **Focus:** Definitely use selective focus for food porn images. That means a wider aperture (smaller f-stop number) and a fast shutter speed. Focus on the area that really stands out in the food, and let the foreground and background blur out.

- ✔ **Lenses:** Because this look uses the selective focus model, a normal to long lens is best.

- ✔ **Lighting:** Set up a diffused lighting scheme. Perhaps some soft boxes, small diffused florescent lights, or even natural light. If you use a strobe, be sure to use a diffuser or a scrim. If you have a nice shiny area, manipulate your lights until you get a lovely highlight on the shine. That highlight is the perfect place to focus on for this type of shot, as in Figure 11-11. (For more lighting tips, check out Chapter 9.)

- ✔ **Sets and props:** Sets and props aren't as important in food porn shots as they are in other types of shots because these images are very close-up. With that said, however, the background, plate, or other prop that does show should fit in well with the subject. In Figure 11-12, the cookies are photographed on plain, wrinkled brown paper, which seems to fit the look pretty well.

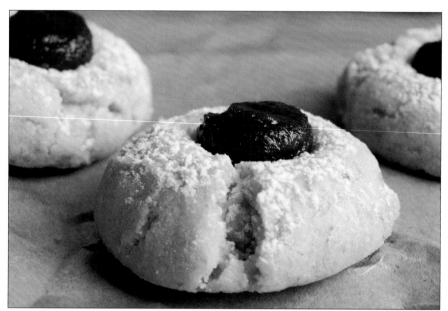

55mm, 1/8 sec., f/14, 200

Figure 11-12: These cookies are shot on a background that doesn't stand out, making the food the star.

Playing with the creative aspects of food porn

The intent of a food porn image is to make the viewer hungry. Really hungry! To achieve this look, start with a generous amount of delicious food. The subject should be lavish or overstuffed. The color of your subject should be rich and saturated if at all possible. (Subtle colors may not translate as well with this technique.)

Because food porn shots are fairly close-up, the set and props can be minimal but they should be interesting and fit in well with the subject.

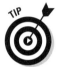

In Chapter 6, I talk about capturing drips. Food porn is the perfect look to embrace that thought and go over the top with dripping, melting goo. As you can see in Figure 11-13, a good subject may include dripping syrup, dripping chocolate, dripping sauce — dripping anything!

While shooting in close, try some varying tilts and angles. The approach you choose can really make the food images appear more interesting to your viewer. See Chapter 10 for ideas on different approaches and angles.

Now go on out there and play with your food!

55mm, 1/20 sec., f/5.6, 500

Figure 11-13: A molten lava cake, with all its melting goodness, is the perfect subject for a food porn image.

Going for Crisp and Clean

Somewhere in the middle, between selective focus and deep focus, lies a look I call *crisp and clean*. This type of image has most of the subject (not just a small portion) in acceptable focus, with the background just slightly out of focus. It's a nice look that's very popular for food photography. I use this look in Figure 11-14.

The approach to the crisp and clean look isn't quite as specific as the food porn look. It's a very commercial look that sells well in the stock photo world and is popular with some advertising and packaging clients as well.

55mm, 1/15 sec., f/5.6, 500

Figure 11-14: The crisp and clean look keeps most of the subject in focus.

For the crisp and clean look, choose an aperture in the midrange, around f/5.6 to f/8. That really is the only specific factor for a crisp and clean shot. All other factors, such as subject, color, distance, angles, props, and sets, are up to you.

Part IV

And for Dessert: Managing Your Photos and More

The 5th Wave By Rich Tennant

Smell-O-Paste
SCRAPBOOKING
SOFTWARE

NEW

Smell-O-Series

"It's very popular with the more traditional scrapbookers."

In this part . . .

*W*hat happens after the shooting is done?
A lot! In this part, I shift focus away
from the camera and head over to the computer.
Chapters 12 and 13 take you through the details of
choosing photo-editing software, editing photos,
deciding on storage options, getting the hang of
post-processing, and beyond.

In Chapters 14 and 15, I delve in to the subject of
creating and building a food photography business.
These chapters include info on websites, blogs,
stock agencies, and advertising. You'll find lots of
helpful tips to get you started on your way to a
tasty, creative, and fun business.

12

Post-Processing

*A*fter shooting some outrageously beautiful food photos, you have to think about post-processing. When you have a gorgeous photo with a tiny flaw, such as an errant speck lurking on the plate or one area that's too light or too dark, it's time for the magic of photo editing.

Although a lot of different photo-editing software is available on the market right now, I've found that the majority of photographers these days rely on Photoshop. So for the purpose of discussion, I'm going to assume you're using Photoshop.

In this chapter, I talk about some of the helpful Photoshop tools available to food photographers. These tools can assist you with modifying and cleaning up any small problem areas in your images.

Notice how I keep saying *small* problem areas? If you have a large problem in an image (such as super under- or overexposed), you need to decide whether modifying the image, which still may not look right in the end, is worth the time and effort.

In this chapter, I also talk about some key image adjustments you can make to enhance or correct small photo issues. Tweaking the *contrast* — the difference between the lightest tones and darkest tones in an image — or the *saturation* — the vibrancy or strength of the colors — can complement the look of your images. And slightly adjusting the levels of black, white, and gray in an image can fix some small exposure problems.

When using Photoshop to clean up images, the key is to be subtle and remember that less is more. Over processing of images can look, well, not so good, especially with food images.

I encourage you to really delve in to the capabilities of your photo-editing software. Knowing how to effectively use the tools and adjustments to edit your photos increases your marketability as a food photographer.

Clean Up on Aisle 9! Removing Imperfections

Because of the messy nature of shooting food, sometimes you'll have an extra drip, bit, or speck of stuff that needs tidying up after the image has been shot. If you don't see any problems initially, zoom in to Actual Pixels (100 percent) view in Photoshop to closely scrutinize your image. You may have a stray bit of fuzz somewhere (frosting is notorious for picking up little bits of fuzz) or another little smudge that may need to be cleaned up, as you can see in Figure 12-1.

46mm, 1/80 sec., f/5.3, 400

Figure 12-1: A small smudge on a dish may not be noticeable until you take a closer look during post-processing.

Luckily, some of the terrific tools available to help make your images look as clean and appetizing as possible include the Clone Stamp tool, the Smudge tool, and the Dodge and Burn tools found in Photoshop. I discuss these tools in the following sections.

Embracing the Clone Stamp tool

Way back in ancient times, photographers learned to use a fine brush and a dark, liquid ink to *spot* their prints. Spotting is the art of painting tiny dots or specks onto a physical print to remove imperfections. Spotting a print takes a steady hand and a heck of a lot of patience.

The Clone Stamp tool in Photoshop replaces the concept of spotting and raises the idea 100 fold. It allows you to spot an imperfection in a picture by using color, tone, and texture. It basically allows you to paint over small imperfections in an image by using sampled pixels for the paint.

When using the Clone Stamp tool, zoom in — zoom way in. Maybe 100 to 200 percent or more! And choose a smaller brush size when cloning. Your modifications will look much more realistic if you work on one small area of pixels at a time.

I find so many uses for the Clone Stamp tool in food photography, as I describe in the following sections. Honestly, it's the one postproduction tool I can't do without.

Cleaning up specks, drips, and drops

When you have a little speck or problem that needs a bit of cleanup, use the Clone Stamp tool to tidy up the image. In Figure 12-2, I shot a shamelessly beautiful apricot and nut square with an amazing lavender scented crust. After the shoot, the little lavender piece you can see right smack in the middle of the crust was bugging the heck out of me. Lavender smells great, and it even tastes great, but sometimes it doesn't look so great in an image.

55mm, 1/25 sec., f/5.6, 200

Figure 12-2: Apricot square with the lavender bit before using the Clone Stamp tool.

I zoomed in, selected the Clone Stamp tool, and then pressed the Option key and clicked (also referred to as Option + click) on a white area of the surrounding crust. I used the tool to paint the white crust-colored pixels over the stray lavender bit. And in Figure 12-3, you can see the result. With just a few little clicks, the image is left with a nearly flawless crust.

55mm, 1/25 sec., f/5.6, 200

Figure 12-3: Use the Clone Stamp tool to get rid of unwanted bits or specks.

Filling in the background

When shooting a food subject, particularly when outside of a controlled studio setting, sometimes you can inadvertently shoot an image that has an unwanted gap or break in the background, as you can see in the top right corner of Figure 12-4. It happens to the best of us; when you intently focus on the composition, lighting, or highlights of a food setup, the background becomes secondary and can sometimes be overlooked.

Now, you can crop out the problem if you'd prefer — that's one way to handle it — or you can use Photoshop's Clone Stamp tool for an easy fix. In Figure 12-5, I used the Clone Stamp tool to get rid of the distracting window-sill line.

Evening out surfaces

One of the coolest uses of the Clone Stamp tool is cloning surfaces. The tool doesn't pick up only color; it also picks up tone and texture.

Unwanted break

42mm, 1/60 sec., f/6.3, 200

Figure 12-4: Sometimes a perfectly good image has a break in the background.

Cleaned background

42mm, 1/60 sec., f/6.3, 200

Figure 12-5: You can fill in backgrounds with the Clone Stamp tool.

On the left of Figure 12-6, you can see the original image. The line right in the front of the pear that wasn't picking up the light needed to be fixed. On the right, you can see that I started to clone a little texture onto the top of the too-dark area.

The key with cloning surface texture is to vary things around a bit. Use the Clone Stamp tool to take a little bit of surface from one area then a little from another. Mixing it up a little helps you get a more realistic look for your image.

48mm, 0.4 sec., f/9.0, 320

Figure 12-6: Image before (left) and after (right) using the Clone Stamp tool to clone surface texture.

Combining the Clone Stamp and Smudge tools to fix problem areas

I use the Smudge tool every so often to even out any surfaces that may look choppy or unreal. With the Smudge tool, you can pick from many different options, such as brush size and type, mode, and strength, to manipulate and spread pixels. I find that using the Smudge tool works well after the occasional tricky modification with the Clone Stamp tool.

As you can see on the left in Figure 12-7, the café background behind the crêpes looks pretty interesting, except for that one bright white line that looks like it's popping directly out of the top of the stack of crêpes. To me, the white line detracts from the overall image (not to mention, it's distracting). So I zoomed in and started to work.

Using the Clone Stamp tool, I Option + clicked to sample the color of the similar gray-brown stripe a little to the right of the white line. After filling in the color, I smoothed the surface ever so slightly with the Smudge tool.

you think needs a little something extra, you can use some of the following options in Photoshop to help your images achieve their full potential:

✔ **Levels:** The Levels adjustment in Photoshop can fix exposure issues by punching up the blacks, whites, or midtones of an image. The easy-to-use slider allows the photographer to preview the levels options.

Choosing Auto Levels offers the software's best guess at accurate levels for an image, although, depending on the image, this may or may not be the best look. If you check it out and don't like it, you can always choose Fade Auto Levels or Undo.

✔ **Contrast:** Adding a slight bit of contrast can provide a little boost to the look of an image. And a little goes a long way. But don't overdo it because a super contrasty food image doesn't look too appetizing.

Although an Auto Contrast option is available, I rarely use that function. Auto Contrast doesn't know you're working with a food image, and it tends to add too much contrast for the subject matter.

✔ **Saturation:** Saturation can provide a little pop for your images. If your colors seem a little lackluster, a small amount of added saturation can add richness to the image.

Keeping Post-Processing to a Minimum

In the world of food photography, a natural look tends to be a more pleasing look, which is why I often work with natural lighting and tend to not overdo any photo-editing enhancements.

The number-one digital don't for me is over processing. Over processing means overdoing it on the saturation, the levels, and so on to the point the image looks a bit fake. Even the best of us can get caught in over processing, so if you think you're there, look at your onscreen image from various angles. Look at it up close, from far away, and from the left and right sides. You can also zoom in and check your images up close at 100 percent.

Do you see an unusual separation of colors? Does the image look a bit artificial? If so, you may have overdone a modification, such as saturation or levels.

In the following sections, I describe how a couple of postproduction tools can make your images look unnatural. But don't worry: I also show you how to avoid that result.

Working (gently) with saturation

Saturation can be a great boost to the colors of an image. But that boost needs to be subtle, not glaring. I rarely bump up the saturation more that 9 or 10 on the sliding scale. Anything more than that can look a little garish.

In Figure 12-9, I increased the saturation to about 6 on the sliding scale in the Saturation tool. I wanted to get full, rich reds to complement the look of the dessert, but I didn't want to overdo it.

40mm, 1/25 sec., f/5.0, 200

Figure 12-9: The Saturation tool is a great way to slightly enhance the colors in an image.

Overdoing the saturation in an image is a common mistake. I catch myself doing it every once in a while in my quest to get a delicious-looking photo. The telltale signs of an oversaturated image are a distinct separation of color tones, and in extreme cases, some pixelation occurs.

If you have a fitting image that you think may translate well to black and white, give desaturation a go. You can select the Desaturate option in Photoshop by going to the Image menu and then the Adjustments menu. Desaturation removes all traces of color from an image, turning it into a black-and-white image instead (see Figure 12-10). Although desaturation is quite unusual for a food image, it's an interesting look that allows you to stretch your creativity and try something different.

Playing with shadows

Shadows can help shape and add texture to the light in an image. Nice light shadows can be an awesome ingredient in your food image and provide a soft, natural look. But when the shadows get too dark in a food photo, it can look too harsh and some problems can persist.

32mm, 1/60 sec., f/4.5, 640

Figure 12-10: Desaturation on a food photo is quite unusual — hello, black and white!

A too-dark shadow can seriously detract from the beauty of an image. Dark shadows aren't that appetizing of a look for food. If you're faced with a shadow problem, use the Dodge or Clone Stamp tool to subtly lighten and soften the look of deep shadows (see the earlier sections "Embracing the Clone Stamp tool" and "Discovering digital Dodge and Burn tools" for more on these tools).

Avoiding too much cloning

Overusing the Clone Stamp tool can make an image look unnatural; for example, take a look at Figure 12-11. At the bottom of the avocado in the top left piece of sushi, I was cloning over a stray tomato seed that found its way on to the sushi. And here's the pitfall when using the Clone Stamp tool: If

you're not careful, you can get a look of sameness when cloning pixels — the same highlights, the same dips in the surface, and so on. Overusing the Clone Stamp tool can look just a bit too patterned and unreal for prime time, and, of course, it is.

70mm, 1/250 sec., f/8.0, 250

Figure 12-11: Overusing the Clone Stamp tool gives an unnatural feel to the image.

13

Editing and Saving Your Photos

*N*ow that your delicious images are "in the can" so to speak, it's time to talk about identifying your best photos. Photographers generally comb through and edit photos on their computer with an image management program, such as Apple Aperture or Adobe Lightroom. These two competing programs give you everything you need to identify and organize your best images. Although I briefly touch on other ways to handle editing photos, in this chapter, I mainly focus on Lightroom and Aperture because they're the current industry standards.

I also talk about postproduction basics. These adjustments help make your best photos even better. Postproduction includes all the various tweaks and image manipulations you use to clean up and perfect your images. You can do a little postproduction in an image management program, but you'll do the majority of postproduction in Photoshop.

In this chapter, I explore the first rule of photography — backing up your images. Imagine waking up tomorrow, booting up your computer, and finding out your hard drive has decided to head on up to the big, hard-drive heap in the sky. *Unrecoverable* is a scary, scary word when talking about your collection of valuable photos. Today, boatloads of backup options are available at a good range of prices, and all of them are pretty simple to work with.

Finally, I provide a peek into a workflow I use when editing and cleaning up images. This example of image handling from start to finish may help you streamline the overall process for your photos. So take note and read on!

Finding the Best Software for Your Needs

When choosing an application to manage your photos, you want to look at a few important features, which I explore in the following sections. The two main software choices are Adobe Lightroom and Apple Aperture, but you can also choose from several other options to handle your photos.

Make sure whatever program you choose is comfortable, fits in with your work style, and manages the image-handling basics well.

Ease of use

One of the first criteria to look at when deciding what photo management program to use is whether it's easy to navigate. Before purchasing new software, first try it out to make sure you're comfortable with its *user interface* (or *UI*) and its look and feel.

Many photographers are keen on the Aperture UI. Word on the street is that Aperture is a little more intuitive than other choices, and photographers love the iCloud backup scheme, among other features.

But many others are more comfortable working in the Lightroom software environment because they like the way the tools and viewer are organized. Lightroom's simple export-to-sharing-sites feature is also a big plus.

The software you decide on is a personal choice based on how well the software fits with your work style and your image management needs.

Pricing

Both Apple Aperture and Adobe Lightroom, the two main photo management programs, run about $150 or so. You can find several other photo management programs that are a bit slimmer on features — okay a *lot* slimmer on features — but they're either free or pretty cheap.

If you decide not to use Lightroom or Aperture to manage your photos, other free or inexpensive software options include the following:

✔ On the Mac side, you can use iPhoto to organize your images, which you can purchase separately for only $14.99. You won't get many of the bells and whistles of the more popular programs, but it may be a good starter program for some folks.

✔ On the PC side, you can use the Windows Photo Gallery, which is similar to iPhoto. Again, this software is very limited, but some folks are more comfortable with how it works for them. Windows Photo Gallery is a free download for Windows users.

✔ Picasa software, available from Google, is another great option for organizing, editing, and sharing your photos. It's free and works for both Macs and PCs.

Off-site image access

One advantage that Aperture has over Lightroom is that it allows you to store and access your images from an external drive. This feature can be a huge benefit if you have thousands and thousands of photos and limited disk space on your computer.

Integration

Because Adobe Photoshop is the main application of choice for photographers, making sure your image management software works well with Photoshop is another important feature to consider when choosing a program. This integration should be pretty seamless to help with your workflow. Apple Aperture and Adobe Lightroom both work well with Photoshop, although Lightroom gets the higher marks, which makes sense because it's also an Adobe product and is seamlessly integrated with Photoshop.

Processing Your Images

Picking out the very best photo from the hundreds you take during a shoot can sometimes be a daunting challenge. But never fear! You can narrow down the playing field in several ways to make the process of selecting photos easier.

And if you end up with several awesome shots to choose from, in some situations, you can use the other great photos that aren't selected for additional monetizing purposes.

In the following sections, I provide a few tips and tricks for pinning down your best images, and I explore some options for what to do with the photos you took that just didn't quite make the cut. I also show you some basics on editing the white balance in your photos to help capture the right color temperature for the look you're going for.

Here's a sample of the standard workflow I use when going through the process of selecting, editing, and optimizing images:

1. **Upload photos to Lightroom.**

 Connect via card reader or USB to upload and import images into Lightroom.

2. **Back up catalog.**

 When the initial backup dialog comes up, choose to back up the Lightroom catalog. This option doesn't back up the images themselves, but it does back up the framework catalog that holds and indexes the images.

3. **Back up images.**

 At this point, you can back up your images. I back up my images to an external drive or the cloud, just for safety's sake.

4. **Cruise, peruse, and identify.**

 Here's where you look through the images and narrow them down to the best ones. Figure 13-1 shows how you can rate your photos with stars in Lightroom. Also see the next section, "Identifying your very best images," for help with this step.

Figure 13-1: You can star notable images in Lightroom.

5. **Edit slightly.**

 While still in Lightroom, make small adjustments, such as white balance or color temperature, to the RAW image. (Check out the later section "Basic editing: Playing with white balance.")

6. **Export.**

 You can either export one by one or do a batch export to a folder. I export images as "Original" format to Photoshop.

7. **Edit in RAW.**

 Additional core edits, such as saturation or contrast, are best handled in the RAW dialog that comes up when first opening RAW images in Photoshop.

8. **Post-process.**

 You can do the majority of other remaining postproduction changes, such as dodging, burning, or using the Clone Stamp tool, in Photoshop.

Identifying your very best images

Faced with a few hundred (or thousand!) shots from a shoot, how do you identify and narrow down your best images of the pack? Gut instinct, focus, color, exposure, and composition all play a part in the selection process.

Over time, you'll develop your eye so you can easily pick out the top contenders right off the bat. But until then, consider the following:

- **Gut instinct:** When first looking at your images as thumbnails in Lightroom or Aperture, you'll notice some images just look better than others. Click on those images to enlarge and see whether the large version is just as good as the smaller thumbnail.

- **Focus:** When checking for focus, I use the View Actual Pixels choice (at the top of your screen when you're using the Zoom tool) in Photoshop. Or you can just zoom in 100 percent — it's the same thing. The area of interest, such as the front-most tomatillo in Figure 13-2, should generally be in crisp focus.

- **Color, exposure, and saturation:** Is the color of the image true with good saturation? You want to locate the images that are properly exposed — not too light, not too dark — and with good, nicely saturated color.

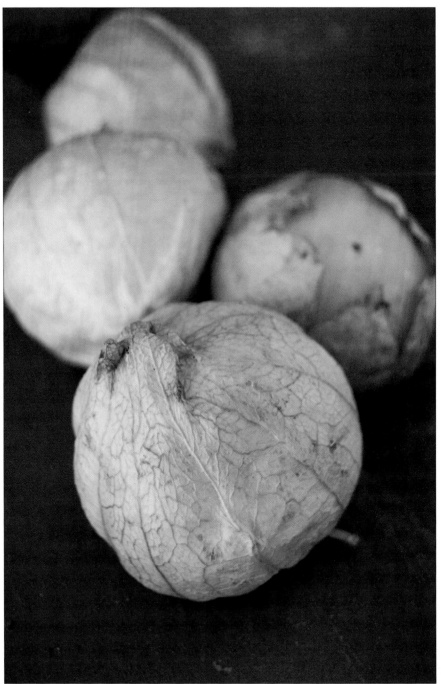

46mm, 1/50 sec., f/5.3, 400

Figure 13-2: A nice composition of tomatillos.

✔ **Different sizes:** After you've narrowed down the field, take a look at different sizes of the selected images. Look at small thumbnails and look at full screen. The images that have impact stand out a bit more when you look at different sizes.

✔ **Compare the contenders:** Doing a side-by-side comparison of the top two or three images also helps you pick out the winning image.

If you're still having problems deciding on the best images, go social. Post small sizes of the images to a social or photo-sharing site and ask your friends, colleagues, and the general public which image they think is best. Feedback rocks when you're stuck with making a difficult decision about images.

Figuring out what to do with your second-best images

When you've had an awesome shoot and have provided your clients with the very best images for their use, what do you do with those really tasty leftover images? Well, if they're for an advertising, editorial, or packaging client and you hold the copyright on that work, you can add the client work to your portfolio and to your website. Adding new images keeps your portfolio content updated and fresh.

I don't suggest using any client contracted work for your stock agencies. If your clients paid for the shoot, reusing their work for another purpose is bad form.

If the initial shoot was for your foodie blog or a stock agency or if it's a trade situation between a chef and a photographer, you also have these options:

✔ **Stock agencies:** If you contribute to various stock agencies, they're the perfect place for these leftover "seconds" images. Provided the images meet the agency guidelines, upload them to your agency portfolio — you just may make a little extra money from the images. I go into detail about stock agencies in Chapter 14.

✔ **Creative Commons:** Consider opening a few images to the *Creative Commons* world. Creative Commons is a license that allows the sharing of an image to the public domain and is easily accessible through sharing sites, such as Flickr (`www.flickr.com`). You can specify the size of the image and the type of sharing license as well as the attribution, so you're credited for your work wherever it ends up.

No money is awarded in going the Creative Commons route, but you receive a heck of a lot of glory! Creative Commons is a good way to get your name out in various websites and publications while fostering a bit of goodwill in the world. Figure 13-3 is one of my contributions.

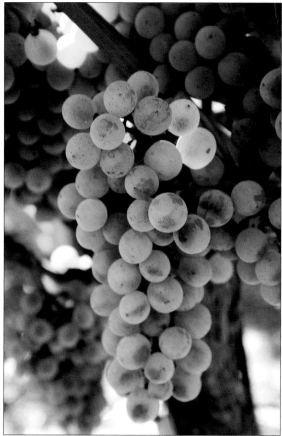

55mm, 1/100 sec., f/7.1, 400

Figure 13-3: A "second" image that I licensed as Creative Commons — Semillon Blanc.

Basic editing: Playing with white balance

Many books are available on the subject of digital photo editing with various software packages, including Photoshop. Covering even a handful of editing techniques is really beyond the scope of this book, but I can get you started on one basic type of edit: adjusting the white balance.

The white balance feature is one of the most helpful postproduction basics. The auto white balance function on your digital SLR is a helpful tool, but unfortunately, it's somewhat imperfect in judging true color temperature in every single situation. Postproduction white balance options can correct any unwanted color casts in your images.

The mushroom image in Figure 13-4 is the *before* white balance picture. This photo was taken in the late afternoon in filtered natural light. As you can see, the image has a very warm cast.

55mm, 1/160 sec., f/6.3, 400

Figure 13-4: Original image of mushrooms before white balance adjustments.

Figure 13-5 is the *after* picture. I simply used the white balance feature in Lightroom to correct the off-color cast, and presto — a pretty darn accurate white balance!

55mm, 1/160 sec., f/6.3, 400

Figure 13-5: Edited white balanced image of mushrooms.

Organizing with Naming Conventions

Standardizing the way you name your photos allows you to organize and catalog your images and find specific images when you need them. When you have tens of thousands or even hundreds of thousands of images, you need a way to provide clear and helpful image identifiers right in the name of the image.

I have a standard way of naming images that works like this: The first part is a four-digit date, such as 0412. Next comes a descriptive title all smooshed together with no spaces, such as CaviarAndBlini. And lastly, I leave the underscore and the actual image number, such as _5436, for tracking. Put all together, the name displays as 0412CaviarAndBlini_5436.

You can see my naming convention in action at the top of the image in Figure 13-6.

Your naming convention can take any format that's most helpful to you, but consistency is key here.

Figure 13-6: Screenshot of a Boston cream pie image, using a naming convention.

Securing Your Images with Backups

If you're ecstatic because you've just shot the most amazingly delectable image but have only *one* copy of that image, you're playing with fire!

Here's when a little paranoia is a good thing, because you should know that anything can happen to that irreplaceable image. A virus or worm can hit your machine, or you can have hard disk failure, some image corruption, or a computer theft. Eek! Need I go on?

So if you're planning on creating or enhancing your livelihood with food photography, take a little effort to protect those precious images! The three main ways to protect your images are to back them up to external hard drives, to a library of CDs, or to the *cloud* (a machine farm or data center). The good news is many options are now very low cost or free. I explore all these options in detail in the following sections.

When choosing a backup option, an important factor to consider is that it should be effortless and not a huge pain in the behind. If it's easy, you'll more likely get in the habit of always backing up your images.

Although some folks have a real bone of contention about the difference between backing up photos and storing photos, for our purposes, I prefer not to split hairs but rather focus on the importance of having an archive of a second set of images, preferably in a different location.

The reason your backup should be in a separate location boils down to this: If mayhem strikes at one location, it's highly unlikely that it'll strike at a second location. So having your backup separate from the original provides a bit more security and protection for your images.

Choosing a hard drive

External hard drives (see Figure 13-7) used to be heinously expensive. About four or five years ago, I needed to buy *terabyte* (1,000 GB) drives for a project on an ongoing basis. Each one ran about $900. Fast forward to today, and the cost is hovering around $100. That's one significant drop in price!

For my use, currently, I tend to purchase two smaller external drives and back up my images to each drive so I have a redundant backup for security's sake.

Because hard drives can fail, I always make sure to have an extra copy just in case, and I always store one of the two drives off-site.

Figure 13-7: An external hard drive is one backup option.

When choosing a hard drive or two for your use, pick whatever size works best for you, but pay special attention to the brand. Do a little research on the web to see whether you can pick the top brands at the moment, such as Seagate or Western Digital. Some of the lower-end brands look great on paper, but they may have a fairly high failure rate.

With an external hard drive, you can upload your images by either dragging and dropping or using an application to facilitate the backup. Apple Time Machine provides users with a great interface for backing up an image library. This app is supported on Mac OS v10.5 and later and is quite easy and effective to work with.

Even a thumb drive works in a pinch as a temporary backup. The key is to have at least two copies of all important images.

Creating a CD library

Managing photographic images on CDs (see Figure 13-8) is another good backup choice for photographers. Some folks just prefer burning their images to CD and keeping a physical library of their work. Doing so is a cool way to see your work in a tangible format.

You can label and organize the CDs in a library by dates, naming conventions, or other identifying methods.

If you decide to go the CD library route for your photo backups, be sure to store the library off-site so you have two copies of your work in two different locations, just in case a disaster heads your way.

Figure 13-8: A CD library of photos is a tangible choice.

Storing images in the cloud

I feel so much safer about saving my images to the cloud than any other backup method available. Here's why: When you upload your images to a cloud service, it creates a second copy of your work in a different location than the original. Your images are safe from problems, such as viruses or hard disk issues on your personal computer, and the photos are safe from theft and disasters as well, which is completely awesome, but it doesn't stop there. After you upload your photos to the cloud, they're also backed up on the data center side. So should any problems occur with your local images, your images are safe and recoverable from the cloud. Yay for redundant backups!

Many companies offer this type of backup now, either directly through a cloud backup service or through a storage service with an FTP or drag-and-drop add-on application. Pricing starts at just pennies per GB or, in some cases, free. For example, Amazon currently offers 5GB of free cloud space for storage with the ability to purchase more space as needed.

Rather than upload your images to a cloud service through a browser, use in conjunction with Gladinet Cloud Desktop or a similar application. Having a backup handled by an application is better because when the images aren't touched by a browser in any way, the image data stays perfectly clean and pristine.

Other free cloud storage options include JustCloud.com (Windows only at this time) and Apple iCloud for Mac and PC.

When backing up images to the cloud, I suggest you go with a well-known company or one that's very well reviewed. You want to make sure your precious images are as secure as possible. Storing your images in the cloud is the ultimate way to feel secure about the integrity and safety of your images in the long term.

14

Making Your Photos Available in Print and Online

*I*f you want to be known for your gorgeous food photographs, the reality is you need to get online. A website or blog is your window to the world these days. If you don't already have a site, setting one up is pretty easy, but the content does require some careful thought and planning.

On the other hand, seeing your images in print is really quite fulfilling. Whether putting your photos in print means framed images for a restaurant or gallery, boutique greeting cards, or cool little postcards, with this route, you can promote your work and earn some income at the same time.

Another great way to get a few bucks off your existing images is to go the stock photography route. Stock photography is essentially the business of selling images for a usage fee. Stock photo agencies promote, license, and manage the images, set the pricing, and oversee the transactions. For providing these services, the agencies take out a percentage of each sale. How much of a percentage varies widely from agency to agency.

In this chapter, I explore the realities of the print and online worlds for food photographers. I show you what setting up and maintaining a food blog is all about, I walk you through submitting and shooting for stock agencies, and I also provide a few tips for putting your gorgeous food images on paper, canvas, or whatever other medium suits your needs.

Creating an Online Presence

So you've put in a great deal of effort to shoot, style, and light your photos, and you've finally pulled together a really solid portfolio. Now it's time to create a little buzz for your work.

The thing about creating an online presence is this: It isn't one-dimensional. If you want to be successful, you can't create only a small blog and leave it at that. A recognizable online presence tends to be multifaceted. So that means you may have a website *and* a blog. Or perhaps you create a business identity on a social network or two and contribute to photo-sharing sites, like Flickr. You may also have your work displayed online by a stock agency. Perhaps you even comment on photography bulletin boards about various issues. And maybe you even have a little ad campaign going on, using Google AdWords or something similar.

All these factors help create a personal fabric about you and your work across the web. And this fabric helps spread the word about your amazing food photos. In the following sections, I talk about how to create your own online presence by building a website and/or blog and putting your name out there with comments and contributions to other people's sites and blogs.

Getting yourself on the web

A website can be a window into your world of fantastic food imagery. A site for your food photography can promote exactly the images and messages you want to convey. Although there are many areas of the web no one can control (for example, comments on blogs and social sites), your own personal website is the one area where you're the absolute decider about what information gets displayed. You can see my website in Figure 14-1.

Figure 14-1: A screenshot of my website.

If you're approaching potential clients, say, some restaurants or caterers, pointing them to your website shows them exactly what you can do with food images. A website is the very best marketing tool there is.

Creating a website

When you're ready to create a site for your food photography, consider the following ways to get things moving:

- **Doing it yourself:** If you already possess some basic HTML skills and an application, such as Adobe Dreamweaver, you can put together a static online portfolio with thumbnails that, when clicked, display the full images. This option is a good, basic way to create a stand-alone portfolio.

- **Hiring someone to create the site:** If you don't feel comfortable building your own website, you can have someone create your site for you. In nearly every community, you can find local student designers or professional design agencies available for hire. In this model, you work with the site designer to create a website that fits well with your content. Depending on who you get to create your site, this option could be the most expensive (ranging from $500 to $2,000), but the site would be completely customized to your needs.

- **Using an editable template:** In my opinion, this option is the very best of the three. Numerous companies provide editable website templates that can be customized with your work and personal aesthetic. Many of these templates have animation or good transition effects for slide shows.

 Several companies provide these turnkey solutions specifically for photographers. Although these companies cater primarily to wedding and portrait photographers, I assure you the format is quite well suited to food photographers as well. Editable templates are in the midrange option financially, around $100 to $600. This option can really be a bargain way to display your delicious images.

For my website, I use an editable template from a company called Blu Domain (www.bludomain.com). Its options for photographers are numerous and inexpensive, and the end results look quite professional.

Adding music to your website distracts viewers from the work you're trying to promote. And music often irritates people who are trying to quietly and discreetly look at your lovely work from the sanctity of their own cubicle. Seriously, I've never come across a feature that evokes such a visceral response in people. So stay away from the tunes in your site.

Choosing images for your site

After you've figured out how you're going to create your website, you have to think about the content and images that will make up your site. Spending time really considering the images is important because these images

become the face of your work to the outside world. So put on your curator hat and carefully evaluate the images in your portfolio.

Although choosing photos for your website requires a great deal of consideration, taking a little time to pull together a great group of images for your site will serve you well for a long time to come.

Find those images that really stand out to you — the ones that look so completely delicious they make you want to devour every last pixel! Ask your friends and colleagues which images of yours are their favorites. If you have an online photo-sharing site you use for food images, look at your most popular photos (the ones with lots of favorites or comments). And if you have a social sharing site, posting some food images to gauge reaction from the blogosphere can be helpful.

Take some time to curate your photos. Make sure you love every last one of them. Each image on your site should be a gem in its own right. Basically, you're building an online portfolio so you want to show your best work.

After you've chosen the images for your site, another aspect to consider is making sure you have a good variety in the look and order of your images, especially if you have a slide show running. So as you finalize the images to include on your website, vary the colors, angles, backgrounds, and tilts. Make sure you don't have too much of the same look repeated over and over again.

I confess: I adore close-ups of foods with a lot of red in them. With that personal preference in mind, I try to break up the red in the images on my website with, say, a somewhat green medium shot, then I go back to a red shot, and next I put a blue wide shot, and so on.

The same variation goes for the tilts and angles, which I talk about in Chapter 10. You want to vary images that tilt to the left with those that tilt to the right and those with no tilt at all.

Chatting about food and photo blogs

Many chefs, home cooks, TV and magazine personalities, restaurant owners, and even folks who just appreciate foods ("I ate this") have food blogs these days. You can also find blogs created by food photographers, food stylists, and food aficionados. Some bloggers even focus solely on one particular type of food — yes, dear reader, marzipan food blogs are out there!

Foodie blogs are a wildly popular phenomenon that's still in their infancy. Right now, a great deal of interest is in food, recipe, and food photography blogs, and many loyal and dedicated followers, well, follow these types of blogs.

Although you can find a lot of really interesting food-related blogs on the Internet, it's a great big world, and there's always room for more deliciousness.

So here's the main thing about a blog — scratch that — here are the two main things: First, you have to get the word out about your blog; second, you have to understand the time involved in the basic upkeep of the blog. If you're going to have a successful blog, you need to commit to updating the blog nearly every single day. When it comes down to it, your followers are looking to you for a continuous stream of information and imagery about their favorite subject — food!

You can promote your blog to the outside world in several ways, including the following:

- Mention it and link to it from social sites
- Put your blog URL on your business cards and advertising materials
- Run small, targeted Internet ads, such as Google AdWords

Blogger (www.blogger.com) and WordPress (www.wordpress.org) are the two main sites for blogs these days. Both of these blog tools are handy, really easy-to-use solutions that can help you create your perfect blog. Another bonus to using one of these blog sites is that the Flickr photo-sharing site (www.flickr.com) connects nicely with both of them. So if you're posting your gourmet images to Flickr, you can easily post those Flickr images to your blog.

When posting to a recipe blog, photographing the preparation and cooking process — not only the finished product — is a really cool idea. These types of food-in-the-making images can make for some really interesting photos. For example, when documenting a luscious pie recipe on a blog, you could initially show the process of rolling out the dough, as you can see in Figure 14-2, and folding the dough, as shown in Figure 14-3.

32mm, 1/20 sec., f/4.5, 250

Figure 14-2: Rolling out dough.

32mm, 1/15 sec., f/4.5, 250

Figure 14-3: Folding the dough into quarters.

When shooting the food preparation process, embrace the pots and pans! As you can see in Figure 14-4, photographing foods, using well-worn pots and pans, baking sheets, and colanders can provide a nice down-to-earth look in a photograph.

41mm, 1/80 sec., f/5.6, 400

Figure 14-4: Placing these figs in a metal colander gives this image a down-to-earth, practical look.

Choosing a Stock Agency

The first photographic stock agencies originated in the 1920s and '30s. The agencies were a venue to market photographic *seconds* (images left over from magazine photo shoots). These images were very good, but they weren't the exact image clients were looking for. Selling these images to stock agencies was a brilliant way to make money from images previously thought of as castoffs.

The golden era of stock agencies started in the 1980s and continued through about 2008 or so. During this time, it was completely possible to make a living, or at least a healthy amount of supplemental income, from stock sales.

But, realistically, the stock photo industry has changed significantly in the last several years. Up until then, a photographer may have made quite a good income from stock photos. But now, because of the quality and availability of cameras and equipment and the fact that significantly more photographers are submitting their work to agencies, things have changed. Depending on the effort made, you can still have a nice revenue stream from selling stock, but it isn't a full-time gig anymore for most photographers.

Stock images are licensed to fulfill a myriad of uses. Many of my stock photos, like the one in Figure 14-5, have been used in textbooks, on wine labels, in newspapers, and in ads, among other things. An image can be used for advertising or for *editorial* use (photos that support and augment the text in newspapers, magazines, or books).

35mm, 1/13 sec., f/4.5, 400

Figure 14-5: Stock images can be used for a lot of different purposes.

The many types of stock agencies include general agencies, such as Alamy and Corbis, artistic boutique agencies, and food specialty agencies. And then there are the microstock agencies, which have greatly impacted the stock agency landscape. Microstock agencies promote super-discounted images, using the business model of selling more images at a lower price. The images can be somewhat formulaic, but the quality has gotten much better over the last few years.

Do some research of your own and search for stock agencies on the Internet. You'll likely find various stock agency aggregators that list numerous stock agencies and specialty options.

In the following sections, I dig deeper into the world of stock agencies, from knowing how and what to shoot to getting involved with a big-name agency, from figuring out what specialty agencies look for to trying your hand — or photos, rather — in microstock agencies.

Shooting for stock submissions

If you plan to take photos for stock agencies, you'll need to meet several requirements for submitting and selling your images. Consider these tips:

- **Get model releases.** When shooting food images for stock, if a recognizable person is in the image, you must obtain a model release that's filled out by you and signed by the person in your image. It's essentially a waiver saying, "Hey, it's okay to use my likeness in this image."

- **Get location releases.** Waivers apply to places, too. If a recognizable location is in a shot, you must fill out a location release before submitting your photo.

 You can find these forms online, but stock photo agencies generally provide them as well.

- **Avoid visible brands.** You can't submit an image to a stock agency that shows all or part of a recognizable brand. Although it's probably okay to post those images to photo-sharing sites, it's an absolute no-go for stock photo agencies.

- **Don't sharpen.** When submitting your work to agencies, don't sharpen your work. Depending on the agency, when sharpened images are uploaded and resampled, they don't look so great online. Some agencies actually have you check a box that indicates you haven't sharpened the image you're submitting.

Feel free to submit all styles of food photography to your stock photo agencies: refined, arty, whitewashed, homey, and beyond. But for the most part, when shooting stock for any type of agency, generic and timeless looks sell best.

Aiming for a big name agency

Fewer than a dozen really big-name agencies exist. And, of course, each agency prefers photographic submissions in a slightly different way. Unfortunately, you most likely won't be able to create one portfolio and submit it to multiple agencies.

Submission guidelines for these agencies vary widely. At one end, some agencies' guidelines are akin to the following: Submit creative RAW images that are converted to TIFF, using a specific dpi, shot at a specific ISO, and submit them on a CD. Test shoots can also be included, but that's the exception, not the rule. At the other end, some agencies want to start with viewing your website to get an idea of your work.

Because agencies will likely check you out online, having a nice-looking website for your portfolio is extremely important. Your website is a great portal and provides an opportunity to show off your work to stock agencies and beyond.

Some stock agencies are very particular about representing only the highest technical quality of images, and some are concerned primarily about creativity. One very large agency even charges some photographers a fee to submit their work. So be sure to check out the requirements and submittal standards for the agency you're looking into.

Although not true for all agencies, some larger agencies may have a rule requiring that submitted images be exclusive to their agency. This requirement provides the submitter with a higher possible revenue rate, and the agency gets its exclusivity bragging rights. So be sure to do your homework about image rights before you sign on the dotted line.

Stark differences exist between the Rights Managed and the Royalty Free licensing methods. A Rights Managed image is licensed for one specific situation, such as a quarter-page layout in a magazine with a limited run of 10,000 that will run between April 2012 and June 2012. Rights Managed is the more standard way to license a photo. Royalty Free means that a specific size of an image, such as 500×333 pixels, is licensed for use. After the photo is licensed, that image can be used by the licensee anywhere, for any purpose, for any amount of time. (See Chapter 4 for more info.)

Appealing to specialty agencies

Just within the realm of food images, you can find specialty stock agencies or sub-agencies that specialize in food, beverages, raw ingredients (such as the Dutch carrots in Figure 14-6) and wine and vineyard photography.

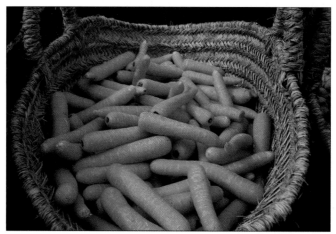

22mm, 1/200 sec., f/8, 100

Figure 14-6: Some stock agencies have a raw ingredients category.

Wine and vineyard photography includes seasonal vineyard photos, grapes, harvest, crush, wine processing, and bottles or glasses of wine. Everything that surrounds the winemaking process is good fodder for these types of boutique agencies (see Figure 14-7).

Many agencies are also interested in images surrounding food preparation, even though no food is visible in the image — it's about the process. Figure 14-8 captures the process of making goat cheese. Although it isn't the most interesting food photo, it's interesting as far as food creation goes.

48mm, 1/60 sec., f/4.5, 400

Figure 14-7: Anything related to winemaking or drinking is great stock for wine and vineyard photography.

45mm, 1/80 sec., f/5.3, 200

Figure 14-8: Food preparation can be appealing for some specialty stock agencies.

Considering microstock

Microstock photo agencies aren't my favorite business model, but they do provide a good, discounted service for companies that need to purchase

inexpensive images. Microstock equals micropayment for photographers, and the theory is that the volume of your sales may make up the difference financially.

Some microstock agencies don't have particularly strict quality guidelines. Some will even accept images from point-and-shoot cameras, although I've noticed a recent trend that some agencies are upping their quality criteria.

Printing Your Photos

You may be interested in printing your images for several reasons. You may want to print some lovely large photos for sale or display, or perhaps you want to print a line of greeting cards. And even a business card with an amazing food image on it is worth at least a thousand words. Although it may sound a little retro, seeing hard-copy images is really pleasing, especially because we're so used to seeing photos only onscreen these days.

The high end of printing most likely involves a *plotter.* A plotter is a really, really big printer, with a width that ranges between 24 to 60 inches wide (see Figure 14-9). The paper typically comes on a roll that's fed through the plotter. And, oh, the papers you'll find: matte finishes, glossy finishes, even pearl finishes. You can also obtain some absolutely beautiful fine art papers that look gorgeous with food photos. Or you can even print on canvas or other cloth-like materials.

A plotter is a really good option for printing your photographs as art for a restaurant, gallery, or art show. I've also printed a large image of work previously done for a client as a thank-you gift.

Figure 14-9: A plotter or large format printer is the tool to use for high-end photos.

Some really great printing companies will take the time to evaluate the color and tone of a digital file and print large images with care. You may be able to find someone local to your area, but you can find some great services online as well. When you find a company that really cares about printing quality images, hold on tight to it!

Not to be outdone by the big guys, a number of great, smaller photo-printing companies have cropped up over the last several years. They print things like the photo business cards seen in Figure 14-10 as well as postcards (Figure 14-11), greeting cards, and so on. These cards can be sent to clients as thank-you notes and reminders, or they can be handed out as advertising tools. Some of these small printing companies are even connected with photo-sharing sites, which is quite handy.

For the most part, the quality of smaller photo-printing services is low cost but still quite good. And if it's not, let them know! A reputable company will be happy to try again for you.

Figure 14-10: Business cards with food images are great advertising tools.

If you're interested in submitting your photos to an existing greeting card company, first find a greeting card publisher whose work you admire. Peruse the greeting card sections at various stationery-type stores in your area and check the back of the card for the publisher info. If you find a company that creates cards somewhat close to your aesthetic, contact it to see whether it's currently accepting new photographers' work.

Figure 14-11: Postcards can be sent out as thank-you notes and reminders.

15

Starting Your Food Styling and Photography Business

In This Chapter

▷ Putting together a portfolio

▷ Making sense of food photography rates

▷ Establishing a name for yourself online

▷ Approaching various ad options

Starting your food photography business starts with promoting your delectable images. In this chapter, I talk about some of the basics involved in getting your business off the ground. The most important first step is creating a robust portfolio of your images.

When it comes to displaying your portfolio digitally, you have loads of options, from the very basic to the highly polished. Whatever option you choose to go with, which I help you decide in this chapter, the images are the center of it all. However, some folks prefer the retro sensibility of an old-school, hard-copy portfolio book. Although this option is unusual these days, if you choose to go that route, you just may make a cool and lasting impression.

Of course, you can always do both! Having a hard-copy portfolio book to bring with you to potential clients is a great way to get them interested in your work, and then you can direct them to your online portfolio for more amazing photos via your website or blog.

After you have your portfolio pulled together, you have to advertise your work. Ads range from small, Internet text-based ads to a spread in a photography design magazine. You can even do a targeted e-mail or direct mail campaign.

Now, if you're illustrating a food blog with your images or are concerned with only posting to a photo-sharing site, the info in this chapter may not be for you. But if you're interested in growing and developing your food photography business, read on.

Selecting Portfolio Images

Your portfolio, whether shown digitally or printed, should be a well-thought-out, curated collection of your very best images.

So how do you distinguish between a good portfolio image, like the baked pumpkin soup in Figure 15-1, and a not-so-good one? No hard-and-fast rules exist, but a couple of tricks can help you through this process.

45mm, 1/200 sec., f/7.1, 320

Figure 15-1: Show off your best work when selecting images for your portfolio.

First, when looking through images from a shoot, do you notice some that stand out or really hit a chord with you? Perhaps the lighting is just right, the color saturation is beautiful, or the angle perfectly fits with the food. Maybe a highlight is crisply in focus, which adds to the overall deliciousness of the shot.

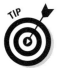

One action that really helps me choose images for a portfolio is reducing the size of the images in question. I just zoom out to a medium thumbnail and then on to a small one. If an image in its mini state really stands out, I know I've got a winner.

If you're having a hard time selecting your best shots, ask friends and colleagues what they think. Ask them in person, or maybe post a couple of shots on your social network of choice and ask for people's honest feedback. And you can always post to a photo-sharing site to see which image gets more attention.

I always check the focus on the images (see Figures 15-2 and 15-3). Of course, the whole photo doesn't need to be in focus, but the area that's most interesting should be. (I go into detail about focus in Chapter 11.)

You can use the Photoshop Zoom tool to zoom to Actual Pixels, or 100 percent. From there, you can clearly see what's in focus in a given shot.

85mm, 1/4 sec., f/7.1, 200

Figure 15-2: In this image, the area of interest is too soft.

45mm, 1/125 sec., f/5.3, 320

Figure 15-3: This photo is better because the area of interest is in focus.

When wading through your possible portfolio images, keep an eye on exposure and saturation as well. You want to have a set of rich and properly exposed images for your portfolio.

For variety (and provided they fit in with your aesthetic), you may choose to include some images that are *high key* (a bright, light-filled, lower contrast image) or *low key* (a dramatic image with lots of blacks, higher contrast, and saturated colors). Figures 15-4 and 15-5 are examples of high-key and low-key images.

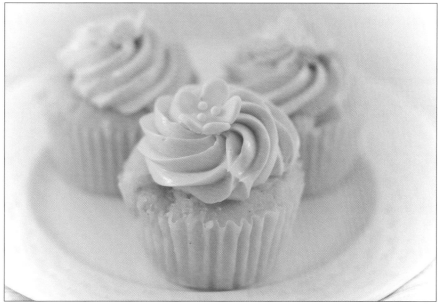

50mm, 1/200 sec., f/2.8, 200

Figure 15-4: A high-key image is bright and full of light.

55mm, 1/30 sec., f/5.6, 400

Figure 15-5: A low-key image is dramatic with more contrast.

In the following sections, I explore what it really takes to create a well-balanced, amazing portfolio: instincts and variety.

Following your gut instincts

When you've completed a shoot, review the photos and look at what stands out. If multiple images are quite similar, does one trigger a little more of a positive reaction in you? Maybe one really gets those taste buds going? If not, try reducing the size and view the thumbnails. Still no decision? Sleep on it, and revisit the images the next day. Sometimes deciding which image is best takes time.

In Figure 15-6, the image is pretty nice, but to me, something isn't quite right with the photo. After closer inspection, I realize it's probably because a point on the apricot jam in the center of the cookie seems to be pointing straight down. If a line was drawn from the point of the jam to the bottom of the image, it'd be nearly parallel with the side of the image.

Figure 15-7 has a little more tilt, and the point on the apricot jam is somewhat askew, pointing slightly to the left. There's also more of a glistening highlight in this image. These differences are really subtle, but it makes Figure 15-7 an altogether better image than Figure 15-6.

Trust your gut instincts. You really don't need to analyze why one image bugs you and another similar image looks awesome. If one image looks better than another to you, just go with it and plop it right into your portfolio.

55mm, 1/25 sec., f/5.6, 400

Figure 15-6: Although this image may look good to the average viewer, my gut tells me to select another shot.

55mm, 1/25 sec., f/5.6, 400

Figure 15-7: This shot has a better tilt and a more glistening highlight, making it a better pick for a portfolio.

Spicing it up with variety

A portfolio should showcase the best of the best of your food photos. Of course, it should always reflect your overall aesthetic, but the images can be, and should be, quite varied.

When choosing photos for your portfolio, you can mix them up in several ways:

- ✔ **Colors:** When selecting portfolio images, try to include a good range of colors in your overall work. So even though you may be drawn to images with lots of green, be sure to throw in some reds, blues, and browns, too.

- ✔ **Angles and tilts:** Recently, I pulled together a portfolio of my work, and I noticed I chose an abnormal amount of images that tilted to the left. Individually, the images looked great, but as a group, it was a little too much of a good thing.

 When selecting photos for your portfolio, be aware that varying the tilts and angles enhances the overall look of your portfolio. For more about tilts and angles, check out Chapter 10.

- ✔ **Subject matter:** If you lean toward shooting one type of food, such as cupcakes — my dream subject! — throw in a few savory foods to round out your photos (see Figure 15-8). Doing so allows the customer to see more of what you can do with various types of foods.

55mm, 1/50 sec., f/5.6, 320

Figure 15-8: Mixing up the food subjects in your portfolio shows clients that you're more than a one-trick pony.

- ✔ **Close-up and wide shots:** Include both close-ups and wide shots. Getting a good variance on distance enhances the overall portfolio.

- ✔ **Studio and location photos:** If you intersperse studio photos with photos shot on location, or even *found* photos (photos you just happened upon unexpectedly), such as the mushrooms in Figure 15-9, you'll have a good, robust collection of images to show.

Be mindful of the images you choose and keep your aesthetic front and center. Don't include images that are too far out of your artistic comfort zone.

Displaying Your Portfolio

Your portfolio is a cohesive reflection of your best work. Now that you've chosen the photos that make up your portfolio, it's time to think about how to best display your images.

The display choices boil down to digital and print. Digital displays are either web based or software based, depending on your preferences and needs. And print is a little more old-fashioned, but because of that, it makes the print choice rather retro cool. I discuss both options in the following sections.

55mm, 1/25 sec., f/5.6, 200

Figure 15-9: Including found photos in your portfolio gives it a rich variety.

Going with printed images

Printing a series of images for a hard-copy portfolio book isn't very common these days. But if you're going to take the time and effort to go this route, I suggest having your images custom printed on high-quality paper, rather than having them printed at the local one-hour photo mart. The quality really makes a difference in the overall presentation of your photos. I talk more about printing your work in Chapter 14.

To top off the effort, house your portfolio in a nice case. A portfolio case should hold a good number of your images — not too many, not too few. Between 15 and 20 images is a good number to present.

And if you need a way to present multiple images on one page, perhaps for an event or a proposal, you can create a composite of a number of your images on a flyer. As shown in Figure 15-10, you can use Photoshop to arrange a mélange of some of your favorite photos, and then add a little text and voilà!

Figure 15-10: A composite sheet allows you to compile several photos onto one page.

Looking into digital options

The iPad is hands down the most professional looking digital portfolio option I've seen. The photo software on the tablet is really robust and flexible, and it includes great transitions for slide shows. Uploading or syncing photos to the device is easy. Several display options help you create a pleasing look for your work (see Figure 15-11).

With that said, other great tablet options are available. Whatever tablet you go with, the devices are all portable, and you can have them in hand when meeting with clients. Tablets are a great way to show off your best work to prospective clients.

Other ways to display your images in an electronic portfolio include creating your portfolio on a photo-sharing site or displaying it on your website as I discuss in Chapter 14.

Figure 15-11: A tablet like the iPad is a great way to display your photos.

If you display your portfolio via the web, your photos will nearly always appear slightly washed out, because of the compression that a specific site uses for displaying images. If you display your work on an iPad or another tablet, it's a different experience. With a tablet, you have no perceivable loss in information or quality in your images.

So go ahead and refer folks to your website or blog, but when visiting a client, bring along an iPad or another tablet, a physical portfolio book, or even a composite sheet. A little show and tell goes a long way when wooing new clients.

Choosing a Pricing Model for Your Business

In the photographic world, instead of an hourly rate, you're better off charging a *day rate*. A day rate is the rate you charge per day for a client. The rate will vary greatly, depending on your experience, your locale, and the current economic climate.

I tweak my day rate slightly depending on the size of the business. If a great, new, small restaurant is just starting out, I'll likely be a little more lenient on my day rate. Maybe shave off $100 or so to help them out. A little goodwill can go a long way.

If you decide to shoot for stock agencies, you need to think about which model works best with your business. Is it the microstock model, with the rock-bottom prices but potentially higher volume? Or is the traditional stock agency model a better fit for your business?

I help you decide how to price your day rate and which stock agency is best for your business in the following sections.

Figuring out your day rate

So I have some good news and some bad news about day rates. Why don't we get the bad news over with first. Day rates at the present time are lower than the day rates of five years ago. There, I've said it. It's an unfortunate fact of life, but it's the new normal for most photographers.

The good news is that many clients are still hiring! So you may have to modify your day rate a bit to match the fluctuating market conditions, but much of the work is still out there.

So what should you charge for a day rate? First, consider your experience. If you're a newbie food photographer just starting out with a good starter portfolio but not much experience, a lower rate is appropriate. It needs to be high

enough so you're taken seriously by your clients but low enough to reflect your newness to the profession.

In my area, at the time of this writing, $500 to $600 per day is an appropriate baseline rate for a new photographer. Mid-level photographers with a good level of experience have a day rate of about triple the newbie rate. And the top-of-the-line photographers can command top-of-the-line rates.

Another factor to consider is your market. Are you located in a large city or a small town? Financially, is it a boom time or is it leaning more toward a recession? You may need to adjust your rates as needed for these types of environmental aspects.

Half-day rates aren't 50 percent of your day rate. Typically, a half-day rate is half of your day rate, plus a smidge. So, for example, if you have a day rate of $1,500, a good half-day rate is $850 or so.

Understanding stock agency prices

Basically, two types of stock agencies exist: traditional agencies and micro-stock agencies. The *microstock* model has lower prices and higher volume, and the more traditional stock agencies have higher prices but lower sales volume (see Chapter 14 for full details). Decide which model suits you best or use a variety of agencies to market your photos.

Within the current stock agency market, microstock prices typically run under one dollar. Traditional stock agencies pay significantly more than the microstock agencies, depending on the usage needed by the client. In my experience with traditional stock agencies, I've sold limited usage images from about $15 for a very small size and run duration to around $500 for a larger size and run.

The coolest thing about shooting for stock agencies is the occasional repeat business. If an image is sold in a specific size for a specific usage to a publishing company for use in an English language textbook, that's great. But several months later, that same image may be relicensed for a run in a translated version of the book. And beyond that, it may be relicensed for subsequent editions or electronic versions of the book. Bonus!

Expanding Your Online Presence

To really go digital with your portfolio and your business, you have to get on the web. I talk about blogs and websites in Chapter 14, but I encourage you to

go full tilt and schmooze it up across the Internet. The more places you have an online presence, the better. Here are just a few ways to get your name and images online:

- ✔ **Create a business page on a social networking site:** Instead of just sharing what you ate for breakfast on your personal social site, creating a business page on a social network allows you to get the word out about new happenings and images in your business. It's a great way to create a positive impression about your work.

- ✔ **Comment on food photo boards:** Get on out there and comment on some food photography lists or bulletin boards. Follow the trends, comment on other photographers' work, and generally make yourself known in the community. You never know what can come of an alliance forged on these boards.

- ✔ **Join forces with a chef:** If you work a lot with a chef, restaurant, or catering company, perhaps you can join together and create an alternate site that promotes both of your businesses. Having alternative sites increases your visibility on the Internet.

- ✔ **Send e-mail blasts:** You can market your services by e-mailing prospective clients. Include some succulent images in the mail to whet their appetites.

Go sparingly on the e-mail blasts. Send blasts occasionally, not every week. If you send e-mails too often, you run the risk of turning off potential clients and having your e-mails treated like spam.

Advertising Your Business

You don't need to spend a fortune these days to get the word out about your new business. Don't get me wrong: If you want to spend a bit of money to get additional visibility in the art and design marketplace, you have options. You can take out ads in photography design magazines, such as *Select Magazine,* which is a London-based photographic showcase, essentially an art and idea magazine. These types of design magazines sometimes have a food images section. These showcase magazines are cherished and kept forever for reference in design houses, ad agencies, and the like.

You can also take out ads in one of the many food or cuisine magazines available nowadays. These ads may also be quite expensive, but it can be well worth it, depending on your circumstances.

But you can also find much more reasonable ways to get the message out about your new business. Small, succinct Internet ads, such as Google AdWords or similar, are a really inexpensive way to get the word out about your work. You can run these Internet ads as much or as little as you want. The ads are composed of just a few lines of text and a URL. Internet text ads are a basic but very effective way to advertise your business.

These small Internet ads are *keyword* based. Keywords are words or tags that your potential clients may search when they're looking for a food photographer. A few examples of ad keywords include *gourmet, cuisine, food, restaurant, photography, photo, photographer,* and so on.

Sending direct mail to a very targeted audience of restaurants, caterers, food companies, and so on is another possibility for advertising your work. You can print your images on postcards that can be sent to potential clients and also to existing clients as nifty reminders of your work.

Part V
The Part of Tens

The 5th Wave — By Rich Tennant

"Let me know when you've got enough lettuce on that taco."

In this part . . .

In this time-crunched world, many folks prefer to get to the heart of the matter quickly and clearly. For those of you of that ilk, this standard *For Dummies* part provides quick bits of info that can help you on your way to taking your food photography to new levels.

In this part, I provide tips for bumping up your business, a list of basic stuff you need for a shoot, and ten ways to accessorize your foods.

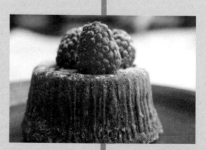

16

Ten Tips for Growing Your Business

*T*he reality of the world today is that a large part of growing your business is Internet based. In this chapter, I discuss ten ideas for increasing your business, including various site and blog options, Internet ads, and participation in food photography forums. I also touch briefly on basic site visibility issues à la *Search Engine Optimization (SEO).* (SEO is the process of increasing your site rankings through a search engine.)

But man (or woman) doesn't live by 1s and 0s alone. I also cover a few ideas for those of us more comfortable with the personal, face-to-face part of the business.

Create Business-Based Social Network Pages

Today, a world of social networks is available, and I'm sure more are on the way. By now, a majority of the population visits these social sites at least once a week. You may have a personal page or two on Twitter, Facebook, Google+, or the like, where you already share your work. But it's time to consider starting a business page on one or more of the social networks as well.

A business page creates a venue for you to share your new gorgeous food shots, promote news and events, suggest helpful tips and ideas, and pose questions you need answers to.

Some of the social networks lean toward a younger audience and some to an older one, so I suggest opening two business pages to market your work to a well-rounded audience.

The most successful business pages I've noticed tend to put out bright, cheerful, and informative messages to engage their followers and potential clients. So think positive thoughts when posting to your new business social network page.

Nurture a Blog

A blog can be a great addition to your food photography business. A blog is a wonderful setting to post beautiful food imagery, recipes, ideas, and anecdotes for your viewers. Food blogs are generally well received because they tend to be lovely, yummy, and inspirational across the board.

But here's the thing about blogs: They risk getting a little stale if they're not properly nurtured and cared for. All blogs require maintenance. And that means *daily* maintenance if you're serious about keeping it current for your viewers.

The most popular food and food photography blogs are updated quite often. If you update your blog frequently, your viewers and followers will visit your site again and again to get cool new information and images. They'll set their expectations for your blog, and they may get into the habit of visiting your site, thereby increasing your hits, analytics, and overall popularity for your blog.

Contribute to Food Photography Bulletin Boards and Forums

Many photography bulletin boards as well as a substantial number of food photography forums are available on the Internet. In a way, these sites are another form of networking (online instead of in person; see the "Network" section later in this chapter for more on in-person networking). Folks have issues, comments, or potential projects, and the online community chimes in to respond.

Becoming a part of that online community is a great way to get involved, share your input, and possibly receive input from others. If you decide to contribute, use your real name. Doing so gets your name online a bit more, which can help your online presence.

The discussions on photography bulletin boards and forums are often really interesting and relatable. These communities are groups of other people who've also been bitten by the passion of food photography. Hearing different views about photographing food from around the world is interesting and helpful. So what are you waiting for?

Buy Internet Ads

Taking out small Internet-based ads is an excellent and fairly inexpensive way to grow your business. In fact, an Internet ad is about as easy and inexpensive as it gets for advertising options for food photography. The tiny ads require minimal start-up effort, and the ads themselves consist of just a few lines of text and a URL that users click to get to your site or blog.

 Be sure to use appropriate keywords in your ad and choose your tags carefully. You want people to find your ad when searching for food photographers, so think of words you may use in a similar search and include them in your ad. (See the next section for more about using keywords.)

A bonus feature that comes with running these ads are metrics and analytics, which are usually included in the package. This feature allows you to clearly see and measure which ads do better than others for your business.

Use Search Engine Optimization (SEO)

Wouldn't it be helpful to have your business displayed near the top of the search results queue when someone searches for a food photographer? Well, in theory, that's what good Search Engine Optimization (SEO) can do for you and your business.

A ton of good books and articles are available about SEO, written by folks who are far more knowledgeable about the subject than I am. But in this section, I go over the absolute basics of the idea, which I'm pretty familiar with.

So without further ado, SEO boils down to the following two basic premises. Taking these ideas to heart can help you put together a good SEO framework for your business.

- ✔ **Clear naming conventions:** You want to use clear and descriptive text in all areas of your site and images. The images present on your site should have overtly descriptive titles, such as Beef Goulash with Spaetzle, and logical keywords embedded. This wording can then be picked up and indexed by the various search engines. And the rest is history.

 When choosing keywords, think about the image from every angle. The obvious keywords are *food,* the type of food, the ingredients, what meal the food may be eaten at, how it was prepared, and the amount of the food in the photo (one or many). Additional keywords can cover geographic regions, colors, descriptive synonyms, backgrounds, the feelings an image evokes (such as warmth), and common misspellings.

- ✔ **Links to your site:** The objective here is to have other sites link to your main website. You can link to your site from your blog, your social sites, your stock galleries, and so on. If possible, place your business info and URL in some food or photography newsletters or forum sites. And make sure any food, photo, or other business associations you're a member of have your complete information and URL posted. (That goes for your alumni association, too!) And don't forget Internet ads with the URL at the bottom that clicks straight through to your site.

 Well, that's a starter list for you. I bet you can think of a few other web options out there that can happily link to your site as well.

Dive in to Stock Agencies

Although stock agencies probably won't be able to provide you with a full paycheck, they certainly can augment your business income nicely. And they can increase your visibility on the web as well.

Almost all agencies provide galleries of your work that you can link to and share with your clients, so shooting for stock is a great way to expand your business.

I talk extensively about stock agencies in Chapter 14. As a food photographer, using stock agencies is a low overhead way to increase your overall business.

Research Opportunities

I'm always on the lookout to increase my business with new food photography or styling opportunities. If you have a fairly robust web presence, sometimes jobs will come to you, but that's the exception rather than the rule, particularly when you're just starting out.

You may be able to find some unique business opportunities by looking on craigslist and other job boards for local restaurant, bakery, or other types of food shoots. And sometimes, food packaging or gourmet event jobs show up there as well. So be sure to keep your eye on those sites.

You can also reach out to the chef community in your area. Get to know them, their specialties, and their style. You never know what kinds of interesting opportunities may spring from your new contacts!

Network

Another good way to potentially increase your business is to get out and network. I'm not talking about digital networking here; I mean get out in your community and meet with folks face to face.

The key to networking is to start small and local, which is often easier than going big and broad. Venture out and introduce yourself to the restaurant owners and employees in your neighborhood. You may even want to bring your portfolio, just in case they have a few minutes to view your work.

Eventually, start expanding your network to areas outside of your neighborhood, like that artisan bakery downtown. Simply drop off a postcard of your work (see the next section) and get to know the folks who work there. If you're a member of any associations in your community, attend the meetings and get familiar with the goings on around town. Some will undoubtedly involve food.

Attend foodie events in your community, such as gourmet cook-offs or festivals that celebrate food and drink. In my area, we have a garlic festival, a pumpkin festival, a mustard festival, and a few lovely wine shindigs. You may have a similar situation in your area. In any case, these types of events are great venues to meet and greet the chefs and foodies in the area — who may eventually need some of their creations photographed.

Send Postcards

Printing some of your food images on postcards via one of the custom photo-printing companies is a great way to show off your images. (You can see some of my postcards in Figure 16-1.) Your images can't be missed on these cards. Using postcards is a really in-your-face way to get your food photos out in your community and beyond.

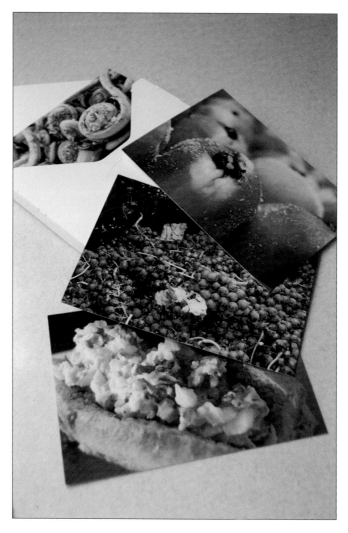

Figure 16-1: Printing your images on postcards is a great way to show them off.

You can mail postcards as thank-you cards, appointment reminders, or direct mail ads to selected clients. You can even hand them out at food events or restaurants as oversized business cards.

Although many terrific printing companies handle this type of printing, my absolute favorite printing company for photo postcards is called Moo (www.moo.com). Its work is fast and high quality, its customer service is amazing, and frankly, I love it with all my heart!

Make Trades

One of my favorite ways to increase the number and variety of the images I have in my portfolio and website, while making some valuable contacts in the food industry, is to occasionally trade chef-provided subject matter for images. For example, I received the food in Figure 16-2 in exchange for the photo.

This trade-off is actually quite beneficial: I get the portfolio material I need, and I provide an image for the client's use.

I don't recommend trading restaurant advertising shots for a food credit. Restaurants can be inconvenient to your location, and honestly, it's not that unusual for restaurants to change hands or go out of business.

As you can see in Figure 16-3, I've also traded photos of grapes and vineyards for bottles of delicious wine. Yum!

Trading food for photos is an unusual arrangement these days, but it really works, particularly under the current economic climate. Just confirm that the value of the trade equals what you'd charge for your time shooting.

55mm, 1/125 sec., f/8.0, 400

Figure 16-2: You can trade beautifully prepared subject matter for photos.

55mm, 1/125 sec., f/8.0, 400

Figure 16-3: Trading vineyard images for wine is a win-win situation.

Ten Indispensable Items for a Food Shoot

In This Chapter

▶ Understanding the benefits of cloth napkins, white tablecloths, and fabric steamers

▶ Working with oil and reflectors to add shine to your foods

▶ Embracing the versatility of duct tape and foam core boards

▶ Remembering to pack extra camera batteries, memory cards, extension cords, and light bulbs

*Y*ou're in the middle of a big outdoor food shoot, and everything is going just fine — until a big breeze blows your linens off the table and you notice that pesky indicator on your camera, telling you that your batteries are almost dead! Don't panic! If you've come prepared with extra batteries, duct tape, and the other eight essential tools and extras that I describe in this chapter, you have nothing to worry about. You may want to keep the smaller items on this list in their own bag or container so they're always ready to go when you are. Just don't forget to pack your camera and lights, too!

Cloth Napkins

Cloth napkins are one of the best change agents in food photography. A nicely placed, folded napkin under a dish offers a great look, as you can see in Figure 17-1. But you also need to have a variety of other colors and textures on hand in case you want to try a different look for your food setting.

To create an alternative background, you can steam out the creases in a napkin and open it up to place under your food. A stack of folded linens can also make for a nice addition in the background of your shot. I talk about all kinds of linens in detail in Chapter 3.

40mm, 1/20 sec., f/5.6, 500

Figure 17-1: A cloth napkin placed under food adds variety and texture.

Cooking Oil

Brushing or dabbing a little cooking oil on dried-out meats, seafood, and even roasted produce creates the illusion of freshly cooked foods (see Figure 17-2). When shooting proteins, in particular, make sure you always have some oil on hand.

What type of oil you use doesn't matter. Whether it's an inexpensive canola oil or a posh Italian extra-virgin olive oil, it will produce the same beautiful, shiny look in your dishes.

Use oil sparingly on foods. Just a touch of oil brushed on food does the trick. Too much will look greasy and unappetizing. (See Chapter 6 for more ways you can use oil to increase highlights and shine on your food subject.)

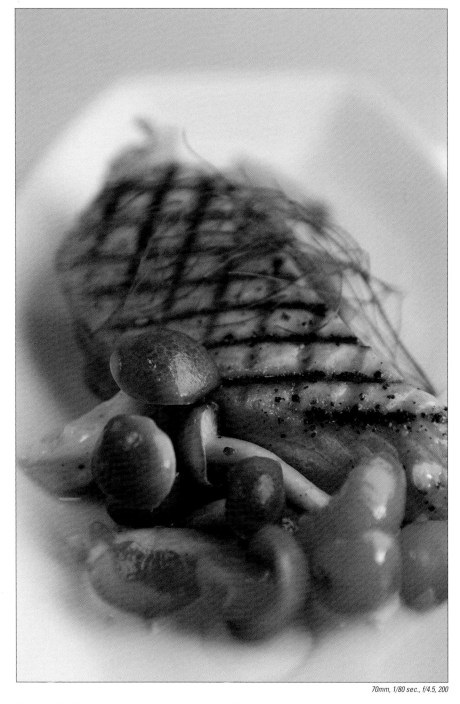

70mm, 1/80 sec., f/4.5, 200

Figure 17-2: Salmon with vegetables, enhanced by a light brushing of cooking oil.

Duct Tape

A shoot without duct tape is like a day without sunshine. Seriously, I rely on duct tape to handle all sorts of tasks around my food shoots. Here are just a few examples:

- ✔ I use duct tape to tape electrical cords out of the way so folks don't trip over them while I'm shooting. You certainly don't want your lights to come crashing down on top of your food — or you!

- ✔ If I want to add a background color to a shot, I often use duct tape to attach a foam core board to the end of the table I'm working on. Duct tape is perfect for holding the lightweight board securely in place.

- ✔ If I'm shooting outdoors and I have flapping linens or papers, I use a little duct tape to keep them firmly anchored so they don't ruin my shots.

- ✔ Sometimes, I use duct tape to add a little flair to my shoots. For example, I once fashioned an elaborate structure with heavy wire, cardboard, and a large amount of duct tape to hold a fork in place above a food dish. Building it took a few tries, but my contraption worked like a charm!

Basically, anytime you need something secured, anchored, or even fabricated during your shoot, duct tape is your go-to tool.

Extension Cord

Most of the places where I shoot (especially restaurants) don't have enough plugs to handle all the lights and chargers I need to use. Or the plugs are way too far away from the table I need to shoot on. So I plan ahead and always bring an extension cord or two with me.

I like to use the heavy-duty extension cords that include a power surge protector, just in case. I also use the power-strip type of extension cords with multiple outlets so I can handle any situation that may arise.

Extra Camera Batteries and Memory Cards

Backup camera batteries and memory cards are extremely important extras to bring to every shoot, but they're especially important for any shoot that

lasts more than half a day. After all, your camera battery will eventually run down and your memory card will eventually fill up. You need to be prepared to swap out these items with fresh ones during lengthy shoots.

Always make sure you charge your camera battery the day before a big shoot (and check that the battery held the charge) and have some extra memory cards on hand, just in case. You don't want to have to stop in the middle of a big shoot to look for the nearest camera supply store (which, realistically, may be quite a distance from your location).

Extra Light Bulbs

Every light bulb will eventually die out, and for some reason, most of them seem to do so at the most inappropriate times! So make sure you always bring extra light bulbs to a shoot.

I confess that I've been in a situation where I had a food scene perfectly lit and then had a key light flicker out and die! Of course, it happened right before I got the shot I was going for, and I didn't have any spares with me. Learn from my mistakes! Always carry spare bulbs with you on a shoot so you can quickly recover from any potential lighting disasters.

Foam Core Boards

Foam core boards are great additions to any shoot (see Figure 17-3). They're super lightweight, weighing in at just a few ounces, and they can help add color and pizzazz to a boring shoot. They come in white on one side and a range of colors on the other side.

If you don't find the color you're looking for, you can always paint the foam core board with your desired color. You can also cover the boards with material or colored paper for a cool alternate look. And when you need an extra reflector in a pinch, you can use the white side of a foam core board as an impromptu bounce card. (See Chapter 3 for more on foam core boards and their many uses.)

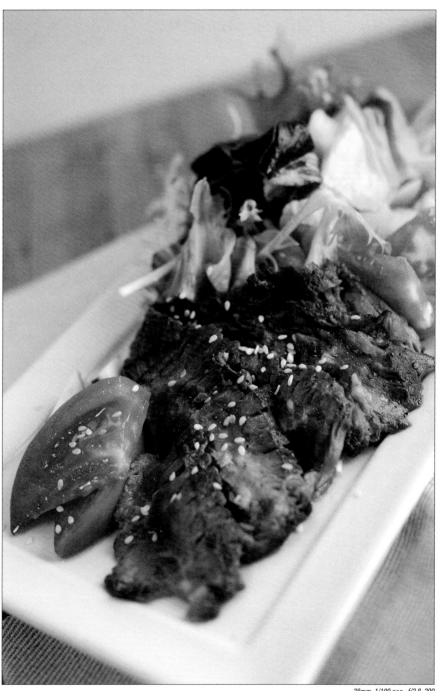

38mm, 1/100 sec., f/2.8, 200

Figure 17-3: Foam core taped to the back of a table creates a nice background.

Portable Fabric Steamer

Sometimes wrinkles are just fine in a fabric background or prop. For example, in a country-style type of shot, wrinkled material can add to the texture and interest in the image. But other times a fabric with wrinkles and creases can seriously spoil a good shoot — or at least increase your overhead cost by forcing you to digitally remove the wrinkles after the fact.

To avoid this time-consuming process and to guarantee I get the look I want at every shoot, I always bring a portable fabric steamer just in case I have some fabric that needs a little smoothing.

A steamer provides a smooth and polished look for your linens and increases your flexibility at a shoot. For example, if you have unintended wrinkles in your fabrics that occurred during transport, you can wipe them out quickly with a little steam. The result is a nice, smooth-looking surface on which you can place your dishes. If you decide you want to change a folded napkin into an impromptu background for a shot, you can unfold the napkin and steam out the creases with your handy steamer. Voilà! Now you have a whole new background.

A steamer provides a smooth and polished look for your linens and increases your flexibility at a shoot.

Reflectors

After you've set up your lights and the food at a shoot, you may notice that one area needs a small boost of light. Or perhaps a shadow is a bit too dark and you'd like to diffuse it a little.

To get the perfect shot you're looking for, grab a reflector or two. You can use any surface with a light or reflective quality to help boost and diffuse the light for your shots. For example, you can use pop-up reflectors, white boards (or foam core board), mirrors, or aluminum foil. (In Chapter 6, I explore other creative uses for reflectors.)

White Tablecloth

A white tablecloth is a clean, neutral background that won't distract from the beauty of the food you're shooting (see Figure 17-4). It's nearly always an appropriate look for a food shot.

If you've tried various background options and aren't completely happy with how things look, pull out the white tablecloth and go from there.

The tablecloth can be nicely pressed or casual and rumpled, depending on the look you're going for. You can place it on a table under your food or drape it in the background as a clean white backdrop. With so many uses, the white tablecloth is undoubtedly one of the most versatile props you can have in your food photographer's toolkit. (See Chapter 3 for more on linens.)

 A white tablecloth doesn't always have to be a *tablecloth,* by the way! I often purchase a few yards of white cotton or linen from a fabric store to use as a low-cost "tablecloth" option.

55mm, 1/80 sec., f/5.6, 800

Figure 17-4: A white tablecloth under food gives the image a clean look.

Ten Awesome Garnishes for Food Images

A garnish is a little something extra for a food. It's essentially a decoration for your food subject that makes your food look a little more interesting in its composition. A garnish can be an accent or a topping. It can be a liquid or a solid, fresh or dried.

Many times, the garnish provides a nice contrast of color or shape, but overall, its purpose in life is to make your images look just a little bit more appetizing.

Way back in the 1960s, a garnish for food meant one thing and one thing only — a curly green sprig of parsley. From these humble beginnings has arisen a modern-day bounty of garnish-y ideas!

So go ahead, step out from behind the parsley sprig, and try on some of the different garnishes I explore in this chapter to make your food photography shine.

Basil Leaves

Basil leaves are the perfect accent for any type of Italian food, but it doesn't stop there. A small sprig can complete the look of a savory pie, as in Figure 18-1. Basil can accent a chicken breast, a bowl of chopped tomatoes, hummus, some grilled vegetables, or even a drink.

With an accent like basil, smaller is generally better. Use tiny leaves or a small sprig, but don't overdo it. The accent should never be the focus of the food image.

48mm, 1/6 sec., f/5.3, 250

Figure 18-1: Basil leaves are the perfect accent for many foods.

Bits of the Subject

Using bits of the subject I'm shooting is my very favorite way to add an accent to a dish. To get this look, take a little bit of the subject, such as the crumbs of a biscuit or the champagne grapes in Figure 18-2, and use that little extra bit to echo the subject.

Having these echo bits in soft focus in the image is preferable and is a really nice use of repetition for an image.

You can use bits as accents with many subjects: another example may be a bowl of watermelon salad with a little watermelon seed or two outside the bowl. You get the idea!

55mm, 1/60 sec., f/5.6, 250

Figure 18-2: Bits of the food subject provide a nice, soft accent.

Chopped Green Onions

Using chopped green onions is such a basic idea for a topping, but it's truly a lovely way to brighten up any dish. When you have a situation where you have a savory dish that could use a little contrasting color, a few green onions can really jazz up the dish.

In Figure 18-3, I sprinkled green onions on some tasty shrimp sushi. Green onions are also a good garnish choice for many other foods, including omelets, baked potatoes, quiche, or salads.

The Double Drizzle

I adore the look of the double drizzle. When one sauce is looking a little too plain, add a second, contrasting sauce, as I've done in Figure 18-4. Drizzle the second sauce over the top of the first in a loose zigzag pattern.

An inexpensive squeeze bottle works just fine for creating the drizzle. You can find these plastic bottles in most cookware stores these days.

Perfecting the messiness of the drizzle may take a little practice. Practice on a plate or a stand-in subject to get your drizzling chops in order.

70mm, 1/100 sec., f/5.0, 250

Figure 18-3: Green onions are a simple but lovely accent.

Fresh Berries

Wow! To me, nothing is more spectacular and seasonal than a topping or accent of fresh raspberries, blueberries, blackberries, or strawberries. These lovely fruits aren't always in season, but when they are, my mantra is to use them as much as possible.

34mm, 1/15 sec., f/4.5, 400

Figure 18-4: The double drizzle is the perfect trick for bringing life to a plain sauce.

Berries are a wonderful fresh accent for foods, either whole, cut, or even mashed into a colorful sauce. The fruit garnishes are generally suited to sweet foods (see Figure 18-5), but they can be used as an accent for poultry as well.

Choose your berries carefully. Select the plumpest, freshest berries you can find and use them the same day, if at all possible.

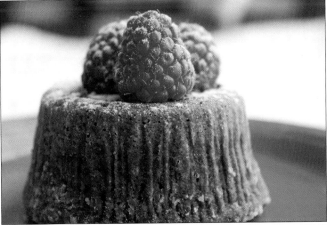

55mm, 1/10 sec., f/5.6, 100

Figure 18-5: Fresh berries, like the raspberries shown here, are a great accent for sweet and some savory foods.

Fresh Citrus Peels

The tiniest bit of fresh citrus peel can truly brighten up a subject. Changing the look of a food from boring to beautiful doesn't take much time or effort.

The cute little cakes in Figure 18-6 were looking too brown and blah to me. Placing just a few strands of Meyer lemon peel on top of the cakes really changed the look. The lightness of the garnish lightens the look of the cakes and the overall image.

To create fresh citrus strands, use a vegetable peeler to remove just a small bit of peel from a citrus fruit and then cut ultra thin slivers of the peel with a sharp knife.

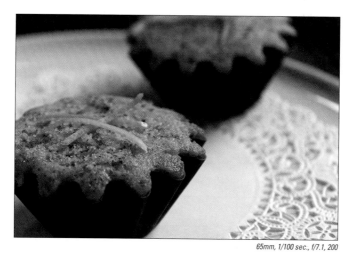

65mm, 1/100 sec., f/7.1, 200

Figure 18-6: Fresh lemon peel gives these cakes a little zing.

Grains of Salt

These days, a plethora of salts are available that can provide different looks for your images. There's large grain sea salt, flaked sea salt, kosher salt, hand-harvested *Fleur de Sel* (an extravagant French salt; see Figure 18-7), gray salt, and red salt, just to name a few.

So go ahead and shake it on, bake it on, or rub it on. The crystalline grains really can add a nice little sparkle to your food images.

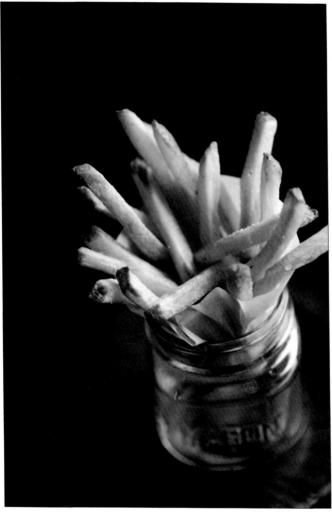

85mm, 1/320 sec., f/2.0, 250

Figure 18-7: A little Fleur de Sel adds just the right amount of sparkle.

Microgreens

You may be thinking, what the heck is a *microgreen?* Microgreens are tiny, leafy, sprout-like baby plants that look absolutely incredible as a garnish (see Figure 18-8). Oh, how I love my microgreens!

Oftentimes, microgreens are radish sprouts or cress. In addition to looking fabulous, they can be quite delicious and nutrient packed. A topping of microgreens can give an ordinary dish the look of absolute freshness. Microgreens just may be the new parsley.

Keep an eye on the base of the greens. You may have to use scissors or a sharp knife to trim the bottoms of the microgreens because they discolor in a fairly short amount of time.

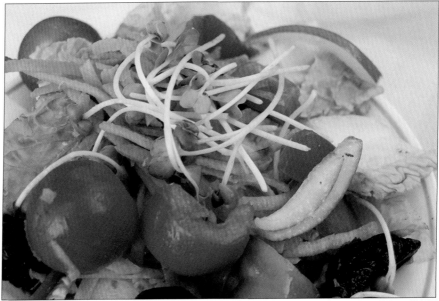

55mm, 1/160 sec., f/6.3, 400

Figure 18-8: A garnish of microgreens adds a look of freshness.

Notes

Apple & Mac

iPad 2 For Dummies,
3rd Edition
978-1-118-17679-5

iPhone 4S For Dummies,
5th Edition
978-1-118-03671-6

iPod touch For Dummies,
3rd Edition
978-1-118-12960-9

Mac OS X Lion
For Dummies
978-1-118-02205-4

Blogging & Social Media

CityVille For Dummies
978-1-118-08337-6

Facebook For Dummies,
4th Edition
978-1-118-09562-1

Mom Blogging
For Dummies
978-1-118-03843-7

Twitter For Dummies,
2nd Edition
978-0-470-76879-2

WordPress For Dummies,
4th Edition
978-1-118-07342-1

Business

Cash Flow For Dummies
978-1-118-01850-7

Investing For Dummies,
6th Edition
978-0-470-90545-6

Job Searching with Social
Media For Dummies
978-0-470-93072-4

QuickBooks 2012
For Dummies
978-1-118-09120-3

Resumes For Dummies,
6th Edition
978-0-470-87361-8

Starting an Etsy Business
For Dummies
978-0-470-93067-0

Cooking & Entertaining

Cooking Basics
For Dummies, 4th Edition
978-0-470-91388-8

Wine For Dummies,
4th Edition
978-0-470-04579-4

Diet & Nutrition

Kettlebells For Dummies
978-0-470-59929-7

Nutrition For Dummies,
5th Edition
978-0-470-93231-5

Restaurant Calorie Counter
For Dummies,
2nd Edition
978-0-470-64405-8

Digital Photography

Digital SLR Cameras &
Photography For Dummies,
4th Edition
978-1-118-14489-3

Digital SLR Settings
& Shortcuts
For Dummies
978-0-470-91763-3

Photoshop Elements 10
For Dummies
978-1-118-10742-3

Gardening

Gardening Basics
For Dummies
978-0-470-03749-2

Vegetable Gardening
For Dummies,
2nd Edition
978-0-470-49870-5

Green/Sustainable

Raising Chickens
For Dummies
978-0-470-46544-8

Green Cleaning
For Dummies
978-0-470-39106-8

Health

Diabetes For Dummies,
3rd Edition
978-0-470-27086-8

Food Allergies
For Dummies
978-0-470-09584-3

Living Gluten-Free
For Dummies,
2nd Edition
978-0-470-58589-4

Hobbies

Beekeeping
For Dummies,
2nd Edition
978-0-470-43065-1

Chess For Dummies,
3rd Edition
978-1-118-01695-4

Drawing For Dummies,
2nd Edition
978-0-470-61842-4

eBay For Dummies,
7th Edition
978-1-118-09806-6

Knitting For Dummies,
2nd Edition
978-0-470-28747-7

Language & Foreign Language

English Grammar
For Dummies,
2nd Edition
978-0-470-54664-2

French For Dummies,
2nd Edition
978-1-118-00464-7

German For Dummies,
2nd Edition
978-0-470-90101-4

Spanish Essentials
For Dummies
978-0-470-63751-7

Spanish For Dummies,
2nd Edition
978-0-470-87855-2

Available wherever books are sold. For more information or to order direct: U.S. customers visit www.dummies.com or call 1-877-762-2974.
U.K. customers visit www.wileyeurope.com or call (0) 1243 843291. Canadian customers visit www.wiley.ca or call 1-800-567-4797.

Connect with us online at www.facebook.com/fordummies or @fordummies

Math & Science

Algebra I For Dummies,
2nd Edition
978-0-470-55964-2

Biology For Dummies,
2nd Edition
978-0-470-59875-7

Chemistry For Dummies,
2nd Edition
978-1-1180-0730-3

Geometry For Dummies,
2nd Edition
978-0-470-08946-0

Pre-Algebra Essentials
For Dummies
978-0-470-61838-7

Microsoft Office

Excel 2010 For Dummies
978-0-470-48953-6

Office 2010 All-in-One
For Dummies
978-0-470-49748-7

Office 2011 for Mac
For Dummies
978-0-470-87869-9

Word 2010
For Dummies
978-0-470-48772-3

Music

Guitar For Dummies,
2nd Edition
978-0-7645-9904-0

Clarinet For Dummies
978-0-470-58477-4

iPod & iTunes
For Dummies,
9th Edition
978-1-118-13060-5

Pets

Cats For Dummies,
2nd Edition
978-0-7645-5275-5

Dogs All-in One
For Dummies
978-0470-52978-2

Saltwater Aquariums
For Dummies
978-0-470-06805-2

Religion & Inspiration

The Bible For Dummies
978-0-7645-5296-0

Catholicism For Dummies,
2nd Edition
978-1-118-07778-8

Spirituality For Dummies,
2nd Edition
978-0-470-19142-2

Self-Help & Relationships

Happiness For Dummies
978-0-470-28171-0

Overcoming Anxiety
For Dummies,
2nd Edition
978-0-470-57441-6

Seniors

Crosswords For Seniors
For Dummies
978-0-470-49157-7

iPad 2 For Seniors
For Dummies, 3rd Edition
978-1-118-17678-8

Laptops & Tablets
For Seniors For Dummies,
2nd Edition
978-1-118-09596-6

Smartphones & Tablets

BlackBerry For Dummies,
5th Edition
978-1-118-10035-6

Droid X2 For Dummies
978-1-118-14864-8

HTC ThunderBolt
For Dummies
978-1-118-07601-9

MOTOROLA XOOM
For Dummies
978-1-118-08835-7

Sports

Basketball For Dummies,
3rd Edition
978-1-118-07374-2

Football For Dummies,
2nd Edition
978-1-118-01261-1

Golf For Dummies,
4th Edition
978-0-470-88279-5

Test Prep

ACT For Dummies,
5th Edition
978-1-118-01259-8

ASVAB For Dummies,
3rd Edition
978-0-470-63760-9

The GRE Test For
Dummies, 7th Edition
978-0-470-00919-2

Police Officer Exam
For Dummies
978-0-470-88724-0

Series 7 Exam
For Dummies
978-0-470-09932-2

Web Development

HTML, CSS, & XHTML
For Dummies, 7th Edition
978-0-470-91659-9

Drupal For Dummies,
2nd Edition
978-1-118-08348-2

Windows 7

Windows 7
For Dummies
978-0-470-49743-2

Windows 7
For Dummies,
Book + DVD Bundle
978-0-470-52398-8

Windows 7 All-in-One
For Dummies
978-0-470-48763-1

Available wherever books are sold. For more information or to order direct: U.S. customers visit www.dummies.com or call 1-877-762-2974.
U.K. customers visit www.wileyeurope.com or call (0) 1243 843291. Canadian customers visit www.wiley.ca or call 1-800-567-4797.
Connect with us online at www.facebook.com/fordummies or @fordummies

DUMMIES.COM®

Wherever you are in life, Dummies makes it easier.

From fashion to Facebook®, wine to Windows®, and everything in between, Dummies makes it easier.

Visit us at Dummies.com and connect with us online at www.facebook.com/fordummies or @fordummies

Dummies products make life easier!

- DIY
- Consumer Electronics
- Crafts
- Software
- Cookware

- Hobbies
- Videos
- Music
- Games
- and More!

For more information, go to **Dummies.com**®
and search the store by category.

Connect with us online at
www.facebook.com/fordummies or @fordummies

FOR
DUMMIES®
Making everything easier!™